MW00323919

LOST SKI AREAS

—— of the ——

Berkshires

JEREMY K. DAVIS

THE
History
PRESS

Published by The History Press
Charleston, SC
www.historypress.com

Copyright © 2018 by Jeremy K. Davis
All rights reserved

Cover images courtesy of Woodward Bousquet, the author, Gary Leveille/Berkshire Archive and the New England Ski Museum.

First published 2018

ISBN 9781540236739

Library of Congress Control Number: 2018948041

Notice: The information in this book is true and complete to the best of our knowledge. It is offered without guarantee on the part of the author or The History Press. The author and The History Press disclaim all liability in connection with the use of this book.

All rights reserved. No part of this book may be reproduced or transmitted in any form whatsoever without prior written permission from the publisher except in the case of brief quotations embodied in critical articles and reviews.

Dedication

This book is dedicated to everybody who was integral in the development of the Berkshires as a premier skiing destination—including the early ski area founders who pioneered the creation of the first ski resorts, the communities and ski clubs who started their own areas to teach others the joy of the sport, the ski patrols who kept skiers safe, the ski coaches and instructors who taught so many, the employees who often worked outside in harsh conditions and the skiers who passionately supported their favorite ski area. The positive impacts of your contributions continue to live on and will not be forgotten.

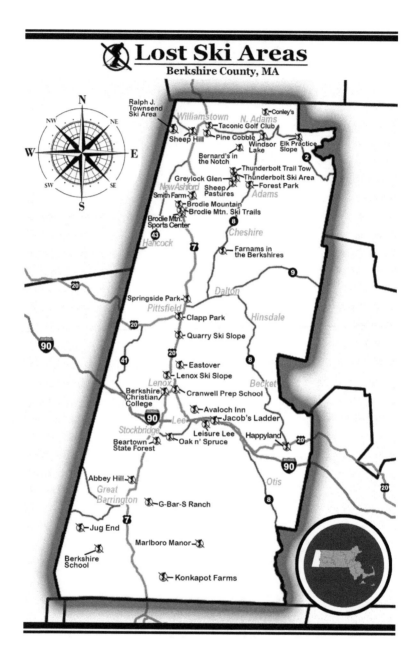

The Berkshires of Massachusetts are home to thirty-seven downhill ski areas that are no longer in operation. Ranging in size from small rope tow slopes to much larger resorts, these ski areas played an integral role of the development of the ski industry. Although now lost, these ski areas' legacies continue to live on in many different ways. *Brandon Capasso.*

Contents

Contents

CONTENTS

Acknowledgements

his book would not have been possible without the contributions of many ski area operators, families, skiers and researchers who shared their memories and contributed their deep knowledge to the book. These contributors are listed in the bibliography. Thanks must be extended to all of those who submitted photographs and maps to help illustrate so many of these areas, including Woodward Bousquet (who also helped with the history of his family's ski area and Berkshire skiing in general), Jud Cairns, Brandon Capasso, Jeremy Clark, Nancy-Fay Hecker, John Hitchcock, Mike Houle, Gary Leveille, Chris Lundquist, Bob McNinch, Frank Prinz, Jim Tsotsi and Dan Xeller.

Several organizations were gracious enough to allow the use of photos from their archives, including Adams Historical Society, Berkshire School, Massachusetts DCR, New England Ski Museum and Williams College. The staff at Sheep Hill, part of the Williamstown Rural Lands Foundation, were very helpful with the history of that area.

Blair Mahar was an invaluable source of insight and materials about the Mount Greylock ski region. He went above and beyond, providing me with sources, photos and contacts about the ski history of that region. His film *Purple Mountain Majesty*, about the Thunderbolt Ski Run, is a must-watch for any reader interested in its history.

I would also like to thank Arcadia Publishing and The History Press for publishing this book. Thanks to commissioning editors Amanda Irle and Ed Mack for all of their help throughout the publishing process. I would

also like to thank Abigail Fleming for copyediting the book and the talented design and production team for their hard work on this project.

Finally, I would like to thank my family, friends and particularly my husband, Scott, for all of their support throughout this project. There were many sacrifices made throughout the writing of the book, and their understanding encouragement is greatly appreciated.

Introduction

A Brief History of Skiing in the Berkshires

From the early days of trails cut by hand by the Civilian Conservation Corps to the first snow train destinations and the varied resorts of today, skiing has been an integral part of the fabric of the Berkshires since the first part of the twentieth century. These ski areas serve as a place for outdoor enjoyment, exercise and spending time with family and friends. A total of forty-four ski areas have operated in Berkshire County since the 1930s.

The modern ski industry in the Berkshires can be traced to two major events: the creation of the Thunderbolt Ski Trail in 1934 and the first snow trains at Bousquet's in 1935. The Thunderbolt put the Berkshires on the map for challenging terrain, while the snow trains at Bousquet's introduced the masses to the new concept of a ski area. Before long, snow trains were reaching destinations throughout the Berkshires, and new ski areas opened rapidly. Rope tows (a continuously circulating rope skiers grab hold of and ride to the top) made reaching the summits easier, allowing for many more runs per day—though the lifts could be difficult to ride. The invention of the Bousquet Tow Gripper by Clarence Bousquet made riding the tows easier, and over time, 500,000 were sold.

Many ski clubs were soon organized, with several opening their own ski areas, like the North Adams Ski Club operating Bernard's in the Notch or the Mount Greylock Ski Club's Goodell Hollow. These areas were welcoming to all members with their affordable membership fees and learn-to-ski programs.

With the advent of World War II, many ski areas closed due to restrictions on fuel and recreational travel, though a few continued to operate, like G-Bar-S Ranch, which featured electric tows. In the immediate aftermath of the war, ski areas reopened, and many new ones like Otis and Jiminy Peak opened their doors for the first time. Tenth Mountain Division veterans (and other veterans) started many ski areas, such as Jacob's Ladder.

Resorts took off from the 1940s and into the 1970s. All-inclusive resorts, like Oak n' Spruce, Eastover and Jug End, introduced thousands of new skiers to the sport with small and personable ski areas. Community ski areas like Clapp Park and Osceola provided an introduction to the sport to children at low or no cost. Schools and colleges such as Williams College built their own ski areas to host competitions and for their ski teams to practice.

The 1960s saw the peak in the number of open ski areas. The number of skiers had exploded, thanks to the baby boomers, with whole families often taking weekend trips to their favorite Berkshire areas. Night skiing was growing in popularity, with Brodie Mountain featuring the most extensive lighted terrain. At the same time, the interstate highway system was expanding, as were more northern resorts.

This led to a downturn in the 1970s. Many smaller areas could not compete with their larger counterparts and did not have the resources to fund capital improvements. Non-skiing vacation destinations were growing in popularity. Resorts that had been so popular in the 1960s and parts of the 1970s struggled under these changes and soon closed. Further losses into the 1980s and into the early 2000s resulted in the closure of popular ski areas such as Brodie Mountain.

But the loss has come to a stop. Today's Berkshire ski areas are active and vibrant places and feature a wide variety of skiing for all levels and tastes. All are historic places, with some like Catamount and the Mount Greylock Ski Club dating to before World War II. Ski areas are innovating for the future, investing in alternative energy sources and energy-efficient snowmaking systems. It is hoped that these ski areas will be here for a long time to come.

About *Lost Ski Areas of the Berkshires*

This book is organized into sections that feature the various types of lost ski areas across the region, including snow train destinations, pre– and post–World War II private enterprises, ski clubs, municipal areas, schools and

colleges and resorts and major ski areas. Proposed ski areas—those that were to be developed but never were—are included, as are the several areas still in operation.

What Is a Lost Ski Area?

Although there are many slopes and trails that have been used for skiing over the years, the author has opted for a narrower definition of what constitutes a lost ski area. Essentially, it is a location that formerly had a ski lift in operation of some kind that no longer operates. This can range from rope to surface lifts like handle tows and T-bars and even chairlifts. Sometimes, lift remnants are left behind, while other times, no trace can be found. Other forms of transportation to the top of a trail or slope, including hiking or being dropped off from a car, do not count—otherwise, there would be hundreds or even thousands of former ski areas.

Only ski areas in Berkshire County were included in this book. Some lost ski areas like Berkshire Snow Basin in West Cummington were not located in the county, despite the name of the ski area. Petersburg Pass, located along the New York–Massachusetts border was entirely in New York, and thus is not included.

Ski jumps are a different entity altogether. If a ski jump was part of a lift-served ski area that no longer operates, it is included. However, there were a few free-standing jumps that are not listed in this book, as they were not served by lifts.

The removal of a ski lift does not automatically mean that the ski area is no longer used by outdoor enthusiasts—sometimes, quite the opposite. The Thunderbolt Trail on Mount Greylock is a prime example. Here, a rope tow was installed high up on the trail, far away from the base. It only lasted a few years before being abandoned. The tow was never the main feature of the Thunderbolt but was a small part of its history. Today, the Thunderbolt is actively used and maintained by members of the Thunderbolt Ski Runners and remains vibrant. Other areas are used for hiking or snowshoeing, like at Beartown State Forest.

There is even a hybrid area. The trails and rope tows at G-Bar-S Ranch, a rope-tow ski area that operated for twenty years, were incorporated as part of Ski Butternut. As it was a distinct operation with a four-year interval between operators, it is considered a lost area.

Exploring Lost Ski Areas

Throughout this book, locations and directions are provided to visit many lost ski areas. However, there are several important considerations if you plan to explore an area.

Several of these ski areas are located on private property and cannot be explored. Areas that are known to be on private property are clearly noted in their histories as areas that should be avoided. Please respect any no trespassing signs and do not disturb property owners. Also note that some areas may become private property or are not marked as such, and it is your responsibility to ensure that you do not trespass.

A few ski areas are located on private property, but portions of them can be viewed from a public road or park. In these cases, be sure that you park in a safe area and not in a manner to block traffic or driveways. Bring along your binoculars to see features that may be difficult to view from a distance.

Consider visiting in late fall, winter or mid-spring. When you visit in late fall, most of the trees and plants will have lost their foliage, allowing more aspects of the former ski area to be seen. In winter, the ground is frozen and often covered in snow, allowing you to explore some areas on snowshoes or backcountry/cross-country skis—though be careful of any hazards buried under the snow. And in mid-spring (late April–early May), temperatures have warmed for some more pleasant explorations, and the ground has also dried out significantly from earlier in the spring.

If you plan on hiking an area during the summer, be sure to bring along plenty of bug spray and check for ticks—wear long pants and shirts while exploring brushy areas that may attract these insects. Mosquitos and black flies can be particularly voracious in the early portions of the summer.

Although some areas can be hiked, not all have marked footpaths or signage. Be sure to plan to take along a compass, topographic map and phone mapping apps. While cell coverage is decent in the Berkshires, a few spots may not have strong coverage and can render apps useless, so have paper maps as backup.

A lost ski area adventure is also more enjoyable with a friend—avoid hiking alone if possible. Plus, with more people, you may catch artifacts or ski area traces that you would have missed.

And if you are not able to physically hike these areas, quite a few can be viewed from a car or public park with handicapped accessibility. These include such areas as the Elk Practice Slope, Springside Park or Clapp Park.

PART I
SNOW TRAIN DESTINATIONS

now trains were a critical aspect of the development of several ski areas throughout the Berkshires. Departing mostly from New York City and southern Connecticut, these trains brought hundreds of skiers at a time to various destinations in the 1930s, including the still open Bousquet's, Abbey Hill, Beartown, Farnams in the Berkshires and G-Bar-S Ranch. The trains provided a way for skiers to relax and enjoy the ride for a day trip or weekend of skiing in the Berkshires. The trains also were portable resorts in a way, often acting as a base lodge with food service, restrooms and space to warm up. They also provided for much social interaction, often hosting parties, music, dancing and meals. Skiers would be able to share stories of their day of fun and adventure in the Berkshires with their fellow riders.

The first snow train arrived in Pittsfield, Massachusetts, on February 10, 1935, in the heart of the Depression. Skiers walked to the nearby fledgling Bousquet's Ski Grounds, where they enjoyed the open slopes. More trains would follow, and Clarence Bousquet soon installed the Berkshire's first rope tow, just a year after the first ski tow in the United States was installed in Woodstock, Vermont. Bousquet's was the first real destination resort in the county.

Before long, other snow train destinations sprouted up. Beartown, whose trails were cleared by the CCC, saw its first train in January 1936. Farnams, an area in Cheshire, opened in 1940 and was the first area envisioned as a joint venture between a railroad company and a ski area—with the ski area built to serve skiers arriving by train. Abbey Hill and G-Bar-S Ranch were some distance away from train stations but were accessible either by a long cross-country trail or a shuttle system.

World War II mostly shut down snow trains, but skiers still occasionally took trains from New York City to the Berkshires to enjoy skiing. And while the trains did resume after the war, they were mostly canceled by 1950 due to the growth of personal automobiles.

Abbey Hill

Great Barrington

1939–41 (No Lift Service), 1947–48 (Lift Service), Informally into the 1950s

The Abby Farm (no *e*) in Great Barrington featured a wide-open slope facing to the east. It was the perfect location to offer skiing in the late 1930s and early 1940s, as it was conveniently located along the railroad in Great Barrington. Skiers could be let off at Abbey Hill, which was just one mile north of the center of town.

Although no lifts were present in the late 1930s and early 1940s, Abbey Hill did feature lights for night skiing operated by the Taconic Ski Club. The club used the slope for practice until the outbreak of World War II, and thereafter, the club ceased to exist.

Following the war, skiers Marston Burnett and Charles Magadini leased out the property and constructed a new, 1,000-foot-long rope tow for the 1946–47 ski season. It served a vertical drop of 125 feet, with a lift ticket of just one dollar. A day canteen serving snacks and drinks was readied.

On opening day February 9, 1947, over one hundred skiers enjoyed the slopes, including three-year-old Jackie Swan of Stockbridge, the youngest skier. The hill continued to operate through at least the end of February and reopened again for the following 1947–48 season.

But Abbey Hill would only last those two seasons. In December 1949, the two owners announced that it would be permanently closed. No reason was given, but it is possible that the operators found running the ski area to be more difficult than expected. The ski area was informally used into the 1950s, including in 1956, when the Searles High School Ski Club in Great Barrington used the slopes for practice.

VISITING THE AREA

Abbey Hill is now covered in homes, located off of Route 41 one mile north of Great Barrington. There are no known remnants of the ski area, and due to the homes on the slope, do not attempt to explore this area.

Beartown State Forest, Beartown Ski Area

South Lee

1935–39 (NO LIFT SERVICE),
1940–42 (LIFT SERVICE), 1945–55 (LIFT SERVICE),
1956–58 (NO LIFT SERVICE), 1959–64
(LIFT SERVICE), 1965–66 (NO LIFT SERVICE)

As one can see by the multiple phases of lift and non-lift service periods, Beartown State Forest's ski area had quite a few ups and downs in its three decades of operation. Despite this complex history, Beartown is remembered for several firsts and records in the ski industry in southern New England.

Beartown's history traces back to the heart of the Depression and to the Civilian Conservation Corps (CCC). In the mid-1930s, the CCC was tasked with constructing public recreation facilities across New England by the federal government. These included hiking trails, lodges, campgrounds—and ski trails. These projects were created to provide jobs for youths and develop facilities that could help boost local economies and promote outdoor tourism.

One such project was on the north slope of Bear Mountain, in Beartown State Forest in South Lee. Here, a steep north slope was found that would hold snow longer than surrounding locations. It was accessible—near the resort town of Lee but also adjacent to the South Lee train station. The ski area would be constructed specifically as a snow train destination—the first

of its kind in the Berkshires. Bousquet's Ski Grounds, in Pittsfield, required a longer walk from the station.

Throughout the summer of 1935, CCC Companies 108 and 112 cleared several trails and slopes at Beartown and constructed a handsome lodge, complete with two stone fireplaces. The trails included the Kodiak, the Grizzly and the Polar Bear trail and open slope. The first two trails were described as having a twenty-to-thirty-degree pitch "without a single level space." In a 1939 guidebook, the Kodiak is listed as "a steep twisting trail with one hairpin or right angle turn after another." The Polar Bear open slope is listed as being "very well sheltered from the wind and is suitable for all classes of skiers. A small natural jump on one side will prove exciting."

To facilitate skiers' access to the slopes, a connecting trail was built from the train platform to the lodge—there was no direct parking next to any of the lifts. At the summit, a small shelter was constructed for skiers to take a break before descending the trails.

In addition to the development at Beartown, the area was interconnected with another new ski area that had been built on East Mountain. This area, soon known as the Great Barrington Sports Center (later the G-Bar-S Ranch), was linked via the Crowe's Nest Trail from the summit of Bear Mountain to the Crowe's Nest Lodge and then a nearly ten-mile cross-country trail to East Mountain.

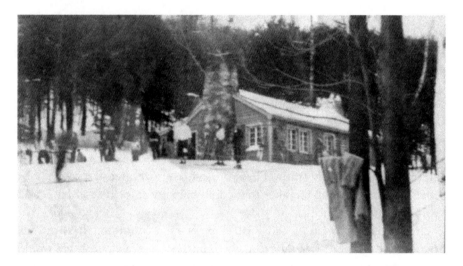

The CCC Lodge at Beartown served skiers for three decades. Inside the lodge, skiers enjoyed sandwiches, soups and hot drinks. It was conveniently located next to the main rope tow, which was installed in 1940. *Woodward Bousquet.*

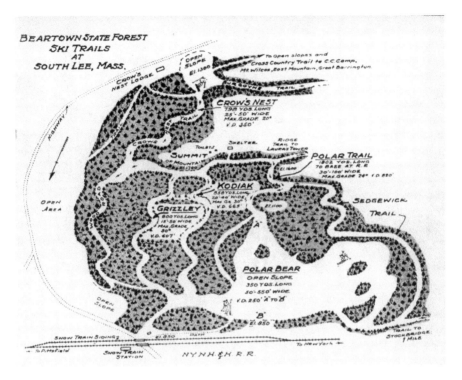

This 1939–40 trail map appeared in a promotional brochure for the New Haven Railroad's snow trains and depicts Beartown just prior to the installation of rope tows. The Polar Bear Slope was the main feature, but expert trails Kodiak and Grizzly descended from the summit. Additional cross-country trails descended the back of the mountain and ended ten miles away at the East Mountain Ski Area (G-Bar-S Ranch, now Ski Butternut). *Woodward Bousquet.*

The Berkshire Division of the New York, New Haven and Hartford Railroad seized on this new opportunity of having a ski area directly behind the South Lee station. The *Brooklyn Daily Eagle* described the area as "the newest ski center in Massachusetts. Here one can ski directly from the station platform and there is room enough for all the thousands that the railroad expects will come." Advertising through newspapers and pamphlets, the railroad announced that at least four trains would bring skiers in early 1936. The trains were to be equipped with special cars to store skis, bars and dining cars—essentially, a portable resort.

In early 1936, the skiers arrived in droves. The first arrived on January 28, with one snow train in February bringing 100 skiers from New York City. The largest group of skiers arrived a month later, for the March 8–9 weekend. Over 350 skiers from New York City, along with 150 locals, overwhelmed

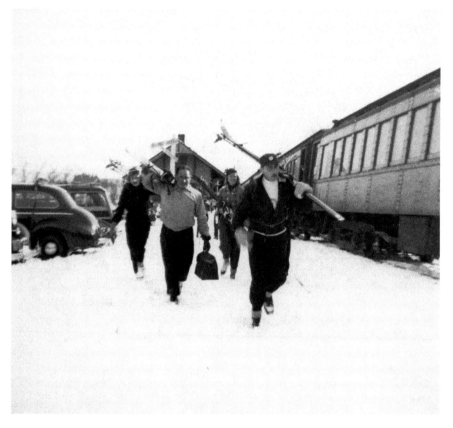

Skiers exit the train platform at the South Lee Station on January 26, 1941, ready for the short walk to the slopes at Beartown. Beartown was specifically designed as a snow train destination, but trains only serviced it for a few years. By the 1950s, the lack of adequate parking resulted in diminished potential for growth. *DCR Archives*.

the slopes. The snow was hard-packed and slick, and there were quite a few injuries. One gruesome accident occurred on the novice trail, where a "skier ran into the island of trees midway down the novice trail and returned to NY with his face looking like raw beefsteak and both eyes completely closed." The steep trails of Kodiak and Grizzly were almost impossible to navigate. But by late afternoon, the sun had warmed the slopes, leaving spectators to "have believed they were witnessing skiing on a borax slide at Miami, as many of the skiers removed their outer garments."

Improvements to Beartown continued into the late 1930s. Trails and slopes were expanded in scope for the 1938–39 season. A cutoff on the Polar Trail was built to avoid a twenty-four-degree schuss. A new trail, the two-

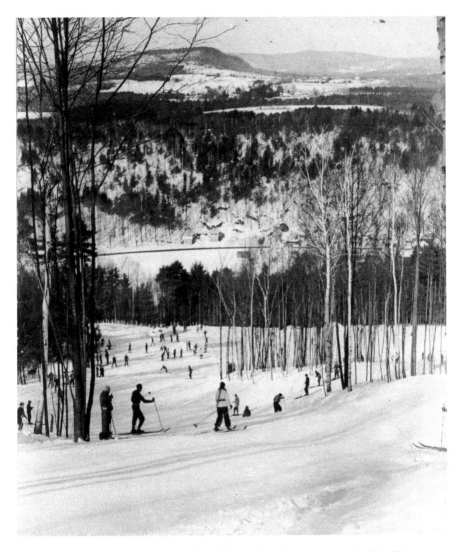

A view from the lower portion of the Polar Trail as it widened out into the Polar Slope, circa 1937. Note that some skiers are making their way up the slope on the left, as this photo was taken prior to lifts being installed. Route 102 can be seen in the background across from the Housatonic River. *DCR Archives*.

thousand-foot-long Sedgewick, was cleared from the summit, along with three additional shorter slopes. One of the slopes was electrically lit for night skiing and operated by the newly formed Stockbridge Ski Club.

Although the ski area was seeing hundreds of skiers enjoy the slopes on snow train weekends, it still lacked a lift. Finally, in 1940, a 1,500-foot tow

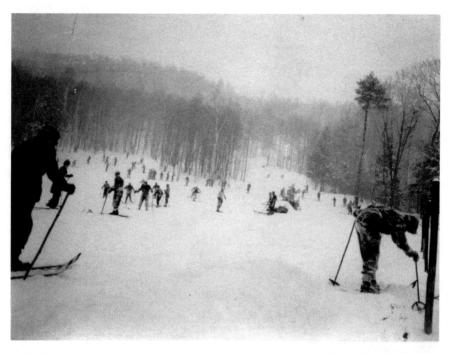

The Polar Bear Slope was popular for skiers to practice their technique due to its wide and expansive nature and relatively easy pitch. This view is from 1936 and was taken during the first season of operation. Other trails at Beartown, like the Grizzly or Kodiak, were very narrow and steep and decisively for experts. *DCR Archives.*

was installed. The tow was steep, with nearly a 400-foot vertical rise, and provided access to the top of the Sedgewick Trail and the halfway point on the Polar Bear. Several exit ramps were built along the route of the tow in case skiers fell or only wanted to travel partway up the slope. The new Panda Road beginner trail was cut from the summit to provide an easier descent for less advanced skiers. During this time, the State of Massachusetts leased out the operation of the tow and lodge to a concessionaire.

As with many ski areas that were just hitting their stride, the outbreak of World War II caused a disruption and temporary closure of Beartown. All of the snow trains were canceled from 1942 to 1945 due to wartime restrictions on recreational travel, and the concessionaire was unable to continue to operate Beartown.

At the conclusion of World War II, the ski area was readied to be reopened. William Murthey of Pittsfield was granted the rights to be a concessionaire, and he had the tow inspected at the end of 1945. A few snow trains also

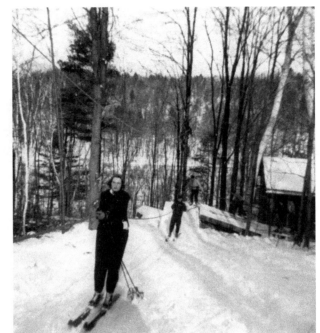

Once installed in 1940, the 1,500-foot-long main rope tow provided much-needed access to a good portion of the trails and slopes at Beartown. The lower section, shown here, was much easier to ride than the upper section, which proved to be quite tiring for most riders. Some of the lift hardware is still attached to trees over seventy years after its installation. *DCR Archives.*

visited that winter, serving the public's pent-up demand to return to skiing after the war years.

Meanwhile, for the following season, the Stockbridge Ski Club was ready to return to action after being inactive for the duration of the war. In October 1946, twenty-five members of the club held their first meeting in several years in the lodge, where Murthey announced new improvements that would soon arrive at the mountain. A four-hundred-foot beginner's lift, the Cub Tow, would soon be built on the wide-open Polar Trail, and plans were made to add another major rope tow to the summit, though this would be six years in the future.

The use of snow trains declined in the late 1940s with the growth of personal automobiles, and by 1950, they had ceased operations completely at the ski area. Murthey continued to manage Beartown into 1949, but by 1950, he had left the operation to open his own brief ski area, the Quarry Ski Slope, in Pittsfield. A new concessionaire would take over—Al Prinz, whose brother Frank was the owner of the recently opened Oak n' Spruce Lodge a short distance away. There, they had built a beginner's rope tow and slope, and the addition of Beartown to their portfolio would ensure more advanced terrain for their customers.

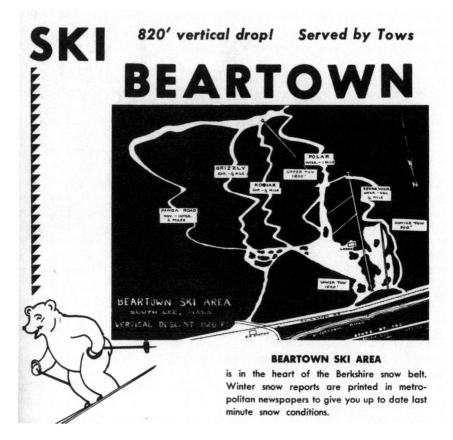

SKI 820' vertical drop! Served by Tows
BEARTOWN

BEARTOWN SKI AREA
is in the heart of the Berkshire snow belt.
Winter snow reports are printed in metro-
politan newspapers to give you up to date last
minute snow conditions.

This 1953 trail map from *Ski Time* magazine shows Beartown at its largest. The rope tows included the Novice Tow, Lower Tow and the difficult to ride Upper Tow. Most skiers stayed on the Novice or Lower Tow and enjoyed the Polar Bear and Sedgewick Slopes. Minimal parking was available at the train station, shown here and connected to Beartown by a footpath. *Author's collection.*

Prinz would operate the area until 1955. During this time, he expanded the lift offerings, first adding two more beginner rope tows in 1951 and later adding a 1,200-foot-long rope tow to the summit in 1952. This tow, hewn through evergreens and blasted through rock, was just about as steep as the lower tow—but boosted the total lift-served vertical drop to 820 feet. Although certainly tiring, the tandem lifts allowed skiers to enjoy southern New England's second-highest lift-served vertical drop—only Catamount had a higher drop at this time.

Prinz would operate Beartown until the end of the 1954–55 season. Citing responsibilities elsewhere, Prinz also noted that the lack of a parking

area deterred many skiers, as the lot at the train station only held six cars. On many days, he took a financial loss operating the area. Prinz was quoted as saying that the "situation is regrettable because the area is potentially one of the best in Berkshire County, and also one of the oldest in the East." In an interview with the author, Al's brother Frank also noted that consistent, deep snow cover was rare, and the narrow, steep trails from the summit were often skied off a few hours after a snowfall.

The lifts at Beartown would be shuttered for another half a decade, just as they had been during World War II. But the ski area was still used by local high school ski teams, including the Lenox Preparatory School. One former team member remembers that the former ski area was not in the best of shape after a few years of no maintenance, but a few of the trails were still excellent for training.

A group of skiers from Westover Air Force Base briefly resurrected the ski area in 1959–60. It is quite likely that they leased the tow on a nonprofit basis and charged skiers to use the facilities. They continued to allow the local schools to practice at Beartown. Races were even held in February 1960, when the Lenox Ski Team competed against the Darrow School. The group would disband after one season, finding the ski area too much to manage.

The State of Massachusetts made one final bid to have a more permanent operator at the state-owned ski area. In November 1960, bids were sent out for a five-year contract. Frank Prinz now owned the ski lifts and associated equipment, but the state owned the lodge. A new group, Beartown Associates, with William McCormack as president, was organized and quickly awarded the contract and began operations for the 1960–61 season.

Beartown Associates was organized in order to "provide wholesome outdoor activity for the family at reasonable rates," according to a brochure. This organization was finally able to solve the parking situation, constructing a new access road off Beartown Mountain Road, which led to several parking areas. Ticket rates were set at an affordable $2.50, or $1.50 for a half a day of skiing.

Trails were soon cleared and fully reopened, but the upper rope tow was no longer operable and never ran again. Skiers could still hike to the summit to enjoy the slopes, but by this time, they were much less inclined to do so and thus mostly stuck to trails available from the top of the main tow, which was now in two distinct sections for easier riding. Additional tows were reactivated or opened near the Sedgewick Slope for beginner use. The lodge, which had been run down for many years, was repaired and reopened to once again serve refreshments.

Focusing on instruction, Thor Steinert was hired to develop a ski school. Over the next several years, he taught families the sport and developed a junior racing league, with a final race each season for those who completed the program. He was also active in promoting the ski area locally, showing ski films and touting the burgeoning ski program.

Races and training continued for the Lenox Ski Team into the early to mid-1960s with the new operators. John Schneiter, a student, recalled training at the area:

> *In the late fall, after football and soccer season and usually just after Thanksgiving vacation, one of our pre-season skiing workouts was to climb the hill at Beartown State Forest. I remember that there was some snow on the ground that made the climbing slippery. We climbed up the outside intermediate trail and would run at full speed down Grizzly where in several weeks we would be in training.*
>
> *After the snow fell, we would take a bus from school up to the mountain and have to climb up Polar, which we used for training for slalom skiing. We would set a course and run it with usually pretty tight gates. I can remember standing by a run-down lodge at the base of the course and watching teammates coming down. For the grand slalom and downhill, we would have to climb, in the winter, to the top and switch boots to ski boots. We would use Grizzly for that training. On that trail, there was a first turn to the left and then a sharp turn to the right. In between those two was something we called the "teacup" that would tend to push you back on your skis, just before the hard right turn. The problem was that at that turn was a large boulder. It was always a struggle to stay forward and edge to make that turn.*

During the final lift-served 1963–64 season, Beartown focused even more on its family-friendly value. The bargain rate of five dollars per family, regardless of size, helped draw in patrons, including up to 435 over the February 22–23 weekend. The expert trails, still not accessible by lifts, were no longer being marketed.

But by 1964, it was clear that Beartown was in serious need of upgrades in order to compete with other nearby ski areas. Butternut Basin had just opened in Great Barrington with a double chair to the summit, and Catamount had recently installed a chairlift to the summit. Beartown, with its rope tows and now reduced vertical drop, needed to modernize to stay open.

Due to the struggles of trying to operate the antiquated ski area, Beartown Associates closed it in 1964. For the next few years, local ski teams were allowed to practice at the mountain, and it is possible that the rope tows were fired up only for practice but were not available to the public.

Beartown reorganized itself and, in 1966, drew up a new $1.5 million master plan to build a chairlift to the summit that would be supplemented by two T-bars. Property adjacent to the ski area was owned by the company and had the potential to be developed into homes or apartment buildings. The plan was contingent on being granted a continuing operating license from the State of Massachusetts.

The plan was immediately attacked by supporters of the failed Mount Greylock Tramway project, which had recently been scuttled in the state supreme court as a breach of public trust. The court had ruled against a for-profit corporation reaping benefits from a state park. Greylock Tramway supporters said that it would not be fair for Beartown to be developed on state land while they were not able to build a tramway farther north.

The plan did not progress, and the associates were denied the ability to progress. In the late 1960s and early 1970s, they were unable to pay taxes on the forty-three acres of land they had bought for the housing development, and the land was seized. It was eventually added to the Beartown State Forest.

Meanwhile, the ski area was left to revert to nature. In the following decades, the slopes became overgrown and the engines for the lifts were removed. The ski teams ceased practicing at Beartown and moved on to other areas. The stoic CCC lodge rotted away, leaving its two fireplaces still standing.

Today, Beartown holds the unfortunate distinction of being the second-largest vertical drop ski area to close in southern New England. It had a tremendous amount of potential—a convenient location, a decent vertical drop, steep terrain and a variety of trails. It was never able to overcome some drawbacks, including a lack of parking, steep and tiring rope tows, and unfortunate timing with the cancellation of a similar development plan on Mount Greylock. Perhaps if a chairlift to the summit had been built, along with a snowmaking system and modern grooming, Beartown would still be in operation today.

VISITING THE AREA

Despite its fifty-year abandonment, Beartown still has much to offer lost ski area explorers. As it is part of the state forest system, outdoor enthusiasts can enjoy exploring its remnants without fears of trespassing.

There are two main options to visit, accessing either the base or the summit. The base is the easiest and shortest method.

Parking is available on Beartown Mountain Road in South Lee, with a small parking lot two hundred feet south of the junction of the road and Pine Street. Across the lot, you will see a gate and a dirt road behind it. Take this dirt road for three-quarters of a mile. It is believed that this road was built to better access the ski area in the last few years of its development, as well as for possible apartments. The road is mostly flat and in good shape, but there are some wet spots. On the way, look off to your left—you will see the remnants and partially overgrown trails of Panda Road, Grizzly and Kodiak, best viewed outside of summer. The access road is listed as a snowshoe trail in the winter on Beartown State Forest trail maps

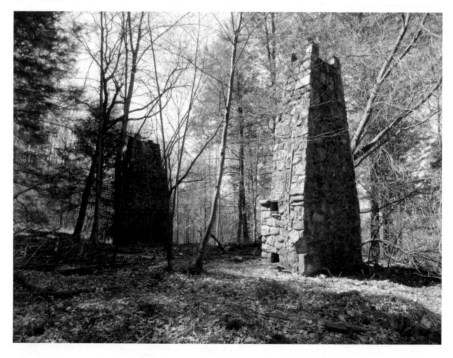

Over eighty years after their construction, the twin stone fireplaces remain standing at the site of Beartown's CCC Lodge. Their solid construction will likely ensure their survival in the decades to come. *Author's collection.*

(https://www.mass.gov/locations/beartown-state-forest), and it would also be suitable for cross-country skiing.

After three-quarters of a mile, you reach Beartown's most prominent remnant—the twin stone fireplaces of the CCC lodge—you can't miss them. They stand as a memory to both the CCC and the ski area operations. Take a moment and stand in front of one of the fireplaces and imagine yourself as a skier in the late 1930s, warming up in front of the hearth after a few runs.

After visiting the lodge, walk just a few feet west, and you will then be in the center of the former 1,500-foot-long rope tow. Note the steep grade to the left and uphill. If you wish to hike it, the grade is easy to follow, but it is quite steep. You can also hike down the line, but it is more difficult to follow. Along the way, there are pieces of rope tow hardware in the trees. You will then reach the bottom of the tow, which is a flat area, prior to more mature trees, with nothing left to explore beyond.

If you return back to the base lodge fireplaces, just west of the lift line was the former Sedgewick Slope. It is now quite overgrown and nearly impossible to distinguish from the rest of the woods. To return to your car, walk back the same way you came in.

The second way to explore the area is quite a bit longer but has several scenic highlights, including a visit to Laura's Tower (directions at https://laurelhillassociation.org). Park at the lot at the end of Park Street in Stockbridge and cross over the footbridge, following the trail to Laura's Tower, three-quarters of a mile away. It is a steady climb but not difficult. When you reach the tower, climb the stairs for an excellent view that includes the Catskills, southern Vermont and Mount Greylock.

After climbing the tower, continue along the trail that wraps behind it for a rolling 1.1 miles. It is sometimes referred to as the Ridge Trail. At this point, you will be standing at the summit of the former Beartown Ski Area. Foundations for the summit tow house can be seen, along with a pulley on the ground. As the pitch drops off to the north, a careful observer can make out the tow line, along with the grown-in Polar Trail. Continue a few more hundred feet—you will soon notice the entrances for the Kodiak and Grizzly Trails, which are still fairly clear. If you continue along the trail, you will eventually reach the gate for the dirt road that leads to the base area—but that would make for a long round trip. It is best to return the way you came to the parking lot on Park Street.

Farnams in the Berkshires, Cheshire Ski Area

Cheshire

1940–MARCH 1942, FEBRUARY 20–21, 1943, 1944–48 (ALL AS FARNAMS), 1960–64 (CHESHIRE SKI AREA)

Farnams in the Berkshires was one of the largest ski areas to have closed in the region. It boasted a six-hundred-foot vertical drop, four rope tows, terrain for all abilities and easy access as a snow train destination in its early years. But the decline of the snow trains in the late 1940s led to its demise, and a brief resurrection as a hobby ski area in the 1960s did not last. Despite this, it holds the record for the longest closure to a reopening of a ski area in the Berkshires, that being twelve years.

In the late 1930s, Berkshire skiing was booming, thanks to the growth of snow trains. Different railroads had their own affiliated ski areas. For the New Haven Railroad, Bousquet's and Beartown were its main partners. On the other hand, the New York Central did not have an area directly in affiliation, and its tracks were too distant from other locations.

To rectify this problem, management went out on a search for a new ski area that could be developed closer to New York Central tracks. Two local businessmen—Howard Sammis, a Pittsfield banker, and Leo Graham of the Mutual Life Insurance Company—were approached by the railroad to develop a ski center in Cheshire. If the two would purchase the John Delmolino Farm located above the Cheshire Reservoir, the railroad would

construct a special eight-hundred-foot-long train platform. The two agreed to the proposal, purchased the farm in 1940 and started to build a ski area. The business relationship was symbiotic—the train would bring paying patrons to the ski area, and the ski area would bring paying patrons to purchase train tickets.

The farm consisted of perfectly pitched slopes for skiing. As it had been a farm since 1912, the slopes had been well maintained by Delmolino and were obstacle-free. In fact, Graham noted in an article in the *New York Sun*:

> *Each year it was heavily fertilized, with the result that it regularly yielded the most gorgeous crop of hay you'd want to see. With this turf for a basis, we know we've got the smoothest terrain in the East. In fact, we're offering a new hat to anyone who can find a rock in it.*

Three rope tows were installed, including two lower tows of 1,300 feet and 1,000 feet in length and an upper tow of 13 feet. The tows were constructed using the latest safety techniques. Little clearing of additional ski terrain was necessary—with the 800-foot-wide open field used as the main ski slope. At half a mile in length, the slope was easily seen from an approaching train. The slopes were particularly favorable for novices and intermediates but did not initially offer much for experts.

To ensure adequate services for skiers, a barn was converted into the "deluxe" Red Barn Lodge, with Graham designing a special crushed-stone floor to prevent skiers from slipping in their ski boots. A lunch counter, serving light fare, hot chocolate and donuts made by Graham's wife, Marion, was a feature of the new lodge. A woodshed was converted into an equipment shop.

Meanwhile, down by the railroad, the New York Central constructed a special unloading platform for skiers in the summer and fall of 1940. This platform allowed for easy egress from snow trains, and a new marketing campaign was soon devised—"Three Minutes from Train to Tow." This contrasted with the longer walk time needed to access rival New Haven Railroad's station for Bousquet. Skiers would be able to exit the platform, cross Route 8 and then walk about one thousand feet farther to the start of the lower tow.

A major ski area of this stature needed a superior ski instructor and pro. Enter John Ericksen, a Norwegian immigrant and 1932 U.S. Winter Olympian. He had placed twenty-fifth in the Nordic Combined event at Lake Placid. In addition, he had worked at Oscar Hambro's Ski Shop in

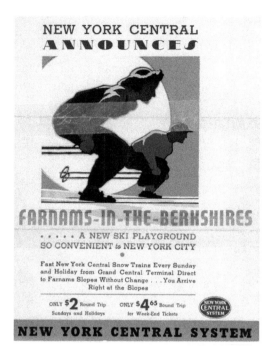

NEW YORK CENTRAL
ANNOUNCES

FARNAMS-IN-THE-BERKSHIRES
· · · · · A NEW SKI PLAYGROUND
SO CONVENIENT to NEW YORK CITY
●
Fast New York Central Snow Trains Every Sunday
and Holiday from Grand Central Terminal Direct
to Farnams Slopes Without Change . . . You Arrive
Right at the Slopes

ONLY $2 Round Trip ONLY $4.65 Round Trip
Sundays and Holidays for Week-End Tickets

NEW YORK CENTRAL SYSTEM

The New York Central ran special snow trains to Farnams. The ski area boasted many conveniences for train passengers. Located less than four hours away, the slopes were just a few minutes' walk from a special platform the NY Central installed alongside its tracks. Round-trip tickets were an affordable two dollars. Nine snow trains shuttled skiers to Farnams in its inaugural 1940–41 season. *Woodward Bousquet.*

Boston, where he made custom wooden skis. Graham and Sammis hired Ericksen, who was invited to make his home at the ski area.

With the new ski area all ready to host its first skiers, the New York Central ran its first ski train to the area on December 8, 1940. Leaving from Grand Central Station, the train took just under four hours to reach Farnams. Round-trip tickets were set at two dollars (about thirty-five dollars in 2018), an affordable rate for most, with lift tickets an additional one dollar. Skiers unloaded from the train, enjoyed the slopes and returned to the city later that afternoon. Those desiring lessons were taught by the able Ericksen for a nominal charge. Only one minor injury was reported.

Farnams was quite successful that first season. Nine snow trains brought swarms of skiers, and combined with locals who enjoyed the slope, over six thousand skied Farnams during that first season.

Building off this successful start to the business, further improvements and tweaks were put into motion for the 1941–42 season. One of the lower tows was relocated above the upper tow, but most importantly, a new 1,500-foot tow was constructed through evergreens to add much needed expert terrain.

Named the Uppercut, the new tow serviced two new trails. The Graham Slam, named for co-owner Leo Graham, took experts down a quick descent to the other tows. The Ericksen Run was built to drop skiers into a sheltered

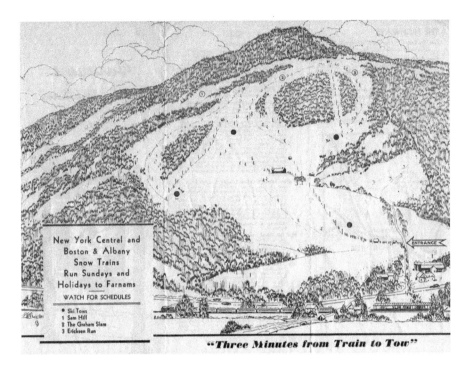

New York Central and
Boston & Albany
Snow Trains
Run Sundays and
Holidays to Farnams
WATCH FOR SCHEDULES

● Ski Tows
1 Sam Hill
2 The Graham Slam
3 Ericksen Run

"Three Minutes from Train to Tow"

This 1941–42 map shows the expanded Farnams in the Berkshires Ski Area. Tow #4 was built to serve a new expert complex called "The Uppercut," where skiers could descend on the Graham Slam and the Ericksen slopes. Other tows served wide-open slopes, including Sam Hill. All slopes were named after the three main figures at Farnams: Leo Graham, Howard Sammis and John Ericksen. Note the special train siding just below the ski area alongside the New York Central Railroad's tracks. *Woodward Bousquet.*

open slope that fanned out toward the bottom. Another slope was renamed Sam Hill in honor of Sammis. "Superb" views were available from the Uppercut, according to a 1941–42 brochure.

As was common with many Berkshire ski areas, these improvements coincided with the start of World War II in December 1941. The full effects of the war on tourism would not be felt right away, however, and the ski trains continued to bring skiers to Farnams during that winter. Trains brought as many as five hundred skiers on weekends in February 1942. Local ski clubs, including the Adams Ski Runners, also patronized the slopes.

The impact of a nation at war hit Farnams in 1942. Although he was in his forties and already a veteran of World War I, Sammis enlisted in the U.S. Navy, with which he served until 1946. Meanwhile, gasoline shortages were expected to hit ski areas hard for the 1942–43 season. Gasoline for tows was considered nonessential, as was some travel for recreational purposes.

Seeking to avoid controversy over the use of precious gasoline, Graham made the decision to cease ski area operations for the season—except for the weekend of February 20–21, 1942.

Enough gasoline was left in storage from the previous season to operate for one special weekend. Although special snow trains were forbidden to operate at this time, the New York Central could still stop and unload skiers at the special platform at Farnams. Skiers were asked to travel light as not to pose a burden for other passengers.

During the weekend, two tows were operation, with 150 skiers enjoying the slopes for the first time in a year. But this was just a one-off weekend—it would be some time until the ski area would return to full operation.

More hardships hit Farnams in 1944. On February 8, Graham passed away after a months-long illness. This left Sammis, who was serving in the navy, as the sole owner of the ski area. Unable to operate the ski area from afar, he contracted with Ericksen to manage the ski area in his absence.

Restrictions on gasoline and travel had been eased over the past few years, and Farnams was able to return to business for the 1944–45 season. With few snow trains to supply patrons, a new parking lot was cleared for vehicles at the foot of the slope. On December 24, 1944, Farnams reopened after an almost two-year absence. Through early 1946, the ski area slowly returned to its prominence of the prewar years.

Snow trains began to return in February 1946, with the second train since 1942 bringing plenty of skiers to the slope. And for the February 23–24 weekend, over four hundred skiers would enjoy the slopes and tows at Farnams.

Sammis returned to Farnams in the spring of 1946. While his full-time job was that of a real estate appraiser, he still managed the ski area. To expand business in the summer, the property was offered as the perfect location for company outings. Sammis added archery, baseball, horseshoes and a softball field in order to attract business. While the efforts were not terribly successful, some local companies took their employees to outings, including the GE Foremen's Association in September 1946.

To help mitigate some problems of wind (which occasionally blew the slopes clear of snow), new trees and fences were planted and installed around the ski area. And over the following seasons, there was some success. Lights were installed for night skiing, extending the hours of operation. Snow trains resumed but carried fewer skiers than in the prewar years. The Adams Ski Club was brought in to help patrol the slopes for the 1947–48 season. Reaching out to local skiers, Farnams advertised in early 1948 that it had

"no waiting, dreamy snow, nice people, and excellent food." One weekend in March brought over five hundred skiers to Farnams, the last to see such numbers in the ski area's existence.

But without Graham, and the slowly fading snow trains (ticket prices were now six dollars for a round trip, reducing ridership), it just was not the same at Farnams. Sammis decided to throw in the towel and close the ski area. Three tows were sold to the new Jiminy Peak, including the engines, towers and 4,200 feet of rope. The property would remain quiet until January 1950, when it was sold to Mr. and Mrs. William Demattia and Louise Raggi of New Jersey, who purchased the area with the hopes of turning it into a dude ranch, which never came to pass. It seemed that skiing was gone for good at Farnams.

Only a few ski areas get second chances after a closure—and Farnams would soon join this rare club. Mary and Joseph Stanton of Flushing, New York, purchased the farm in 1955 to use as a weekend getaway. They would often host local friends who reminisced about all the fun times they had at Farnams—and how great it would be if it could come back in some form.

The Stantons were not skiers and knew nothing about ski area operations. But after enough pressure from locals, they enlisted the help of Frank Soldo. He put together a team, including Robert Belini, Louis Levesque, Leo Sondrini, Ed Soldo, George Bushika and Robby Martin, to reactive the ski area. The slopes were cleared, and the one rope tow that remained was refurbished. Fred Lamb, a local garage owner, supplied an engine to power the tow. The Stantons contributed by fixing up the lodge where skiers used to warm up between runs and grab food.

The ski area would operate on a semi-cooperative basis. Essentially, it would be run for fun for the owners, who never expected to make any money off of it. Employees would be paid with free skiing benefits, and the owners' friends and families permitted were to ski for free.

After a twelve-year hiatus, Farnams reopened on January 23, 1960, with a new name—the Cheshire Ski Area. As was expected, paying customers were far outnumbered by nonpaying ones. In the following month, lights were reinstalled for night skiing. Although the crowds of yesteryear would never return, fifty skiers did enjoy the slopes during a weekend in late February 1960.

Another rope tow was installed for skiers the following season, with tickets set at just two dollars—one dollar more than the opening season. Kids could ski for just one dollar. But with the area a mostly noncommercial venture, and the obsolete facility, maintaining the ski area was a lot of work for the Stantons. The Cheshire Ski Area closed at the end of the 1963–64 season and faded into history.

VISITING THE AREA

Farnams was located on the north side of Fisher Hill Road, and while the slopes are still clear, they are all privately owned—please do not trespass. However, there is one remnant associated with the ski area that is easy to visit. On the Farnams Road Causeway, park at the lot for the Ashuwillticook Rail Trail. The large hillside to the east that rises above the reservoir was the site of Farnams.

Walk east until you reach the Rail Trail, and then walk south on the trail. Immediately on your left, you will notice a large stone wall, along with a flat area just off the trail that continues for several hundred feet. This was the location of the unloading platform for passengers arriving on the snow trains. The Rail Trail is a destination in and of itself for outdoor recreation, and a visit is highly recommended by the author.

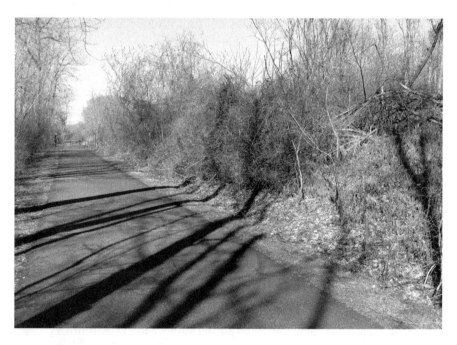

The Ashuwillticook Rail Trail now runs along the former corridor of the New York Central Railroad. On the right (east) side of the trail, just south of the Farnams Road Causeway, the remnants of the unloading platform grade and foundations can still be seen. *Author's collection.*

East Mountain State Forest Ski Grounds, Great Barrington Sports Center, G-Bar-S Ranch

Great Barrington

EARLY 1937 (NO LIFT SERVICE), LATER 1937–57 (LIFT SERVICE)

G-Bar-S Ranch is one of the more interesting lost ski areas in the Berkshires. It operated for several decades in the 1930s and into the 1950s and was a popular destination for snow train riders. After being lost for six years, its former ski trails and rope tows became a part of what is now Ski Butternut, and some of them can still be skied today. The author considers this to be a hybrid lost ski area—portions of its trails were not incorporated into Butternut, but given the distinct and noncontinuous operation, it qualifies as a former operation.

In the summer of 1936, the CCC was busy clearing ski trails throughout the Berkshires. On Warner Mountain in Great Barrington, two trails were cleared: the Taconic and the Forgotten Bridge, the latter named after its characteristic quick drop and sudden rise, as if it were missing a bridge in the middle. Both descended off the Appalachian Trail as it cut across the forest and had vertical drops of six hundred feet. At first, no lifts were constructed. The area was referred to as the East Mountain State Forest Ski Grounds, though East Mountain itself was a short distance away.

At the trails' base, the future G-Bar-S Ranch was in operation, developed by Henry Cairns, who had purchased the property from James Strike in

1929. Cairns owned a farm at the base and was developing it into a dude ranch. To supplement his income, he tied the property into the nearby ski trails and began offering wintertime activities, including skiing and skating on the trout pond.

With the trails ready, on February 7, 1937, the first ski train passengers made their way to the area. Skiers unloaded at the Beartown Forest Ski Area, and some actually skied their way the eleven miles to the ski grounds, a four-hour trek. This trail was a cross-country run called the Wildcat and connected the two areas. Skiers not wishing to ski the long distance were shuttled over in vehicles. Several other snow trains brought enthusiastic skiers to the slopes during the rest of the season.

The ski area was without a tow for that first season, with Cairns installing two tandem rope tows during the fall of 1937. The first tow was 1,200 feet in length, while the second was 1,800 feet long. The lifts provided access to the top of the Forgotten Bridge and Taconic Trails. From here, skiers could also descend on the Appalachian Trail, which led to several more slopes, including the Ranch Slope and a portion of the Wildcat, to the base.

That year, the East Mountain Ski Grounds name was dropped and replaced with the Great Barrington Sports Center, which more accurately reflected the location. The ranch now included accommodations: an inn and cabins for forty-five skiers, a ski shop, a canteen that could serve six hundred hungry skiers, a large parking area, and a beginner slope. One of the main buildings, the Ranch House, dated from 1732 as a tavern. Additional slopes were added, including the Warner Slope from the top of the highest tow and the Bottleneck, which could be accessed from either one. All trails were of beginner-to-intermediate difficulty, with no real expert terrain.

In 1940, the name of the ski area had been shortened even further to G-Bar-S Ranch—a shortened form of the name that also touched upon the expanding dude ranch.

G-Bar-S Ranch continued to attract plenty of skiers on snow trains, often hundreds at a time. Some patrons returned in the summer months to enjoy the ranch and horseback riding. More expansion took place up to the start of World War II, with two new tows added by 1942, including a beginner tow and one that served the Ranch Slope. This made G-Bar-S Ranch the second-largest ski area in terms of lifts in southern New England, just behind Bousquet.

As World War II broke out, many ski areas shut down due to the lack of gasoline and bans on recreational travel. A few areas like Bousquet had leftover gasoline from the year before and operated on a limited basis, but

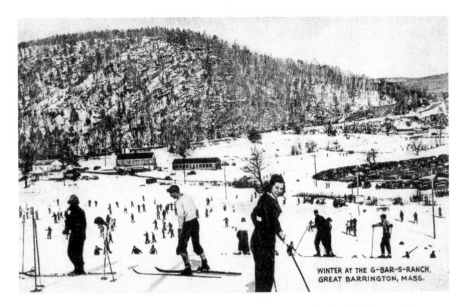

WINTER AT THE G-BAR-S-RANCH,
GREAT BARRINGTON, MASS.

G-Bar-S was often packed with hundreds of skiers and the parking lot full. Here, skiers enjoy the easy pitch of the Bottleneck Slope. One skier can be seen riding the rope tow on the lower right. In the background, one can see the historic Ranch House (*left*), Bunk House (*middle*) and the Recreation Hall (*right*), as well as Route 23. *Gary Leveille/Berkshire Archive.*

at G-Bar-S, the situation was much different—its tows ran on electricity. In addition, the operation had plenty of horses and wagons from the dude ranch. With a few trains still making their way to Great Barrington, Cairns used three two-horse wagons that could transport thirty persons apiece about half an hour's ride from the train station.

A glimpse into this rare scene of what it was like to ski in the midst of World War II took place on a January weekend in 1943. All four electric tows were running, with 274 tickets sold. But the only car in the parking lot was an employee's. Twelve round trips shuttled the skiers from the train station. On one trip, the wagon was so full of skiers and equipment that a wheel broke—but it was soon fixed. A shortage of hamburger meat led to creative solutions like cheese and jelly sandwiches at the canteen. Still, the skiing must have been a nice break considering the stresses of war.

During the following month, Bousquets was nearly out of gasoline, and G-Bar-S Ranch was essentially the only nearby ski area in operation. Much-needed income continued to flow into the resort and into Great Barrington, with an economic impact of $3,000 to $4,000 per weekend. Meanwhile, the closure of Farnams and Bousquets resulted in losses up to $15,000 per

weekend in Pittsfield. During the following two seasons, the same pattern played itself out, with some renewed competition from Bousquets, which was able to order bottled gasoline for limited tow operation.

With the conclusion of World War II, many nearby ski areas resumed operations, and the restrictions on gasoline and recreational travel ended. Bulldozers were brought in during the summer of 1946 to help reshape and smooth out trails. Snow trains resumed for a short time through 1947, with some weekends bringing hundreds of skiers. Professional instruction was also available in 1948, when Josafina de Bat, the Czechoslovakian downhill champion, teaching lessons. Some night skiing was available in the late 1940s and early 1950s, but it never became a permanent feature.

After running the G-Bar-S Ranch for thirteen years, Cairns decided it was time to sell in June 1950. He also owned Berkshire Oil in Canaan, Connecticut, and decided to focus on that business. The ranch was sold for $100,000—about $1 million in today's money. The principal shareholders of the nearby Jug End Resort purchased the ski area, including Spencer Logan, Frank Lord, Robert Thomas and Robert Wheeler. The two resorts

Founder Henry Cairns (*middle*) and his daughter Bette Griffin Cairns (*right*), along with an unidentified skier, stand in front of one of the rope tows at G-Bar-S Ranch in 1949. Note that they are wearing Bousquet Tow Grippers around their waists. Grippers consisted of a belt with a cord attached to a clamp that went around the rope tow, allowing for an easier ascent. *Dana Cairns.*

were merged, and guests at Jug End could now use the facilities at G-Bar-S and vice versa. Yet another rope tow was added during this time—above the upper tow—and increased the vertical drop to over seven hundred feet, but the tow on the Ranch Slope was removed.

Jug End provided good stewardship of G-Bar-S Ranch during its ownership. Crowds continued to enjoy the slopes in the early 1950s, and in 1952, manager Harvey Cadwell confidently announced, "Consistently good snow has made our business constant….[T]his is already better than last year." Hundreds of skiers kept the inn full and the slopes busy.

The fun didn't end after a full day of skiing, either. A 1953 advertisement declared that "when evening comes, there's fun for everyone—dancing, friendships before the fireplace, ping-pong, darts—and perfect slumber in preparation for another day of thrilling adventure." The Rumpus Room was the center of entertainment, and an orchestra played on Saturday nights. During this time, G-Bar-S was truly an all-inclusive resort and at the peak of its popularity.

Jug End continued to operate the area until 1954, as it was determined to focus on its own burgeoning resort. The ranch was sold to Francis Mahar, who founded his own corporation, G-Bar-S Corp. A series of poor snow years followed, and the ski area barely operated in 1954 and 1955.

A series of devastating fires hit G-Bar-S hard in the mid-1950s. In 1955, a fire destroyed the Ranch House, resulting in a $45,000 loss. The facilities of the Main House were moved to the Recreation Hall, including the kitchen and dining room, but on May 13, 1956, fire destroyed the building. Damage was estimated at $14,000, and neither building was rebuilt.

Mahar cut his losses and sold the resort area to Stanley V. Wincek, who also owned the Mountain View Club. Wincek owned the area through September 1956 before selling it once again, due to an illness in the family. The area was sold for $26,000 to Robert K. Wheeler in September 1956. He would act as a custodian for the resort for several years until the next buyer was found.

Beginning in the fall of 1956, the State of Massachusetts seriously considered earmarking $30,000 to purchase the property and turn it into a state park. It had convenient access to the East Mountain State Forest and also boasted swimming facilities that were sorely needed in the state park system. Nothing would come of this, and the legislature never approved the earmark.

One last hurrah for the ski area took place for the 1956–57 season, with Wheeler determined to make it successful. Hugh Dickinson of Claverack,

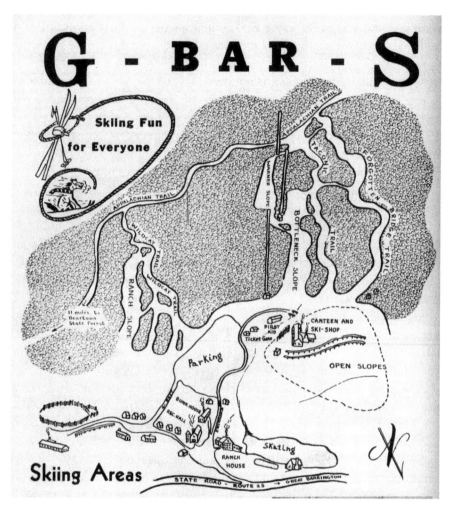

This 1953 trail map depicts the G-Bar-S Ranch at its maximum size. Three tandem rope tows took skiers to the top of several trails, including the Forgotten Bridge and Taconic. Two additional rope tows on the Open Slopes took beginners to the top of a gentle slope. The complex was located at the base of all of the trails. Note the eleven-mile-long cross-country run to Beartown—still shown on maps but only rarely used in the 1950s. *Author's collection.*

New York, a Tenth Mountain Division veteran, was hired as the ski instructor. Crowds once again thronged the slopes, and H. Albert Stevens noted in February 1957 that the area was "mobbed as it was in the ski train days." Don Winn and Robert Minkler were contracted to serve hot food out of the canteen, while Peter Groff ran the rental shop with 250 pairs of skis.

The year 1957 would be the final season of operation of G-Bar-S Ranch. With the numerous fires and sales of the property, it was never able to fully recover. On April 15, 1960, Wheeler sold it the Barrington School and James Joyce, who were to use the property for educational purposes. This too would not last long, and in August 1962, it was sold yet again—to Channing Murdock, who opened Butternut Basin on its slopes for the 1963–64 season. Murdock enlarged the area tremendously, adding a double chair, which increased the vertical to one thousand feet. Most, but not all of the trails were incorporated into Butternut, but all were renamed. The tandem rope tows to the top of the former Warner Slope were reactivated as well and lasted until the 1970s before being removed.

Today, Ski Butternut continues the legacy of the G-Bar-S Ranch and remains a popular southern Berkshire ski area with five chairlifts, several surface lifts, multiple base lodges and full snowmaking capabilities.

VISITING THE AREA

With the majority of the G-Bar-S network integrated into Ski Butternut (www.skibutternut.com), skiers can still enjoy many of these trails. From the Highline Quad, one can ski the Bottleneck Slope (now Lower Main Street), Forgotten Bridge Trail (Fiddler to Downspout), the Appalachian Trail (now Crosstown), Warner Slope (now Nuthatch) and Taconic Trail (now Twisted to West Way). While skiing down Nuthatch, look to the left, and you can make out a bit of the old rope tow line in the woods.

From the Cruiser Quad, the lower Wildcat is now part of the Lower Cruiser Progression Park. The Paddy Wagon Double accesses the former open slope. The Ranch Slope is now part of the Tubing Park.

PART II

PRE-WORLD WAR II PRIVATE ENTERPRISES

*I*n addition to snow train destinations, many individuals developed their own ski areas. These operations were the trailblazers, setting the stage for other small business ski areas and resorts to follow. Four such areas were open before World War II, but only one, Brodie Mountain Ski Trails, survived past the war.

Two areas, the Lenox Ski Slope and Elk Summit, were brief rope tow operations that were in operation on the late 1930s and early 1940s. While the Lenox Slope did not make much of a lasting impact, the Elk Summit area lived on, with its rope tow later moved to Bernard's in the Notch.

The most fascinating of these areas was the Brodie Mountain Ski Trails, founded by Gregory Makaroff. A Russian immigrant, Makaroff built his ski area despite having medical issues and was fiercely independent. When the Brodie Mountain Sports Center opened next door, he took the owners to court for copyright infringement on his name—and won. The area closed in the late 1940s after being operated by one season by the future founder of Mount Snow, Vermont. The ski trails were never incorporated into the more modern Brodie Mountain in the 1960s, but the area did generate enough interest in the potential for a major ski area on the mountain.

Brodie Mountain Ski Trails

Lanesborough

1939–42, 1943–48

The name "Brodie Mountain" has been used for three different ski areas, all within a few hundred feet of one another in the towns of Lanesborough and New Ashford. While the largest and most famous operated from the 1960s into the early 2000s, Brodie Mountain Ski Trails, owned by Gregory Makaroff, was the first. Makaroff would develop a reputation as quite a unique character among Berkshire ski area operators.

Skiing began on Brodie in the early 1930s, with the construction of the Brodie Mountain Trail from the 2,600-foot summit. Mostly a novice run, it terminated on the property of Gregory Makaroff. Several races, including one on New Year's Day 1936, were held on the trail. In that particular race, two-way radios were used to ensure accurate timing. By 1938, the trail was still popular but was criticized for its terminus around a sharp turn, where skiers would sometimes find themselves unable to stop and end up on the Williamstown Road, now Route 7.

Makaroff, seeing the growth in skiing, decided to start his own development, utilizing portions of the lower Brodie Mountain trail. He was a native of Ilek, Russia, and a U.S. veteran of World War I. While in the war, he had fallen off a horse, sustaining severe injuries that plagued him for the rest of his life. Eventually moving to Lanesborough, he became a self-employed cabinetmaker and Brodie Mountain fire tower observer. He often had grand ideas, like lobbying for Brodie Mountain to become a national park, that often did not succeed.

Three ski trails were cut in 1939: the short and fast Diamond Trail, the 0.4-mile-long novice-intermediate Silver Trail and the novice-intermediate 0.3-mile-long Gold Trail. Both the Silver and Gold Trails ended in a wide-open slope. An 1,100-foot-long rope tow was built and operated by Chuck Wright for the first season. In mid-November, up to sixty cars were spotted in the parking lot.

For the following 1940–41 season, competition would arrive—directly next door. A rival rope tow, owned by Fred Johnson and Lincoln Cain, was installed on slopes just north of Makaroff's area, on the New Ashford side of the mountain. They used a similar name, too: Brodie Mountain Sports Center. Skiers would sometimes ski over to Makaroff's area without paying him for use of the tows. Makaroff refused to accept this situation and took the owners to court.

While he lost his first court case in July 1941, he won an injunction against the Brodie Mountain Sports Center in January 1942. The operators were barred from using the name "Brodie" at their ski area. With the loss of the case, the Sports Center was sold just a few weeks later, ending the direct competition.

But greater challenges were on the horizon. With the advent of World War II, a gasoline shortage developed for the rest of 1942. In a scheme to solve the gas crisis, Makaroff offered to contribute one dollar to the State of Massachusetts to efforts to drill for oil at Brodie—and pledged to sign over his deed to his property to the state if found. The plan went nowhere, and by December, Governor Saltonstall had instituted a travel ban on pleasure driving in the state. Skiers were forbidden from driving their own cars to reach ski areas and faced fines or arrests if caught.

There was an exception—driving was allowed for religious worship on Sundays, and Makaroff, seeking an opening, wanted to offer church services at Brodie. By doing so, skiers would be able to get around the ban on driving and stay after services to enjoy his slopes. He believed that skiers "may also enjoy healthful sport and wholesome communion with nature—all on one motor trip." An advertisement for a "hard-boiled" minister was placed in the *Berkshire Eagle*, but had no takers. Skiers rapidly dwindled in December, and the few who showed up were in fear of arrest on the way home. This, coupled with an ice storm, shut down the ski area for the rest of the season and into the next.

Makaroff was not done yet—he worked on reactivating the ski area for the 1943–44 season. He was able to operate the area sporadically again, as well as into 1945, but the lack of any good season because of the war took its toll and he tried to sell the area in 1945, with no luck.

Right: An unidentified skier descends one of the slopes on wooden skis at the Brodie Mountain Ski Trails, circa 1940. The possible top of the rope tow is visible on the upper left. *Raymond Josephson via Mike Houle.*

Below: The lodge at the Brodie Mountain Ski Trails was built by Makaroff and served as a place where skiers could warm up and grab refreshments. Pictured here are skiers gathering outside the lodge, along with many skis visible in the rack, circa 1940. *Raymond Josephson via Mike Houle.*

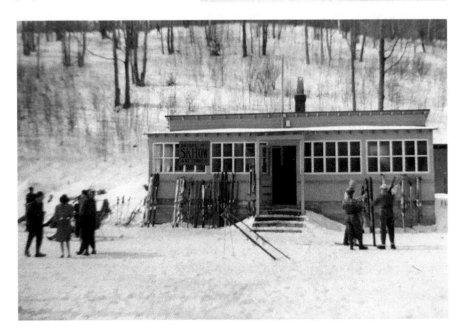

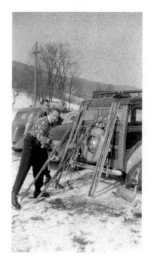

Raymond Josephson and a friend are shown here outside their car in the parking lot for the Brodie Mountain Ski Trails, owned by Gregory Makaroff. In the background, one can see the slopes for the rival Brodie Mountain Sports Center, which directly abutted the property. Skiers occasionally skied over from the Sports Center to his area, infuriating Makaroff, who later sued the owners. He won an injunction in 1942 that forbade the Sports Center from using the name Brodie, resulting in its closure. *Raymond Josephson via Mike Houle.*

By 1946, not in the best of health, Makaroff had hired a manager for Brodie: Walt Schoenknecht. Schoenknecht and his wife, Peg, would end up opening the ski area on their honeymoon. Schoenknecht expanded the area, adding an additional slope and two rope tows. Music was piped in across the slopes. It was during this time that Makaroff suspected skiers of not always paying for their tickets—and would let air out of the tires of their cars. After this one season, Schoenknecht headed south to start a new ski area, Mohawk Mountain in Connecticut, and moved one of his rope tows to that area. He would later found Mount Snow in Vermont and is heralded today as a major ski pioneer.

One last gasp at Brodie was in store for the 1947–48 season, when Williams College ski coach James Parker took over the operation. His health declining, Makaroff had left the area and moved to Montana, where he could enjoy the open space and fresh air. Parker made a few improvements, including a Baby Brodie rope tow across the street for a new novice trail, but success was elusive. The area closed at the end of the season, and Makaroff would pass away a year later in July 1949 at a hospital in Oregon. In 1950, the area was listed for sale, but issues with finding a will and next of kin delayed settling the estate for over a decade. Most of the trails quickly reverted to forest and were barely noticeable when the new Brodie opened next door fifteen years later.

Visiting the Area

Brodie Mountain Ski Trails is is located a tenth of a mile along the access road to the former Brodie Ski Area off of Route 7, on private property, and cannot be explored. Makaroff's house is still standing but is a private home; please do not disturb the owners.

Brodie Mountain Sports Center

New Ashford

1940–42

A brief operation, the Brodie Mountain Sports Center was open only for the 1940–41 ski season and a sliver of the 1941–42 season. It was the second of what would be three ski areas to open on the eastern slope of Brodie Mountain in New Ashford.

Due to the area's brevity, only a few scant details about the operation are known. Lincoln Cain (of Pittsfield, Massachusetts) and Fred Johnson (of Paterson, New Jersey) were the owners of the five-hundred-acre property, which was located on the former Jordan and Stills Farm. It operated for the 1940–41 season with a rope tow and several wide-open slopes on the former farm. Clearly, with such a large piece of property, the two business partners had plans for a significantly larger area.

Gregory Makaroff, who owned the Brodie Mountain Ski Trails area directly adjoining the Sports Center, was not pleased. Not only did the new area utilize almost the same name as his, but skiers often migrated from the Sports Center over to his area without paying for a ticket as well. Furious, Makaroff took took the partners to court.

The first case was thrown out on July 12, 1941, on the grounds that any losses that Makaroff suffered were too speculative. And although the Sports Center likely opened again in December 1941, Makaroff sued Cain and Johnson once again. This time, Makaroff prevailed—and the partners were permanently enjoined from using the Brodie Mountain name and had to pay for Makaroff's court costs.

This collapsed building is likely the summit drive building for the rope tow at the Brodie Mountain Sports Center. Pictured here in 1995, it shows the deterioration of over fifty years of abandonment. *Dan Xeller Photography, http://www.dan-xeller.com.*

After losing the case, the partners decided to close the ski area and sell their property. Negotiations had been ongoing for months prior, perhaps in anticipation of yet another court case. It was sold to Paul Kollsman, an instrument manufacturer from New York City. Kollsman was the developer of the Snow Valley Ski Area in Winhall, Vermont, another lost ski area. Although Kollsman surely had plans to redevelop the Brodie Mountain Sports Center, they did not come to fruition—the start of World War II was almost certainly to blame.

Portions of the ski trails were later incorporated into the beginner trail Irish Stew as well as the Novice Rope Tow area at the larger Brodie Mountain Ski Area, which is now a lost ski area. The Brodie Mountain lower parking lot also used a portion of the former Sport Center's lower slope.

VISITING THE AREA

Today, the former Brodie Mountain Sports Center is but a memory—a mere blip in the rich history of the other Brodie Mountain ski areas. It is not accessible, as the access is gated into Brodie Mountain. From the gate, or from Route 7, one can see the Irish Stew Trail and the parking lot that formerly made up the Sports Center.

Elk Summit Practice Slope

Florida

1935–38 (No Lift Service), 1939–41 (Lift Service)

As skiing took off in the North Adams vicinity in the mid-1930s, a location was sought for a practice slope that would have consistent snow cover. Easy accessibility and a high elevation were two requirements needed in order to fulfill this goal. A perfect slope, high up on the Mohawk Trail in the town of Florida was found—directly behind the Elk on the Trail Monument. The monument is dedicated to lives lost during World War I. At an elevation of 2,170 feet, it was, by far, the highest slope directly located next to a plowed road.

The slope was nearly one thousand feet long and had a few hundred vertical feet of intermediate-level skiing. It was frequently used by members of the North Adams Ski Club, who could hone their skills at the Elk before moving on to more difficult terrain on the Greylock Range. Often, the Elk Summit would have the only skiing available.

While it was initially an earn your turns area (with skiers needing to climb the hill first before making runs), in 1939, brothers Lewis and Donald Canedy installed a one-thousand-foot-long rope tow at the slope. The brothers operated tourist ventures along the Mohawk Trail, both at Whitcomb Summit and the Hairpin Turn, and were seeking to expand their winter business. Their father, Charles Canedy, had founded the first tourist gift shop along the road in 1915. The tow was the highest ski lift in Massachusetts at the time and operated for two seasons, into 1941.

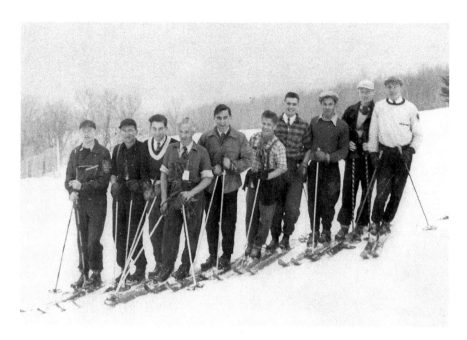

Members of the Thunderbolt Ski Runners enjoy an outing at the Elk Practice Slope in the late 1930s. Ski fashion has changed quite a bit from shirts and ties to today's modern fabrics. *Blair Mahar via Berkshire Outfitters.*

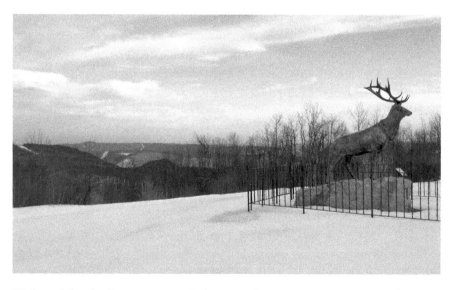

Elk Summit Practice Slope was located directly behind the Elk on the Trail Monument and was lift-served from 1939 to 1941. Today, the slope has become mostly reforested. *Author's collection.*

Chartered buses were sometimes used to access the area. Reminiscing in his column Along the Ski Trail in the *North Adams Transcript*, Howard Lanfair remembered that he and his fellow skiers used to "charter a Berkshire Street Railway bus and go off for the day to Sheep Hill or the Elk. We took our lunches, laid out the skis in the aisle, clambered over them and fell into a seat and sang all the way."

In 1941, the brothers received an offer from the North Adams Ski Club to purchase their tow, which they accepted. The tow was removed in the fall of 1941 and installed at Bernard's in the Notch. (See that ski area's history for more information on the dismantlement of the tow.) Thus ended organized skiing at the Elk, and since the 1940s, the slope has become mostly reforested.

Visiting the Area

One can easily visit the location of the former Elk Practice Slope. A parking area is found next to the Elk Monument, located just southeast of the Whitcomb Summit Retreat (http://www.whitcombsummitretreat.net). Look down the slope to the east of the Elk Monument—this was the former ski area. There are no remnants, as the lift and engine hut were removed to Bernard's in the Notch in 1941.

Lenox Ski Slope, Crosby Trail

Lenox

CIRCA 1939–42

The Lenox Ski Slope, sometimes referred to in guidebooks as the Crosby Trail, was an obscure ski area that operated near the center of Lenox. Owned by Llewellyn Crosby, it operated from around 1939 until 1942 and consisted of a lighted rope tow and wide-open slope. The slope faced east, was wide open and was rated novice. In addition, a skating rink was available.

Despite its location near Lenox, the ski area was quite small and likely closed with the outbreak of World War II.

VISITING THE AREA

This ski area was located near what is now the intersection of Route 7A and Route 123 just southeast of downtown Lenox. After seventy-plus years of abandonment, development has erased any trace of this ski area.

PART III

POST-WORLD WAR II PRIVATE ENTERPRISES

*O*n the immediate aftermath of World War II, skiers were anxious to resume the enjoyment of the sport. During the war, many ski areas closed, some temporarily, others never to reopen again. Skiing was considered to be a non-essential activity, and many ski areas were unable to find enough gasoline to run their rope tows.

But once the war was won, returning veterans, particularly from the Tenth Mountain Division, wanted to use the skills they had learned from training and combat in the mountains. These veterans often began to work as ski patrol members, instructors and, in some cases, owners and operators. One such area was Jacob's Ladder, founded by veteran Floyd Rossi; it even featured ski trails named after aspects of the Tenth Mountain Division.

Some ski areas operated only briefly, including Conley's, Konkapot, Quarry Ski Slope and the Smith Farm. One area, Happyland, was intended to complement a nearby amusement park for children. The Thunderbolt Ski Area, not to be confused with the Thunderbolt Ski Trail, was an enterprise started by young Roger Picard. It operated for only a few weekends before Picard was nearly killed in an accident involving the rope tow.

Conley's Hill

Clarksburg

1947–48

Found at the Four Corners in Clarksburg (the junction of Middle and Cross Roads), Conley's was a brief ski area that may have only operated for one season, 1947–48. It only appeared once in *The Skier's Guide to New England* and never appeared in any other printed guidebook.

According to the guidebook, the ski area had a five-hundred-foot-long novice slope that was three hundred feet wide, with a one-hundred-foot vertical drop. It was exposed to the southeast, needed just three inches of snow to be skiable and was lit at night. The rope tow was four hundred feet long and was open only on weekends and holidays.

Little else is known about this brief ski area or the reasons for its closure, but it is unlikely that it operated beyond 1948.

Visiting the Area

Nothing appears to be left of Conley's, which was likely located on the hill at the northwest corner of the junction of Middle and Cross Roads. The area is developed with houses and is on private property and cannot be explored.

Happyland

Becket

1959–65

Only one amusement park has ever operated in Berkshire County—Happyland, in Becket, which opened in 1958. It was the brainchild of John Young, who developed the park as a "wonderful story-book land where fairy tales come to life." Attractions were based on classics such as Little Boy Blue and Mother Goose. In 1959, after one year of operation, a winter attraction was added across the street—the Happyland Ski Area.

Young constructed the ski area on a north-facing hillside in order to open for the 1958–59 season, and a fourteen-acre "well groomed" slope was cleared. According to Happyland's brochure, novice and intermediate skiers could access the trails using a 1,200-foot-long rope tow. The expert skier would find the slope "ideal for practicing new techniques, especially in the evening when ski conditions become fast." A simple lodge with a fireplace and refreshment stand allowed skiers a chance to grab a bite to eat and warm up between runs. Rentals were available along with a ski shop with the latest equipment. For skiers who wanted to stay the night, the Bonny Rigg Motel was right across the street.

The ski area opened in early 1959, and had a decent first season. A new trail was added for the 1959–60 season—an 1,800-foot-long trail that provided "challenge for the hearty skier." And for the third season, a four-hundred-foot-long beginner's rope tow and novice slope were cleared for new skiers.

Happyland was popular both as an amusement park in the summer months as well as a ski area in the winter months. This bumper sticker was sold in the gift shop. *Author's collection.*

As the Berkshire's most eastern ski area, Happyland marketed toward the Springfield area (one hour away), both for night skiers as well as for special buses for families to enjoy the slopes on the weekend. Bob Klein, Young's son-in-law, recalled that skiers from as far away as New York City, Boston, and New Haven came up for the weekends. The famed anchor Walter Cronkite also enjoyed the ski area from time to time.

By 1961, the original manila rope tow had been replaced with a synthetic rope, which allowed for an easier ride to the summit. Tickets remain affordable for the next few years, topping out at $2.00 for weekdays and $2.50 for weekends in 1963.

Happyland persisted until 1965, when an accident involving an escaped three-hundred-pound black bear named Betsy—she was shot by the state police—resulted in bad press. Both the amusement park and the ski area closed.

But Happyland would continue to be used for another six years for motorcycling. During this time, the site was used as part of the Berkshire International Trials, a ninety-nine-mile course through neighboring towns. The last events were held in the early 1970s. Thereafter, the area slowly became reforested, and now, nobody would ever know a "happy" little ski area used to exist on the hill.

VISITING THE AREA

Happyland was located on the hill that is at the southeastern quadrant of the intersection of Route 20 and 8 in Becket. It is now reforested, with scattered homes bordering the old slope, which is nearly indistinguishable from the surrounding terrain. Wetlands have also formed at the base of the old ski

area. As this is private property, please do not attempt to explore it, and there is nothing much to see from Route 20.

Happyland itself is now the Bonny Rigg Campground, and it is open to the public for camping.

Please visit the campground's website for more information: www.bonnyriggcampground.com.

Jacob's Ladder Ski Trails

East Lee

1948–50

Jacob's Ladder Ski Trails was a classic example of a postwar ski area founded by a Tenth Mountain Division veteran. Many of these veterans returned from World War II and, with their extensive knowledge of the sport, opened their own ski areas, worked on ski patrols or were hired as managers.

Floyd Rossi had served in the Tenth Mountain Division in Italy. Upon his return at the conclusion of the war, his mother and stepfather, Olga and Dominic Masiero, purchased the Here-U-R Inn in East Lee in August 1946. The Masieros were in the hospitality business and had operated a restaurant in Newark, New Jersey, along with a resort in the Catskills of New York. Floyd's brother Guido Masiero also became involved with the operation of the inn. The inn and its attendant restaurant became known for Italian dishes as well as for dancing.

After a year of ownership, plans were drawn up by Rossi to construct a small ski area directly across the street. The ski area's location was prime, directly on Route 20, which was then the only major highway in the area prior to the construction of Interstate 90. Across the street was a pine forest with a steady pitch that faced north, ideal for skiing. The name "Jacob's Ladder" was chosen as homage to the byway of the same name that was part of Route 20.

Rossi's initial plan included the clearing of two ski trails during the fall of 1947—the Tenth Division and the Belvedere, in honor of the

accomplishments of his division. The Tenth Division Trail was 1,000 feet in length and of intermediate difficulty; it was described as "interesting" and "sporty." The Belvedere slope was named in honor of the mountain that saw some of the fiercest battles for the Tenth in Italy but also translates to "beautiful view," which it provided skiers to the north. This slope was semi-open, up to 100 feet wide in places and accented with several tree islands. All trails had an approximate 155-foot vertical drop.

To serve patrons, dorms for up to forty skiers were readied at the Here-U-R Inn, and upgrades to the restaurant were initiated to better serve skiers. A skating rink was built behind the inn as well. John Barnini was brought in to run a small ski shop.

Construction for the ski area was completed in time for an opening on New Year's Day 1948. The Mount Greylock Ski Club held its men's and women's races at Jacob's Ladder, with the men racing on both trails and the women on Belvedere.

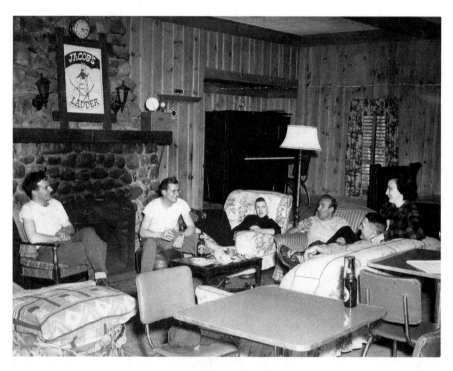

The interior of the Here-U-R Inn lent itself to relaxing après skiing parties around a cozy fireplace. Many of the those affiliated with Jacob's Ladder are pictured here. *From left to right*: Floyd Rossi, Jeddy Brooks, Lenore Brooks, Frank Presjnar, Cecil Conrad and an unidentified woman. *Jeddy Brooks Collection via Blair Mahar.*

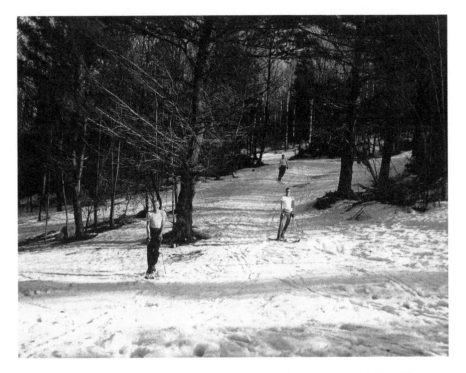

From front to back: Frank Presjnar, Jeddy Brooks and Floyd Rossi enjoy on the ski trails at Jacob's Ladder, possibly the Tenth Mountain Trail. Brooks and Presjnar were instructors and ran the ski shop, while Rossi owned and operated the ski area. *Jeddy Brooks Collection via Blair Mahar.*

While there were no other written reports for that first season, it is known that further improvements were made for the following one. For the 1948–49 season, two new trails were added. The Step Ladder was very similar to the Tenth Division Trail in terms of its length and difficulty. But the greatest addition was a beginner's slope, called Beginner's Delight, a wide-open slope approximately eight hundred feet in length. A new beginner's rope tow of six hundred feet was installed on the novice slope.

Two new ski instructors also made their debut during the second season. Fellow Tenth Mountain Division veterans Frank Prejsnar and Jeddy Brooks were hired to teach the Arlberg Technique, developed by the famous skimeister Hannes Schneider. A reunion of fellow Tenth Mountain Division troops enjoyed the ski area in late January 1949.

Rossi's management of the ski area came to a close on September 7, when his family sold it to the Cavaller Corporation, owned by Joseph Dragone. Dragone opted to keep the ski area in operation for one more

season, into 1950. The quality of the food in the restaurant was emphasized in an advertisement in the *Berkshire Eagle* in February 1950: "When this great winter sport creates an appetite that craves delicious meals, the menus at the Inn will satisfy all desires."

Despite all of the assets of the ski area, including its easy-to-access location, nearby lodging and north-facing slopes, skiing did not continue for the following year, and the Here-U-R Inn changed ownership once again in 1951. Dragone would later lead up the effort to build a tramway on Mount Greylock and work for the failed Greylock Glen development.

The inn continued operation at least until the 1970s as a restaurant, and today, it is now Beaver Storage. The restaurant remains as part of the storage facility. The ski trails, still visible in aerial imagery through 1960, became overgrown by 1970, and the area is now mostly reforested, with a few homes dotting the former slopes.

VISITING THE AREA

Jacob's Ladder was located across the street from what is now Beaver Storage on Route 20. There are several homes in the area and a driveway, and the ski area has completely disappeared. As this is private property, please do not try to explore it.

Konkapot Farms

New Marlborough

1945–46

The southernmost lost ski area in the Berkshires, Konkapot Farms appeared to operate for just one season during the winter of 1945–46. It was a classic family farm ski area, featuring a rope tow that served open fields and a few woods trails.

The Underwood-brand rope tow at Konkapot was built in 1945 and was 1,200 feet long, making it one of the longest lifts in the Berkshires. According to its brochure, "Konkapot Farms Ski Area has wooded slopes and plenty of open spaces for the beginner. There are other slopes steep enough to satisfy the most ardent winter sports enthusiast. Cross country and rapid descent runs on these slopes will give plenty of thrills to all skiers."

Konkapot boasted of being closer to New York City skiers than other ski areas. It encouraged visitors to take snow trains to Canaan, Connecticut, where buses would meet skiers and bring them to Konkapot. After a morning full of outdoor exercise, skiers could warm up in the lodge and enjoy a light lunch.

The exact reason for the closure of this brief ski area is unknown. The snow trains were becoming less frequent, and there were other, more established ski areas in the vicinity, including Beartown and G-Bar-S Ranch.

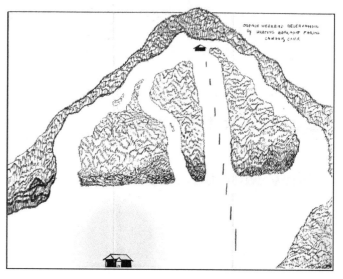

Konkapot Farms was the southernmost ski area to operate in Berkshire County (despite its Connecticut mailing address) and one of the briefest, open just for the 1945–46 season. Three trails were available from the summit, served by a 1,200-foot-long rope tow. *Chris Lundquist.*

VISITING THE AREA

Konkapot Farms was located a short distance from the Connecticut border, just west of the junction of Clayton Mill River Road and Brewer Hill Road in New Marlborough. It is farmland that is partially reforested, but there are no known remnants of the ski area. The area is on private property.

Quarry Ski Slope

Pittsfield

1950–51

A very brief operation, the Quarry Ski Slope appears to have operated for just one season, from 1950 to 1951. It was owned and operated by William Murthey, who was the former manager at the Beartown State Forest Ski Area.

Murthey used his experience at Beartown to construct a short, 350-foot-long rope tow near his Quarry Snack Bar off South Street in Pittsfield. It was to serve a slope with a vertical drop of just 100 feet but was one of the few areas to offer night skiing.

The Quarry Ski Slope did appear in a ski report that season, but almost no other details are known about its operation and it disappeared from any listing after 1951.

VISITING THE AREA

There are no known remnants of this ski area. The former Quarry Snack Bar is now the Berkshire Flower Company.

Smith Farm

Williamstown

1946–49

From 1946 to 1948, the Smith Farm in Williamstown was the location of a small ski area, located just south of the Mill on the Floss Restaurant, on the west side of Route 7. It was previously used as a practice slope and sledding hill, and a rope tow was erected by Bernard Mackey likely in late 1945 or early 1946 and opened for skiers on February 10, 1946. It was a relatively short tow, just three hundred feet in length, but the overall width of the slope was almost nine hundred feet. Ski writer Bart Hendricks described the lift as "sputtering and fussing" during the first weekend of operation, but that the "up-altitude ride was more exciting than the down!"

Hendricks also noted that the area was great for families, and its singular, wide-open slope allowed tobogganers to utilize a portion of it too. In fact, a few weeks later, a seventy-year-old woman rode up the tow in a toboggan for an exciting ride down.

While it is unknown if the ski area operated the following season (plans had been made to upgrade the tow), Mackey did sell the ski area operation to a Robert Herne, a former GI, who operated the tow in February 1948, at least for a few days. The tow was operated in February 1949 by Daniel Steinhoff. Thereafter, there are no further mentions of this ski area, and it likely never operated again.

VISITING THE AREA

Today, the Smith Farm is on private property, but it can be seen roughly off of Cemetery Road, just south of the Mill on the Floss Restaurant on Route 7. Please note that the former ski area is on private property and no remnants are visible from the road, so please do not attempt to explore it.

Thunderbolt Ski Area

Adams

1958

A brief operation, the Thunderbolt Ski Area operated for just a few weeks in early 1958. It was owned by one of the youngest ski area operators in Berkshire history, Roger Picard. At just twenty-two years old, he wanted to develop his own ski resort at the foot of Mount Greylock. A serious accident involving the rope tow put a quick end to its existence.

Louis Picard, Roger's father, owned a family farm at the end of Gould Road, sandwiched between the site of the Sheep Pastures Ski Area and the finish for the famous Thunderbolt Ski Trail. Roger himself was an accomplished skier, as in 1953, when, as a senior, he served as the captain of the Adams High School ski team. In 1957, he began plans to capitalize on the growth of skiing as well as the rich ski history literally in his backyard. While he would operate the area, his father would provide assistance.

The initial plans for a ski area were modest—a 1,200-foot-long rope tow and a wide-open 40-acre slope. Ambitious plans were laid out for the future—including a 4,000-foot-long T-bar to access the lower half of the Thunderbolt Trail and an extension to the rope tow. The barn was eventually going to be refitted into a lodge, but for the first year, the farmhouse would have to do as a warming hut.

Following a decent snowfall, the Thunderbolt Ski Area came to life on January 11, 1958. Ticket prices were set at $1.75 for adults and $1.00 for children. It opened for the following weekends, until February 1, 1958. On

The Thunderbolt Ski Areas's brochure features a prominent lightning bolt, reflecting the name of the ski area. The ski area was located just downhill of the historic Thunderbolt Trail and was operated by Roger Picard for a few weekends in early 1958, before Picard was involved in a near-fatal accident with the rope tow. *Jeremy Clark.*

that date, a terrible accident involving Roger Picard and the rope tow took place. He fractured his arm, broke ribs and had other injuries that took place when he got caught up in the machinery. While Picard survived, due to these serious incident, the Thunderbolt Ski Area shut down following his accident, never to reopen.

The Picard farm was eventually sold and became part of the ill-fated Greylock Glen Ski Area, and no remnants of the rope tow exist today.

Visiting the Area

As the Picard Farm was sold and merged into the Greylock Glen Development, there are no real remnants available for exploration. The Picard Farm was located roughly in the central slopes of the longest chairlift in Greylock Glen. One can park at the last public lot on Gould Road before the road becomes private, then follow the directions laid out in the chapter for Greylock Glen.

PART IV

SKI CLUBS

everal lost ski areas in the Berkshires were operated by ski clubs. As skiing took off in the 1930s, like-minded individuals organized themselves into various clubs. Not only did these clubs serve a social function, but they also helped grow the ski industry by encouraging potential skiers to take the plunge into the sport. By operating their own centers, members could practice and take lessons in familiar surroundings. The public was often welcome at these areas, though occasionally there were restrictions, usually to ensure uncrowded skiing for members.

The Adams Ski Club, North Adams Ski Club, Thunderbolt Ski Club and Stony Ledge Ski Club all operated their own areas in the general vicinity of Mount Greylock. Out of all of the lost ski areas, the Thunderbolt Ski Club's rope tow at the Forest Park Country Club lasted the longest, until 1967. One ski club area, the Mount Greylock Ski Club's Goodell Hollow, continues to operate today and is a living example of the club areas of the past.

Bernard's in the Notch

North Adams

1937–40 (No Lift Service), 1941–44, Sporadically through 1954, 1954–58

A ski club–managed area later owned by a landlord, Bernard's in the Notch operated for nearly two decades. While it opened to much fanfare, it struggled during the 1950s due to logistics and was abandoned in 1958.

In the early days of North Adams skiing, skiers could enjoy the big mountain challenges of trails off Mount Greylock, or utilize a high-elevation practice slope in Florida at the Elk Summit. A location for an in-town practice area was sought by the North Adams Ski Club. The Bernard Farm, located at the foot of Mount Williams on Notch Road, was selected for its open slopes. Owner Paul Bernard welcomed the use of his slopes as a ski area, and in late 1936, thirty ski club members arrived to clear away additional portions of the slope.

A lack of snow proved detrimental for the first season, and it wasn't until around March 19, 1937, that a foot of new snow finally allowed skiers to enjoy the slopes. Throughout the rest of the late 1930s, the area was an earn your turns area. Several races were held at Bernard's, including a downhill and slalom race in January 1938 and a competition with the Thunderbolt Ski Club that same month.

With the proliferation of rope tows around the region, the North Adams Ski Club began to plan for adding rope tows to Bernard's. In the spring of 1941, Webster Ottman, who would later go on to found Dutch Hill

in Vermont (another lost area), was elected president of the club. Other officers included Edson Clark, Margaret Tilch, Madelon Mulroney (Ottman's future wife and assistant at Dutch Hill) and Esther Garrat. This group pushed ahead to find a rope tow, and as luck would have it, the Canedy brothers were looking to sell their rope tow at the Elk Summit. The plan was to move the tow from Elk to Bernard's in the late spring and make it the primary lift at Bernard's.

Dismantling and installing the tow was a significant amount of work. Club members, along with Paul and Harry Bernard, worked hard to move the lift. According to a December 19, 1941 *North Adams Transcript* article by Howard Lanfair:

> *Every night and weekend pandemonium raged at the Elk. Poles ripped up, pulley taken off, the tow house walls were sawed in two and things took on the looks of a battlefield. The old truck was piled high with fence, lumber, wire and wheels, motor and all the fixings and after a number of trips everything was stored in the hayloft of the Bernard farm barn.*

By summer, the lift was being erected at Bernard's. Club members were frequently on scene, clearing the lift line, removing brush and hoisting the towers. Materials for a second and shorter practice tow, powered by a Nash engine, were procured, and that lift was installed following the completion of the main tow. Three trails were cut from the top of the main tow, along with the wide practice slope.

The area was ready to open in December 1941, unfortunately timing with the start of World War II. Limited skiing was available for the first season, though a race was held on a warm day in March. The North Adams Ski Club continued to operate Bernard's through 1944 on a limited basis, then gave the area back to Harry Bernard.

Harry Bernard sporadically ran the area from the mid-1940s until 1954, with some years not operating at all due to a lack of snow. He also had troubles with the rope on the tow, and in 1955, there was vandalism of the tow buildings.

For its last years in operation, Bernard's added night skiing and overhauled the tow, but times were changing in the ski industry. A continued series of poor snow seasons took its toll, and Bernard's closed at the end of the 1957–58 season for good. In 1963, it was noted that remnants of the former ski area could be seen by drivers ascending to the summit of Mount Greylock.

Visiting the Area

Today, Bernard's in the Notch is partially clear and visible while driving along the Notch Road. From the junction of Notch Road and Route 2 in North Adams, drive along Notch Road for 2.1 miles. You will then see the former lower ski slopes on the right. The road then makes a sharp turn to the right as it ascends Mount Williams on the way to the summit of Mount Greylock. A hikers' parking lot is soon reached after 0.2 miles on the right. Directly north of this parking lot, through the woods, were the upper slopes of Bernard's In the Notch.

Forest Park

Adams

1936–52 (No Lift Service),
1953–67 (Lift Service)

The greens of the Forest Park Country Club, located just one-third of a mile from downtown Adams, were home to a small ski area that was served by a rope tow for almost fifteen years. However, prior to the installation of a rope tow, its history dates back to the early days of skiing in the Berkshires.

In 1936, the fledgling Adams Ski Club had identified Forest Park as the perfect location for ski instruction. It was located so close to Adams that skiers would not have to travel far out of town to learn the sport. In addition, the already smooth slopes of the fairways and a modest vertical drop (fifty to sixty feet) made the area ideally suited for beginners. In 1936, many members of the ski club came to Forest Park to practice, and classes were held on weekend afternoons.

During the following season, the level of instruction was raised, as Donald Linscott took over as an instructor for the club, which was now known as the Thunderbolt Ski Club. He had attended a weeklong ski school in Hanover, New Hampshire, where he had learned the finer points of teaching.

By 1938, the club was officially leasing the use of the fairways and had rented space in the clubhouse to use as its headquarters. A small ski shop with new and used equipment was available. Many club members continued to use the slopes for practice into 1941.

For the 1941–42 season, a local ski expert, Oscar Cyr of the Williams College Ski Club, was contracted to provide more formal instruction,

teaching classes of twelve skiers each. The lessons were so popular that lights for night skiing allowed for lessons to be taught a few nights per week.

Like so many ski areas, during World War II, there was little or no action at Forest Park, and the Thunderbolt Ski Club took a multiyear hiatus. Many of the club members who were instrumental in running the club were in the war, and several did not come back, including President Gavin McColl.

The Thunderbolt Ski Club was reorganized in 1945 following the war, and for the next five years, it was in a rebuilding phase. The club held several races on the Thunderbolt Ski Trail, occasionally used the rope tow on Sheep Pastures and often held ski movie viewing parties.

For the 1950–51 season, the club officially restarted its lesson program at Forest Park. Once again, lighted night skiing was available a few evenings per week for both club members and their friends. Although this setup worked for a few years, the search was on for a lift to serve the slopes.

In December 1953, President Bill Linscott became aware of a portable three-hundred-foot long rope tow (its exact origins are unknown) that was procured by a club. A work party was held in early December, and by the fifteenth, the tow was ready to be used. The first riders were not skiers but rather some late-season golfers, who took a trip up the tow to save themselves the climb.

Throughout the rest of the 1950s and into the mid-1960s, the tow remained in operation, mostly in the evenings with night skiing as well as on weekends. But by its final 1966–67 season, the skiing landscape had changed dramatically across the region. The Thunderbolt Trail, the club's namesake, was being utilized less and less each year, as it was not lift served. Many other ski areas were expanding or opening throughout the region, and the use of smaller practice facilities like Forest Park diminished in usage.

The last lift-served skiing concluded at Forest Park in March 1967, and shortly thereafter, the Thunderbolt Ski Club dissolved. The slopes were not abandoned like so many other areas, as they were part of an active golf course, and are essentially untouched today.

Visiting the Area

The Forest Park Country Club is open to the public for golf on its nine holes. If you would like to view the ski area, you can do so by playing a round of golf or by driving through the course, which is bisected by Forest Park Avenue. There are no remnants of the rope tow left. For more information on the course, please visit the club's website at forestparkadams.com.

Sheep Pastures at Gould Farm

Adams

1935–39 (No Lift Service), 1940–42 and 1948–50 (Lift Service)

Located near the foot of the famed Thunderbolt Ski Trail as well as the Bellows Pipe Trail, Sheep Pastures, on Claude Gould's Farm, served as a practice slope for the Thunderbolt Ski Club. It was easily identified due to the power line that went directly up the slope, which was also near the landslide on the east side of Mount Greylock.

Early use of the Sheep Pastures dates back to January 1935, when members of the Adams Ski Club (which became the Thunderbolt Ski Club in December 1936) used the slope for outings as a practice slope area and for cross-country skiing. The farm was also used as a staging area for many of the races held on the nearby Thunderbolt.

Despite being the location of Massachusetts's most famous ski trail, the east side of Mount Greylock did not have a lift-served ski area until the 1940–41 season. At that time, the growing Thunderbolt Ski Club was holding many races on the Thunderbolt, as well as offering ski lessons at Forest Park. But no tow was available near the Thunderbolt.

This would change in 1940, when the club opened up a rope tow paralleling the power line and utilized several open pastures that were used for sheep grazing in the warmer months. For the first season, the terrain was rather rough, but for the 1941–42 season, improvements were made. These included trees being removed at dangerous locations, the terrain smoothed and graded and other enhancements to the trail.

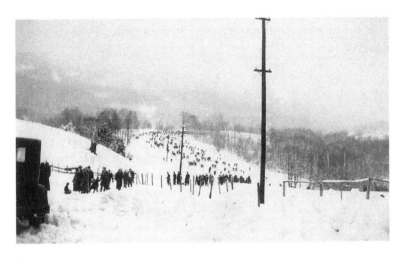

Throngs of spectators descend down the Sheep Pastures slope on the east side of Mount Greylock after watching a race on the Thunderbolt. These races would often bring hundreds or thousands to watch the spectacle. In 1940, a rope tow was installed to serve skiers on this slope. *Adams Historical Society via Blair Mahar.*

Despite the advent of World War II at the beginning of the season, Sheep Pastures was able to remain in operation, mainly during weekends and for school winter vacation week. Lessons were taught on Sunday mornings, with each class consisting of twelve potential skiers. Expert lessons for slalom racing were also held, taught by expert skier Oscar Cyr.

Throughout the war, operations of the tow, if any, were quite limited, and it was not until the 1948–49 season that skiing returned in earnest. For that season, the tow was lengthened and lights were installed for night skiing, which was available every Thursday evening from 7:00 p.m. to 10:00 p.m. The operators of the tow included Ralph Anthony Sr., Ralph Anthony Jr. and Henry Sojkowski.

During this time, the ski area was open mainly for the use of Thunderbolt Ski Club members but available to the public when the slopes were not crowded.

Skiing would continue at Sheep Pastures until the conclusion of the 1949–50 season. Thereafter, the ski area was abandoned, with interest shifting to Forest Park in Adams, which was more accessible to the nearby population.

Although portions of the Sheep Pastures have returned to forest, the heart of the wide-open ski slope remains. The author was granted permission by owner Roger Picard to visit the lost ski area. The tow house is long gone, but Picard's vegetable garden now fills in the foundation. In

addition, the warming hut was incorporated into Picard's home and is now his kitchen.

VISITING THE AREA

Sheep Pastures is on private, gated land and cannot be visited by the public.

Taconic Golf Club

Williamstown

1949–52 (No Lift Service), 1953–59 (Lift Service)

Several golf courses in the Berkshires served as locations for small rope tow ski areas, and the Taconic Golf Club in Williamstown was one of them.

Operated by the Stony Ledge Ski Club, ski classes were held at what is the ninth hole of the golf club from around 1949 through 1952, though no lift was in operation. The classes were geared toward children but were occasionally held for adults. A few winter carnivals were held as well, hosting competitions for children based on their winter sport skills.

After a brief hiatus in the club, the ski program began anew in 1953. William Burnett was elected head instructor, to be assisted by Peter Strong, William Burnett, Albert Trudel and Alton Perry. Classes were held after school from 3:00 p.m. to 4:30 p.m.

A new portable tow was procured for the lessons and first operated for the 1953–54 season. No more than four hundred feet long, it offered a vertical drop of just forty feet—certainly not long enough to make any substantial turns but perfect for children to learn how to ski.

The tow was removed at the end of the ski season so as not to interfere with the summer golfing season. For the next several years, it was installed at the beginning of winter, with classes usually held in January and February, either after school or on weekends. Dances and ski sales were held in the off-season to raise funds for these lessons. In 1957, portable lights were

purchased to allow for night skiing. The tow operated at the golf course until the 1958–59 season, and then was moved to the Snow Bowl behind the Pine Cobble School, where it operated for one final season.

VISITING THE AREA

The former slope, part of the ninth hole, can be viewed from Route 43, just south of Meacham Street. Note that the Taconic Golf Course itself is a semiprivate club.

To learn more about the golf course, visit taconicgolf.com.

Thunderbolt Trail Tow

Adams

1958–60

One unique lost area in the Berkshires was a brief rope tow that operated on the Big Schuss section of the Thunderbolt Ski Trail. This lift is an outlier as compared to almost all of the other former ski areas in the region, in respect to its remoteness as well as its location on the most famous ski trail in Massachusetts. In addition, it is important to note that the Thunderbolt Ski Trail itself is not abandoned and is actively in use each winter.

The Thunderbolt Ski Club was involved with several rope tow ski areas prior to the construction of a rope tow on its namesake trail. One was at Sheep Pastures, on the lower slopes of Mount Greylock, while the other was a beginner tow on the Forest Park Country Club. Both featured relatively easy terrain.

In the fall of 1957, the ski club made plans to erect a tow about halfway up the Thunderbolt Ski Trail. In a meeting held on November 27, 1957, the club approved its construction. Its location at nearly 2,500 feet in elevation would make it the highest ski lift in the state of Massachusetts. The Big Schuss location on the trail was one of the wider and straighter locations to operate a rope tow.

On December 1, 1957, club members held a work bee to build the tow, and it became operational that winter. The tow was completely inaccessible by vehicles and was gasoline powered—meaning that members needed to carry the gas themselves, not an easy task, requiring a hike of over a mile

from the end of Thiel Road. Several excursions to use the tow were held by club members in February 1958, with members first meeting at the Adams Free Library and then carpooling to the trail. Along with good skiing, members also enjoyed one another's company with a picnic lunch.

The tow was operated sporadically in the 1958–59 season, with troubles with the rope itself ultimately requiring replacement. The tow was used at least a few more times for the following 1959–60 season, including in early March. Just before the last recorded use, on March 6, 1960, a Caterpillar tractor owned by George Ruebesam was used to drag a sleigh filled with skiers to the slope.

This rope tow does not appear to have operated after 1960. It is surmised that its far-flung location, along with declining use of the Thunderbolt Trail, resulted in less interest in keeping the tow functional.

VISITING THE AREA

Remnants for the rope tow are still visible nearly sixty years after its final use, with pulleys located high up in the mature trees along the Big Schuss. If you are hiking the Thunderbolt, look to the south (left) at the top of the Big Schuss to spot the pulleys. You will reach this section approximately 0.9 miles from the start of the trail at the end of Thiel Road.

One can still ski the slope as well. The Thunderbolt Ski Trail is an earn your turns trail that is just as challenging today as it was eighty years ago. Information on the trail can be found at www.thunderboltskirun.com. If you are interested in events held on the Thunderbolt, or if you wish to help support efforts to maintain the trail, learn more from the Thunderbolt Ski Runners at thunderboltskirunners.org.

PART V

MUNICIPAL SKI AREAS

Three municipal-operated ski areas once existed in the Berkshires, with only one remaining open to this day—Osceola Park. Springside Park and Clapp Park were both in Pittsfield, while Windsor Lake used to operate in North Adams. These areas were either free or offered at low cost to members of the communities that they served, often hosting lessons geared toward children and families. None had fancy facilities—a short rope or warming hut—but all were perfectly sized to suit their purpose as an affordable training ground for future skiers.

With Pittsfield operating Osceola Park, it became no longer necessary to operate the smaller Clapp and Springside Parks. Windsor Lake struggled through poor weather conditions and a series of mishaps. Despite their small statures, these small community areas will be remembered as friendly places to ski for children and parents alike.

Clapp Park

Pittsfield

1943–51 (No Lift Service), 1952–64

Clapp Park, one of Pittsfield's parks operated by the city's parks and recreation department, used to feature a small beginner ski area. It first operated as a simple practice hill and grew into a rope tow area, mainly for children and beginner skiers. Skiing was available along a narrow ridge on the east side of the park, with a vertical drop of about forty feet.

Organized ski lessons at Clapp Park began on February 10, 1943, when the first public lessons were taught by Martha Stern. Run by the parks department, the lessons were taught to twenty children, as fifty onlookers watched. Lessons were occasionally offered into the early 1950s.

With the growth of nearby ski areas, a lift was sought to improve the skiing experience. In the winter of 1950–51, buttons for the Winter Carnival were sold, and the proceeds went toward the purchase of a portable ski tow. Costing $640, the tow was briefly installed at Springside Park in late December 1951, but then quickly moved to Clapp Park. The tow, six hundred feet in length, was capable of hauling five skiers at a time to the summit. It first operated on January 12, 1952, and numerous lessons—at times for up to fifty students—were held for the remainder of the winter. Lesson costs were fifty cents for children and one dollar for adults.

Throughout the rest of the 1950s, the tow continued to operate, mainly for lessons and for children. U.S. Eastern Amateur Ski Association–certified instructors taught the majority of the classes. The area operated mainly on weekends, holidays and a few select nights, and most seasons saw less than a

The rope tow at Clapp Park in Pittsfield was located on the left side of this long ridge. Today, it forms the eastern boundary of the park's baseball field and track. *Author's collection.*

few dozen days of operation. For the 1959–60 season, the area operated for approximately twenty-nine days, having only operated nine in the year prior.

The final year of operation appears to be in 1964, when organized skiing ceased at Clapp Park. The city's ski programs were moved to the nearby Osceola Tow, which had a bit more vertical drop, as well as to Springside Park. It is very likely that the tow, or portions of it, were relocated to Springside for 1965 when that area opened.

VISITING THE AREA

Clapp Park is an easy lost ski area to find and explore. Located on Route 20 about a half mile west of the junction on Route 9 and 20 in Pittsfield, the area features several baseball fields, a running track and a playground and has plenty of parking. The former ski area is easily seen as a long mound, just east of the baseball field, with the tow having operated on the north slope. You can walk to the top of the hill and enjoy an elevated view of the park as well as Bousquet Ski Area to the south. No remnants of the tow are visible.

Springside Park

Pittsfield

LATE 1940S AND 1960–64 (NO LIFT SERVICE),
DECEMBER 1951 (LIFT TEST),
1965–75 (LIFT SERVICE)

Springside Park was (and is) a sprawling public park located to the north of Pittsfield off of Route 7. Over the years, it has been known for a petting zoo, ice-skating rink and ball fields. It also was the site of one of the shortest ski areas in southern New England.

Pittsfield is rare for a municipality in that it has been the site of three public and free ski areas over the years, including Clapp Park and the operational Osceola Park ski areas. Skiing at Springside can be traced back to the late 1940s, when ski lessons were taught by Syd Anderson and Hobart Tower. Lessons were available on weekday evenings on the gentle slopes, though no lift was available.

A few years later, Springside was used to test a portable rope tow that the Parks and Recreation Department had procured in December 1951. After a short test, the lift was moved to Clapp Park, where it operated until 1964.

In the meantime, Springside began to be used once again as a practice slope for children around 1960. The 150-foot slope had a vertical drop of no more than 40 feet and was about as easy of a slope to learn the sport as one could imagine. It was open and supervised after school and on weekends at no cost.

One lonely
rope tow
tower remains
standing in
the gardens at
Springside Park
in Pittsfield.
In April,
the former
lift tower is
complemented
by an amazing
bloom of
daffodils. *Author's
collection.*

In 1965, the rope tow that had operated at Clapp Park was almost certainly moved back to Springside. Here, it would operate, at least sporadically, until 1975. The parks and recreation department offered occasional after-school classes for kids during this time, which made learning the sport quite convenient.

After 1975, the tow closed and was removed, except for one tower. It is likely that it was no longer necessary to run two different ski areas in the city, and instead, all ski-related activities were consolidated at Osceola Park, which continues to operate to this day.

VISITING THE AREA

Springside Park is located at 874 North Street in Pittsfield and is well worth a visit. Besides the location of the lost ski area, it is also home to the Hebert Arboretum (www.hebertarboretum.org), which features a diverse landscape and several garden areas.

Park at the lot just west of the Springside House. From here, walk east through fields and gardens for about five hundred feet along the top of the hill. Then, look south, and you will see one lone telephone pole in the garden. This is all that remains of the rope tow. The former ski slope is particularly striking in late April when thousands of daffodils are in bloom on the hill.

Windsor Lake (Fish Pond)

North Adams

1967–70

A brief ski area operated by the North Adams Parks and Recreation Commission, Windsor Lake (sometimes referred to as Fish Pond) had noble goals of providing affordable skiing to children and families. It was plagued by bad weather and mishaps and only operated for several seasons in the late 1960s.

Prior to the brief ski area, Windsor Lake was noted for its winter sports activities. A 1949 article in the *North Adams Transcript* noted the park's ideal location for ice-skating, good coasting and skiing on its open slopes. However, it would take over fifteen years before a proposal for more formal operations would be developed.

Seeing the need for affordable family skiing in an era of increasing costs at major ski areas, the North Adams Parks and Recreation Commission, led by Commissioner George Fairs, began making plans in 1965 to develop an affordable ski area. A search was made to find the ideal location. Several residents offered the use of their own hills, and the commission seriously considered building a rope tow at the Brayton School. These locations had some drawbacks, including a lower elevation or issues with parking.

Instead, an area was found on city land at Windsor Lake Park, directly across the street from the lake on Windsor Park Road. Ample parking would be available, and the slope was located a few hundred feet above the city, which, in theory, would help with additional snowfall and maintain the slope

a little longer than if a more in-town location was chosen. In addition, there would be no issues procuring the use of the land, as it was already owned by the city.

In November 1965, commissioners considered opening a ski area at Windsor Lake, but it was too late in the year to clear a slope. Instead, they focused on opening a ski slope at Brayton School, which already had an open slope available.

No further action would occur for the 1965–66 season. But the development of the ski area became a priority in 1966. Movement continued into January 1966, when Commissioner Fairs brought the topic up at a meeting: "First, we believe that skiing will be brought within reach of a great many additional youngsters; and secondly, we believe that the great family sport of coasting will be revived."

By late fall, plans finally came together to develop the slope—and rather rapidly at that. At a meeting on December 14, $3,731 in funds was transferred to the commission to build the ski area. It was not totally without controversy, however. Commissioner Lawrence Moreau called it "a frill, though maybe a necessary frill." He was concerned that the funds were being diverted from needed street repairs in North Adams.

Clearing of the slope began in earnest, commencing in mid-December, with the goal of having the area open around the new year. Out of the total budget, $2,475 was set aside to purchase a gasoline motor for the tow as well as one thousand feet of rope for the lift (which would be five hundred feet in length). On December 27, Larchmont Engineering of Lexington, Massachusetts, was contracted out to build the tow, which was estimated to be delivered within a week and a half and then installed within three days. The shortness of the tow and the relative gentleness of the slope would make for an easy installation.

Residents were excited to have this new recreational facility in North Adams. On the opinion page of the *North Adams Transcript* on December 30, one resident, "LC," wrote that "with costs at the average area well out of reach of many incomes, it is good to see a municipality supply facilities which can introduce the sport of skiing to youngsters." Clearly, the cost of skiing was rising even fifty years ago and already becoming a concern for the skiing community.

The ski area opened up shortly after New Year's, and for the first year, it was relatively basic, with no lights and no warming hut. It closed for the season on March 26, with Commissioner Fairs quite pleased on how the first season went.

With the success of the first year, significant plans for the improvement of the facility were developed, and by November, $9,682 had been appropriated. Improvements would include lights for night skiing, grading and smoothing of the slope, along with other improvements to the park for the summer months. The lights were expected to make the ski area a mecca for residents. Out of the funds, $925 was awarded in a contract to Yare Electric Company of Lee, Massachusetts, which installed the lights within a week.

Most ski areas had some kind of a warming hut or lodge. For Windsor Lake, the cost of building one was too much for the budget, but a plea was put out in November 1967 for the donation of a suitable building. The hope would be to find a six-hundred-square-foot hut that would have space for bathrooms and for ski patrol/first aid. If one larger building was not available, the community hoped someone would donate two smaller ones.

There were no initial offers. By early December, with winter fast approaching, the urgency rose. A nominal moving fee was added to sweeten the pot.

The North Adams community rose to the challenge. Within two weeks, eight different buildings were offered by residents, all at no charge. In the end, Wilfred Rose donated the former "Fish Net" hut on State Road. On the morning of December 22, 1967, town agencies, including the police, utility company and public works, moved the hut to the top of the ski slope. It would take a few weeks to completely finish the hut, but it would be ready by early January.

The second season commenced on December 30. Due to freshly fallen snow, residents with snowmobiles were asked to bring them to Windsor Lake to groom the slope that morning. The first night of skiing took place that day, from 6:00 p.m. to 9:00 p.m., and the rest of the season was mostly uneventful.

It was the final two seasons that would hit the ski area hard and force its closure in 1970. In its third year, the area was affected by terrible weather. An ice storm in early January 1969 made the meager snowpack completely unusable. By mid-January, the slope was still too icy for skiing, but sledding was allowed.

Two snowstorms raised spirits in early February. The first dumped plenty of snow—but howling winds stripped it all away from the slope, leaving it bare. Another storm in mid-February did provide sufficient snow cover, but then the lift broke down. Even with the lift failure, some skiers enjoyed the slope, but they had to hike back up after each run. It had been a near record day prior to the mechanical failure.

Warm temperatures arrived on February 22, 1969, melting quite a bit of the snow, with pooling of water near the loading area for the tow. The large puddle shrank a few days later, and a rare Monday night of skiing was held on the wet snow, as personnel usually assigned to the town's outdoor skating rink were available to run the tow.

To add even more to the drama of that season, a fire broke out in the engine building and burned a wall. Thankfully, the engine was unaffected. By the middle of the month, warm temperatures melted the remaining snow cover, and the area closed for the season.

The commission gave Windsor Lake one more chance. Similar to the first year, a large December snowfall of twenty inches resulted in unpacked snow, and a call went out once again for snowmobilers to come and pack the slope. When none was available, Jim Kelley from Brodie Mountain came forward to offer the use of his packer, which was brought to the area on a trailer from Williams College. This did allow for good early season skiing, but the 1969–70 season would be its last. Given the difficulty of running a ski area, including the rapidly varying weather conditions and a lack of a permanent packer (groomer) or snowmaking, Windsor Lake would not reopen for the 1970–71 season.

The lower portion of the slope would remain mostly clear into the early 1990s, when the author discovered the former ski area on a Boy Scout camping trip at Windsor Lake. But trees and vegetation would soon swarm the lower slope, while the upper slope is maintained to this day.

VISITING THE AREA

The former ski area at Windsor Lake can be explored and does have several interesting features to see. The upper portion of the slope is mowed and maintained, while the lower portion is overgrown. Towers for the rope tow remain in place over fifty years after their installation. The author

Remnants of the former rope tow are found at the bottom of the slope at Windsor Lake. Also note the rope tow lift tower still standing, with an attached pulley, through which the rope used to pass over. Much of the lower slope is overgrown, though the upper, flatter slope is still maintained. *Author's collection.*

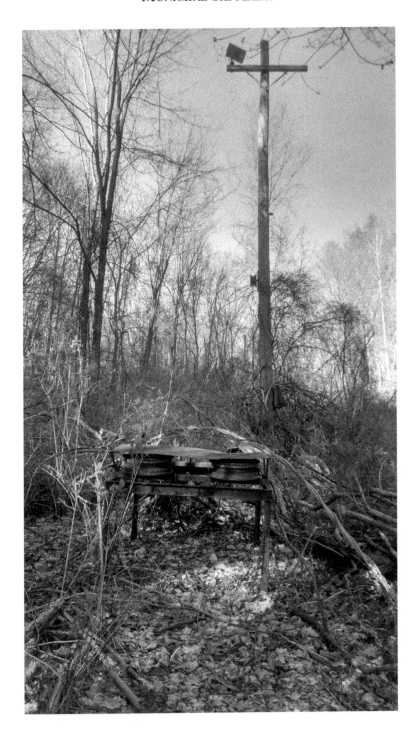

recommends visiting in late fall, winter or early spring, as the lower portions of the ski area are quite overgrown in the summer.

To explore, begin from the north parking lot on Windsor Lake Road, which borders the lake. Walk three hundred feet north and then turn left—you'll be standing at the top of the former ski area. You'll notice several lift towers and the unload station for the tow on your left. Walk down the slope, where several informal paths are visible. It is a short walk, just five hundred feet, to the base of the ski area. When you reach the base, you can find remnants of the engine. Looking back up the hill, note the lift towers and pulleys that used to pull skiers to the summit. Return the same way you came.

Windsor Lake remains a vibrant park today, with cross-country ski trails and snowshoeing during the winter months close to the former ski area.

For more information, please visit explorenorthadams.com/item/windsor-lake.

PART VI

SCHOOL AND COLLEGE SKI AREAS

ix areas in the Berkshires were operated by schools and colleges. These areas provided a place for students to learn the sport, train for meets and meet physical education requirements. Four were relatively modest rope tow ski areas and open only to students: Berkshire Christian College, Berkshire School, Cranwell School and Pine Cobble. The other two, operated by Williams College, were more substantial. Sheep Hill operated for decades and was one of the earliest lift-served ski areas in the county.

The Ralph Townsend Ski Area on Berlin Mountain, however, was a much more substantial facility and had the steepest slope in the Berkshires. It had a vertical drop of 1,300 feet, though only a portion was served by a handle tow. It also featured two natural ski jumps and cross-country trails. Plans to add a more substantial lift were scuttled due to high costs, but today, it is still used by backcountry skiers.

Berkshire Christian College

Lenox

1964–65

For just one season, the Berkshire Christian College in Lenox featured its own ski area just for students and members of the Hope Church. Located just less than one mile south of downtown Lenox, the college was situated on Lanier Hill overlooking Lily Pond. The west slope of the hill featured enough of a vertical drop (nearly two hundred feet) to be suitable for a ski area.

In 1965, Owen Burtt, Ray Bowden, John Ladd, Warren Whitney and Madison Taylor, all affiliated with the college, built the rope tow. According to Whitney,

> *The tow rope, which was approximately one thousand feet long, was attached to and driven by the back wheels of a small dump truck. We packed the snow down by sidestepping up and down the hill.*
>
> *It was open on holidays, Saturdays, school vacations and closed on Sundays. It was free to any person connected to Berkshire Christian College and Hope Church. It existed for one year, the winter of 1964–spring of 1965. At that time, a new dormitory access road was opened across the slope.*
>
> *It might appear to the average person that this was a lot of work for only one year of existence. However, to the students, faculty and their children, along with the folks of Hope Church, it has great memories. It not only*

was used for skiing but many a person went down the hill on various sliding apparatus, including, but not limited to, toboggans, sleds, flying saucers, cardboard, inner tubes and car hoods.

Berkshire Christian College remained in Lenox until the late 1980s, when it relocated to Haverhill, Massachusetts. Later, the site was redeveloped into luxury condos.

VISITING THE AREA

The former school is now a luxury condo complex and on private property and cannot be explored.

Berkshire School

Sheffield

1949–50 (No Lift Service),
1950–71 (Lift Service)

Beginning in 1950, the Berkshire School operated its own private ski area for students, especially those on the ski team. Over the course of two decades, hundreds of students learned the sport and fine-tuned their racing skills on its slopes. Countless alumni fondly remember the ski area to this day.

Looking to expand the training opportunities for the ski team, a new slope was cleared by students for the 1949–50 ski season on school property at the base of Mount Everett—just steps away from campus. The slope was initially not served by a lift. It was named after Joel S. Coffin III, a graduate who was killed in World War II. The slope was used for practice in the slalom for the first season.

In the spring of 1950, headmaster Arthur Chase, along with ski coach Worden McCallum, toured local ski areas to learn how to build and maintain a rope tow. They installed a $1,500 rope tow during the summer of 1950, using lumber from the trees that had been cleared on the slope. McCallum expected that this lift would be a giant improvement: "Work, especially in the slalom, will be advanced to the point where we will accomplish three times as much during practice periods."

And indeed, the new rope tow was a huge success, allowing the team to practice on a slope that was very convenient to class, requiring no transportation to get there. A new slope, the Warner, was soon added. A

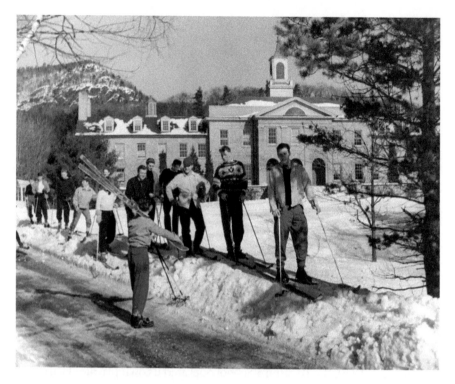

With a location on school property, students could access the Berkshire School ski area by simply skiing across campus. At the time, most schools and colleges had ski areas that were located a fair distance away, but not at Berkshire School. Countless students learned to ski in the area, and the ski team won many meets and championships. *Berkshire School.*

small ski jump was built. Chase, whose nickname was "Bear," operated the rope tow along with C. Twiggs Myers, a history teacher who joined the faculty in 1953. Both Chase and Myers were experienced outdoorsmen who also ran the school's Maple Syrup Corporation on campus. Myers would go on to become a beloved teacher, cross-country coach and campus historian.

Throughout the 1950s, the ski team and other students practiced on the two slopes whenever the snow depth would allow. Arthur Chase's son Ed, who learned to ski at Berkshire School, recounted what it was like skiing here during this time:

> *The area was run for the students at the school, primarily by faculty members, who maintained an old Ford motor and would splice rope every fall. Those students participating in skiing for the winter were required to ski daily, and whenever there was significant new snow, all were required*

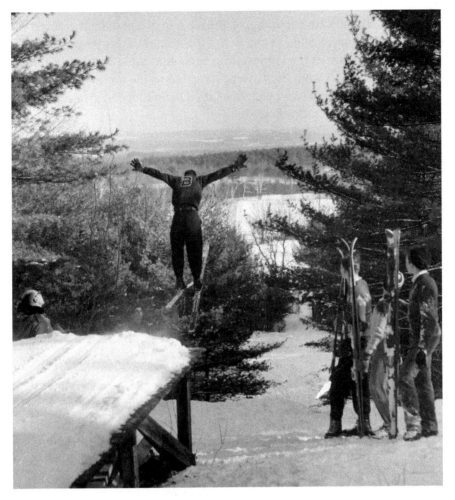

In the early 1950s, a small jump was available for students at the Berkshire School. Here, a student practices his technique after launching from the jump. The jump only lasted for a few years and was soon abandoned in favor of focusing on the slalom. *Berkshire School.*

to ski pack the slopes. I grew up learning to ski on these four slopes, and while I was in elementary school in Sheffield, my father would keep the tow running a bit longer on school days so that I could have a couple of runs.

Ed Chase would later go on to have a four-decade career in the ski industry, including working for K2 Skis, where he was the ski technician for Olympians Phil and Steve Mahre, who are regarded as two of the best skiers of all time.

In 1960, a significant expansion of the ski area was undertaken. A second rope tow was extended above the first, for a combined lift length of 1,800 feet. This also boosted the vertical drop to a respectable 320 feet. Both the Warner Slope and Coffin Slope were extended to the top of the new trail and a new Chute Trail was built above the Coffin Slope to give skiers a bit of a speed boost for descending.

Gerry Michaud, a Berkshire School alumnus, remembers when the tow was extended:

> *Having attended Berkshire School from 1958 through 1962, the ski hill was the highlight of my career at the school. When I arrived there was one rope tow and a downhill race course, which we had to climb. In 1960, the school extended the slope up the mountain and installed a second rope tow. We were in heaven! I particularly remember the downhill course because it was narrow and almost always icy.*

The expanded terrain was ideal for the students and was in use for another ten years. The ski team continued to win many championships and meets. However, natural snow proved to be minimal during this time. Myers recalled, "The average annual snow fall in the south Berkshires does not make for great natural skiing; the best winter we ever had was forty-four days of operating the tows. More often than not, we were lucky to get ten days to two weeks during the final years of operation."

In the final years of operation, students tried out the new sport of snurfing, a precursor to snowboarding. Chris Groves recalled the last years of operation and trying out the new sport:

> *I graduated from Berkshire in 1973 and skied and snurfed on the Berkshire School trails in the winter of 1969–71.*
>
> *Prior to 1970, the Berkshire ski team would practice giant slalom on the upper trail (flatter terrain) and practice slalom on the steeper lower trail. Even when the lifts were not running, Bob Brigham (Ski Team Coach) would have his team pack the hill on skis and run gates if the natural snow was sufficient. Walking up the hill would ensure that you would make every turn count and you would see the best line as you sidestepped up past the gates!*
>
> *The two rope tow lifts were also used by snurfers who would ride up the rope tow standing behind a skier on the tail section of their skis. It was challenging going up the steep lower lift, especially if the track was frozen with ruts. These were the days before Jake Burton perfected the snowboard!*

The snurfers at Berkshire enjoyed the ski trails and also would snurf down to campus from the top of Mount Everett. Typically, five boys would share a cab ride to the trailhead that led to the summit of Mount Everett. After walking in to the downhill section, the glide down to campus was 80 percent downhill and had some very exciting narrow sections that required accurate turns to miss trees, boulders, and stream beds. These truly were the good old days for me.

According to Myers, "By 1971, Berkshire's two hills were not sophisticated enough; we had no snowmaking capabilities, and the insurance companies wouldn't cover our primitive rope tows." Official lift-served skiing at the school ended in 1971. A search was made for a suitable replacement training facility. They did not have to look very far—nearby Catamount Ski Area, located only ten minutes away, was chosen as a new training ground. It featured snowmaking, better lifts and night skiing.

Yet despite the official closure, ski team members still trained on the slopes in an unofficial capacity until they became too overgrown. John Borwick '81, the ski team coach at Berkshire School, was one of the students:

I've spent some time on the Berkshire ski hill in my younger days, in that our ski team captain at the time, Randy Hoder '79, along with Bob Valentine '79, Jeff Parks '80, Kurt Vermeulen '81, Eric vanZon '81 and I would hike the old ski trails in which to train prior to breakfast. Mind you, this was in addition to Coach Brigham running us all out to Catamount for our normal team practices, yet the effort to come together as a team, hiking in the predawn darkness, actually brought the team closer together. However, teachers and other students had always been confused to see a small cadre of

The year 1971 marked the final season of operation of the rope tows at the Berkshire School. Here, a student rides the lower tow. A lack of snowmaking and the denial of insurance coverage led to its closure that season, with the ski team relocating to Catamount for training. *Berkshire School.*

ski racers hiking down from the woods at a quarter to seven in the morning, having spent the better part of an hour hiking and running gates on an unlit and boot packed trail.

Today, the ski team continues to train at Catamount and is one of the best regarded teams in New England. The slopes at Berkshire School gradually became reforested, and today, they are very overgrown and just a memory, though Coach Borwick takes students on hikes each year through the former ski area, teaching them about its heritage.

VISITING THE AREA

As part of the private Berkshire School campus, the ski area cannot be explored by the general public.

Cranwell School

Lenox

1940s–50s (No Lift Service), 1960–75 (Lift Service)

Skiing was a popular sport for students of the now defunct Cranwell School, which was operated by the Jesuits. The school, which opened in 1939, was formerly known as Wyndhurst, one of the many classic cottages that dotted the Berkshire landscape. Beginning in the 1940s and 1950s, students used the school's golf course to learn the sport and make some runs. Even a homemade jump was available. Tom Dwyer, class of 1948, remembered skiing here in the 1940s:

I was a student at the school from the fall of the 1944 until I graduated in the spring of 1948 and taught myself to ski on the hill there. There was no lift, and I had to climb back up after each descent. Of course if it had snowed heavily the night before then I and my fellow fanatics had to pack it down first, which took most of the afternoon.

The hill terminated in a fairway on the school's golf course, and to reach it, the skier had to pass between two sand traps near the bottom, which were about five feet apart. If his aim was off, he would fly over the edge of one of the traps and crash at the bottom. There were many such finales to ski runs on that hill! There was also a ski jump nearby made out of an old door, which saw a lot of action.

With the growth of many ski areas in the region, the school decided to make the skiing facilities more official. During the fall of 1960, a rope tow was constructed by the grounds crew, led by Thomas Scannel. Paul Leventi, who was a mechanic and welder, also helped construct the tow.

The rope tow was built on the fifth fairway, using locust trees that were harvested from the school grounds, with wheel rims used for pulleys. The tow was seven hundred feet in length and powered by a ten-horsepower engine. A unique observation tower, overseeing the slopes, was constructed.

Throughout the 1960s, the school's ski club and team practiced their technique on the rope tow. Coach Albert Vinatier, who joined the school in 1961, led the growth of skiing at Cranwell. By 1965, 105 out of 243 students—many of whom had never skied before attending the school—were members of the ski club. Hermy Henriquez was one of those students:

I graduated Cranwell in 1963. Being from Panama, I was introduced to snow skiing at Cranwell. I never reached expert but learned enough on that hill with its famous rope tow to be able to take trips to Mount Snow and major slopes and be able to get down some of the intermediate runs. My rented learning skis were wood, with bindings that my peers referred to as "bear traps"—there was no way my skis would ever come off no matter how hard I might crash! But that slope was a great place to learn, down fast and almost back up as fast on the rope tow with its diesel chugging in the background. I also remember going down on a four-man toboggan, and when we hit the road that ran across the bottom, we all went flying in the air like shrapnel!

Ski meets, including downhill and slalom racing, were often held on the hill against opponents like Berkshire School and Wahconah Regional. Kurt Sullivan, class of 1973, recalled training on the slope:

The slope served as a slalom for those who wanted to work on mogul technique as well as a hill for anyone brave enough to strap on a pair of skis and take a shot at making it to the bottom. It was fairly steep and also saw use in the fall as a location for the cross-country team's practices, as runners would sprint up the incline and sometimes even run backward up the slope.

In 1975, the Cranwell School closed its doors, as its finances had taken a hit, and the school was unable to come up with the $1 million needed to keep it in operation. The rope tow closed at this point, never to reopen.

VISITING THE AREA

Today, the property is the Cranwell Spa and Golf Resort, but unlike many of the lost areas, skiing is still offered for cross-country skiers. Ten kilometers of trails are available, winding their way through the golf course and the former ski slope. No remnants of the tow are known to exist.

For more information on the resort, visit www.cranwell.com.

Pine Cobble Snow Bowl

Williamstown

1957–58 (No Lift Service), 1959–60 (Lift Service)

The "Snow Bowl" was an area located directly behind the Pine Cobble School that was utilized for a few years for downhill skiing. It began on January 8, 1957, when ski lessons were taught on the short slope. Students were broken up by grade level and were taught the techniques of the U.S. Eastern Amateur Ski Association. Dwight Little Jr. served as the director. While there was no lift for the first year, ski lessons were continued on multiple afternoons per week, teaching many students the sport of skiing.

Improvements to the ski area arrived for the 1959–60 season. The portable rope tow that operated down the street at the Taconic Golf Club was moved by the Stony Ledge Ski Club to the school to operate for one final season. James and William Burnett taught lessons at the Snow Bowl, just as they had at the golf club.

The Stony Ledge Ski Club was rapidly coming to an end due to declining membership and a shift away from the trend of ski clubs operating their own areas. The club folded shortly after, likely in 1960 or 1961, resulting in the end of lift-served skiing at Pine Cobble. Ski instructor William Burnett was hired as the ski school director at the New Petersburg Pass Ski Area. In 1963,

a meeting was held to try to reactivate the ski club, but nothing came of it and the club faded into history.

VISITING THE AREA

Pine Cobble is now a private school, please do not trespass to visit this lost area.

Sheep Hill

Williamstown

1934–36 (No Lift Service), 1937–43, 1947–60

One of the Berkshires earliest lift-served ski areas, Sheep Hill was primarily used by students of nearby Williams College for decades. In addition to many competitions and Winter Carnivals held there, it also gave students a place to earn their physical education credits. A somewhat low elevation combined with its wide slope exposed to the east and southeast led to frequent melting of the snowpack, eventually resulting in its demise as a lift-served ski area. Today, it is one of the Berkshires' most vibrant lost areas, offering a wide variety of outdoor recreational offerings along with an education center.

Skiing at Williams College has deep roots. The ski team was founded in 1919, with Roland Palmedo as the captain. Palmedo would later go on to build the single chairlift at Mount Mansfield (Stowe) and then founded Mad River Glen (both in Vermont) in 1949. The Williams College Outing Club has a similar pedigree, dating back to 1915, and was heavily involved with the development of Sheep Hill.

Skiing expanded at Williams College in the early 1930s. For the 1933–34 ski season, Williams began a multidecade partnership with Arthur and Ella Rosenburg, who owned a farm on Sheep Hill called Sunny Brook Farm. It was named Sheep Hill, as sheep had grazed on its steep slopes since the 1800s.

Sheep Hill had the benefit of being close to campus (less than two miles), as well as a fairly steep pitch on wide-open slopes. Little clearing would be needed. For that first season, the ski team practiced on the slope.

On February 5, 1934, the college held its second Winter Carnival, but this was the first to offer ski-related activities. Along with other events held at campus and on the Thunderbolt Ski Trail, a slalom and downhill race and jumping competitions were held. To balance out the all-male students at Williams, 150 female students from Smith, Vassar, Wellesley and Bennington Colleges also attended, with dances being held on campus.

With the success of the events held at Sheep Hill, plans were made for the 1935 Winter Carnival. This time, major colleges and universities competed, including Yale, Dartmouth, Amherst, Princeton, University of New Hampshire and Middlebury. Three hundred students from eastern women's colleges also attended. James Parker, the ski coach at Williams from 1934 to 1936, helped organize the races. A planned race on the Thunderbolt Trail was canceled due to icy conditions, but this only helped increase the attendance at Sheep Hill. Over one thousand spectators came out to enjoy the events on the weekend of February 3 and 4, leading to massive traffic issues.

For the downhill race held on February 4, student A.T. Clement, a Williams sophomore, won the half-mile race in 41.85 seconds. Clement was the nephew of the Stevens brothers from Saranac Lake, New York, who had won gold in the 1932 Lake Placid Winter Olympics.

Some improvements were put in to the facilities at Sheep Hill during the summer of 1935, including $200 toward a new jump that was now rated at 40 meters. The previous record for the old jump was 107 feet, a record that was hoped to be broken at the 1936 Winter Carnival. There are no records for the 1936 carnival to note whether it was broken or not.

The days of no lift service were about to end at Sheep Hill. During the summer of 1936, ski coach James Parker constructed a 900-foot-long tow in the center of the main slope at Sheep Hill. It was a steep tow—covering 250 vertical feet. He was "confident that the tow will lure many skiers to Williamstown whose facilities for winter sports are being sorely neglected."

The tow was ready in December, but there was no snow to speak of. Instead, Parker attended an indoors and revolutionary ski meet and winter sports show at Madison Square Garden in New York City on December 17. In front of a crowd of twelve thousand spectators, he raced in a slalom and met skiing luminaries like Hannes Schneider.

But almost no significant snow would fall for the 1936–37 season. A few inches fell in early January, but not enough to sufficiently cover the slope. By early February, only three inches were on the ground, which resulted in most outdoor Winter Carnival events being canceled. The weather pattern persisted into March, and the lack of snow started to

become humorous—with Parker portrayed in a campus newspaper as the "character of the month," depicted lounging at the rope tow shack with spring flowers underfoot.

The following few seasons would see at least somewhat more snow, and the lift was finally put into operation for the 1937–38 season. Lowell Thomas, the famous journalist and skiing promoter, even visited the ski area in March 1938 with his family while on a tour of Berkshire ski areas.

During the 1940 Winter Carnival, almost three hundred spectators enjoyed the slalom and downhill races. It was a family affair, with Phil and Don Cole coming in first and second in the downhill. Their father, Donald Cole Sr., was the operator of the tow. John Jay Jr., who had graduated from Williams in 1938, also raced. A longtime Williamstown resident, Jay would go on to become the inventor of the modern ski film, producing three dozen of them in his fifty-year career.

Like many early ski areas, there were growing pains. On February 22, 1940, student Hadley Griffin broke his leg and it took nearly an hour to remove him from the slope and take him to the campus hospital. First-aid supplies were limited, and there was not any real ski patrol. Within five days, plans were made to increase first-aid supplies and to ensure that there was always someone available on-site with first-aid training. With the growth of skiing, many skiers were attempting terrain over their ability levels, which led to more accidents. Thirty-six were reported for the 1938–39 season, with forty-nine for 1939–40. Many students were using the hill now to earn their physical education credits but did not really know what they were doing, which led to the increase in accidents.

Development of the area continued into the early 1940s. A new full-time ski coach, Oscar Cyr, began his tenure in 1940. Cyr had operated a ski school in Woodstock, Vermont. He would also develop a ski school by 1942, with three daily classes on weekends along with afternoon lessons. When deep snows hit in February of that year, up to six hundred skiers would be found schussing the slopes on an afternoon. Records were continually set on the jump, with Mezzy Barber, the 1940 national ski jumping champion, setting a new record in 1941.

Meets and competition continued into 1943, but with World War II progressing, the ski area was shut down at the end of the season. It would lie quiet and silent for the rest of the war and into 1947.

As was typical of many ski areas in the postwar era, there was a strong desire to see them reactivated, expanded and improved. James Parker worked on building another rope tow above Bee Hill Road and above the original ski

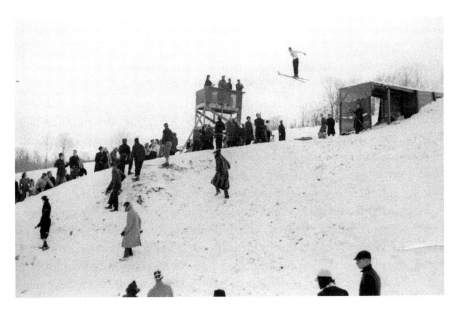

A ski jumper soars through the air after taking off from the forty-meter jump at Sheep Hill. Though undated, the picture likely dates from the late 1930s. *Williams College Archives/Special Collections.*

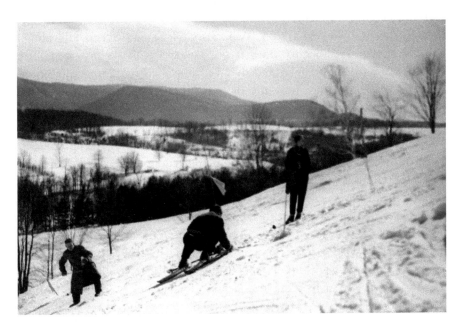

Williams College students prepare gates for a slalom race on the wide-open slopes of Sheep Hill in the late 1930s. Mount Greylock rises above the landscape in the background. *Williams College Archives/Special Collections.*

area. The tow was 900 feet in length, similar to the lower tow, and expanded the vertical drop by an additional 200 feet to 450 feet. The slope on either side of the tow was farmland and already clear, so little cutting of trees and brush was necessary. In early March 1948, the ski jump was repaired in time for the first Winter Carnival since before the war.

While the new ski terrain was originally leased, it was purchased in August 1948 from Kenneth Ware. The new tow had received high marks the previous season, and skiers were enjoying the doubled size of Sheep Hill. A new part-time ski instructor, Albert Trudel of the Stony Ledge Ski Club, was brought in to teach lessons for the following season.

Progress and expansion continued, and plans were drawn up for an even better season for 1948–49 and to recapture more the prewar glory at Sheep Hill. The Winter Carnival would feature a torchlight ski parade along with the Eastern Junior Division Championship. And Parker would expand the new tow another 350 feet, expanding the vertical to 500 feet. Seventeen more acres of land were added to Sheep Hill near the upper tow, and a new warming hut was built at the base, along with revamped jumps and the addition of night skiing. When all was said and done, $5,000 were spent on the expansion. With good snowfall that year, up to five hundred skiers were on the slopes in February.

With the push for expansion, Williams College and Sheep Hill aimed to offer similar facilities to other major colleges with ski programs, like Dartmouth and Middlebury, and they certainly had requisite experienced staff. In 1949, John Jay, now the director of athletics at Williams, hired back James Parker—who had gained additional experience installing ski lifts in Westchester, New York; Westchester, Vermont; and Mount Rainier, Washington—to oversee the operation and management of Sheep Hill.

All of the efforts to improve the hill were much appreciated by the Williams community, and it shined for the 1950 Winter Carnival. Thirty-five jumpers took off from the recently rebuilt jump, which was now described as "one of the best" for a college ski area. Once again, students from eight major universities and colleges came out to participate in the carnival.

Sheep Hill would reach its pinnacle over the next few years. Yet another rope tow, this one for beginners, was installed on the lower slopes by Parker in late 1950, in order to provide a location for novices to practice. On the weekend of February 11–12, 1951, Sheep Hill saw its largest crowd of skiers to date—with one thousand enjoying the slopes.

After running the ski area since its 1947 rebirth, Williams College took a hiatus from late 1953 to 1955. The ski area was operated by the Rosenburgs.

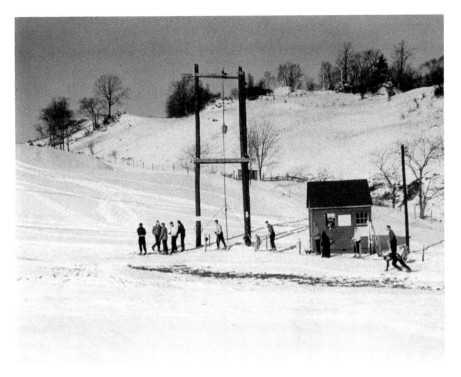

Skiers gather at the base of the rope tow in February 1950. Note the counterweights that were used to provide the right amount of tension for the rope. *Williams College Archives/ Special Collections.*

It is unclear exactly why Williams temporarily ended its relationship with Sheep Hill, but there had been several poor winters in a row in 1952 and 1953. And the Rosenburgs did not have much luck either—with poor snow conditions, Sheep Hill was only open for one week for the 1954–55 season. The upper ski tow was abandoned at this time, never to return, as the focus was shifted back toward the lower slopes, with that slope becoming rapidly grown in during the following years.

But in late 1955, Williams College retook management of the area, leasing it once again from the Rosenburgs. But the final five years of operation would not match those of the previous ones. Poor snow conditions became the norm, limiting operations. Winter Carnival events were now held on the Thunderbolt Trail and at Goodell Hollow, home of the Mount Greylock Ski Club, which usually had better snow.

Over its final few years, operations at Sheep Hill gradually wound down. The nearby Pine Cobble School did start using the area for its own meets, but

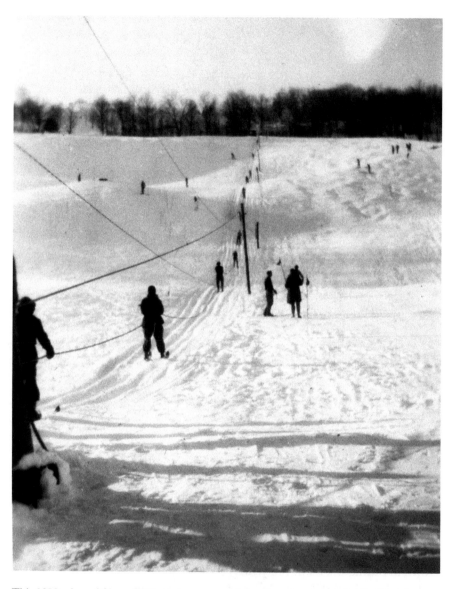

This 1950s view of Sheep Hill's main rope tow shows the steepness of the lift. Note the moguled terrain to the right and the location for the ski jump just to the left of the middle of the tow. Higher up on the ridge is the upper tow's slope—still visible, but abandoned. *John Hitchcock.*

collegiate competition was mostly done. It was still open to the public, with affordable rates of one dollar a day for adults and fifty cents for children, but with frequent poor snow conditions, skiers mostly stopped coming.

The final season at Sheep Hill was 1959–60. A search was made for a larger facility with better snow and a higher elevation. One such area was found on Berlin Mountain on the New York–Massachusetts border, located only five miles from campus. In January 1960, ski coach Ralph Townsend made an announcement that operations would end at Sheep Hill at the conclusion of the season, with the plans for development of Berlin Mountain finalized. The final event at Sheep Hill occurred on February 3, 1960, with a ski meet between Cobble Mountain and Berkshire Country Day School.

With Williams College ending at lease of Sheep Hill, the Rosenburgs continued to maintain the fields and farm for their own use. And since they continued to maintain the property, instead of allowing it to become reforested, it remained in an open state. In 1992, Arthur Rosenburg sought to make sure that his property would be preserved forever. He passed away in 1998, and two years later, Williamstown Rural Lands Foundation (WRLF) acquired the farm—preserving it forever for outdoor recreation and natural study. It became the foundation's headquarters and an environmental outdoor recreation center. This is a most favorable outcome for a lost ski area—instead of becoming developed or overgrown, Sheep Hill continues to be an active, vibrant place eighty years after its birth as a ski area.

In 2016, Sheep Hill nearly held some skiing and snow events as part of the Winter Carnival, but a complete lack of snowfall prevented this. Instead, students enjoyed a barbecue and outdoor games.

VISITING THE AREA

The Williamstown Rural Lands Foundation (www.wrlf.org) maintains an excellent series of hiking trails throughout the Sheep Hill property, making it one of the best lost ski areas to explore. In addition, views of the former ski area and of Mount Greylock can easily be obtained at both the base and summit with limited walking.

The property is located at 671 Cold Spring Road in Williamstown, at the headquarters of the WRLF. Parking is available at the farmhouse and interpretive center, where historical and natural exhibits are on display.

Stunning views of Mount Greylock still greet today's hikers and outdoor enthusiasts at Sheep Hill. The former ski jump was located near the birch tree in the middle of the slope, with the rope tow running through the foreground. *Author's collection.*

Throughout the year, many programs take advantage of the natural settings around Sheep Hill. There is a kiosk available with trail maps available for the property.

As you face the wide-open slope, begin on the Rosenburg Ramble trail, which heads north along the base of the former ski area. After a few hundred feet, walk to your left to a small cluster of trees on the flat section of the slope. You will notice several old telephone poles that were once part of the rope tow. Returning to the trail heading north, you will then notice a small pile of wood—this is all that is left of the former engine house for the tow.

From here, you can continue north along the Ramble, which climbs slowly for a quarter of a mile before turning south along the top of the hill, paralleling Bee Line Road. After another quarter of a mile, you'll be directly above the farmhouse as well as the former rope tow. There are no remnants of the top unload of this lift. Enjoy the expansive views of Mount Greylock from this point—a stone bench is available for resting.

Directly behind you, on Bee Line Road, the upper rope tow towers still remain standing. These are on private property, however. A keen eye may be able to spot them when there are no leaves on the trees. Note

that WRLF's Fitch Trail traverses part of the old grown-in slope, though it is now all forest. Directions for hiking this trail can be found on the foundation's website.

From here, you can continue along the Rosenburg Ramble, which arcs around the southern end of the property before heading back to the farmhouse, or head down the Meadow trail, which takes you down the former ski slope. If you take this route, two thirds of the way down you'll reach a few birch trees—this was the location of the jump. Continue down the trail back to your car.

Ralph J. Townsend Ski Area, Williams College Ski Area

Williamstown

1960–65 (No Lift Service), 1966–77 (Lift Service)

The Ralph J. Townsend Ski Area, also known as the Williams College Ski Area, was the last ski area to be developed by a major college or university in New England. It was unique in that its primary function was to be used by the Williams College Ski Team for practice as well as for Winter Carnivals, but the public could also use it if they wished. The slalom race slope was so steep that it was said to have no other rivals besides Tuckerman Ravine in New Hampshire. Its downhill trail and slalom slope had the most vertical drop of any college or university ski area in New England. Williams College would have been hard-pressed to find a more capable ski coach than Ralph Townsend. Townsend, originally from Lebanon, New Hampshire, was on the ski team at the University of New Hampshire in the early 1940s. During World War II, he served his country in the Tenth Mountain Division, K Company, Eighty-Seventh Regiment—and was seriously injured at a battle at Cimon della Piella, Italy. His injuries were so severe that he was subsequently awarded the Purple Heart for his bravery—but told he would never ski again. Undaunted, he returned to UNH, where he began competitive skiing again.

Townsend became a national champion in both 1947 and 1949—winning the Nordic Combined Championship. In 1948, he was a member of the U.S. Olympic Ski Team in St. Moritz. And in 1950, John Jay brought him on board as an assistant professor of physical education as well as the ski

team coach. He was actively involved with the Winter Olympics, serving as secretary of the Squaw Valley Olympic Games Committee in 1960, as well as serving on the 1964 committee. He was also the first coach to develop a Christmas break training camp for ski team members.

Throughout the 1950s, the Williams College ski team under Townsend had practiced at Sheep Hill, which was also used for the college's Winter Carnival. But a series of poor snow years in the mid- to late 1950s had led to the relocation of the carnival's jumping events to the Mount Greylock Ski Club Hill (Goodell Hollow) or the downhill on the Thunderbolt. Both had their drawbacks, as jumps at Goodell Hollow were limited to one hundred feet or less, while spectators could not view most of the downhill on the Thunderbolt. This led Townsend to consider other options for a better location, with a full-time search commencing in 1959.

Thankfully, Townsend did not have to look very far. Less than five miles to the west of Williams College is 2,818-foot Berlin Mountain, straddling the

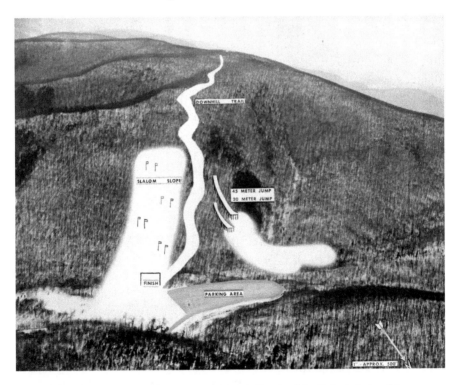

A ski area on Berlin Mountain was proposed in 1959 and originally included a slalom slope, downhill trail, two jumps and plenty of parking. Most of these plans came to fruition, except for lower portions of the downhill trail, which was connected instead to the top of the slalom slope. *Williams College Archives/Special Collections.*

New York–Massachusetts border. The summit is in New York State and is the highest peak outside of the Catskills and Adirondacks, but on its northeast flank on the Massachusetts side was a steep and cascading slope. The area was located near the terminus of Berlin Road, a narrow dirt road that was gradually becoming abandoned as farms disappeared along its western end. It would be possible to have a downhill trail and slalom slope here, with a vertical of 1,250—at the time, the highest drop for a major ski trail in Massachusetts outside of Mount Greylock. The slalom slope was extremely steep and described by ski writer John Hitchcock as "the most testing college carnival site in the east and no beginner's delight."

A portion of the northeast slope, including the area that was developed into a slalom slope, was owned by the Town of Williamstown. The upper portions of the mountain were owned by the Carmelite Fathers (who granted the college permission to develop a ski trail), and Williams College was able to purchase the area around the base of the mountain. In order to utilize the town land, Williams requested a lease from the Town of Williamstown.

Stipulations were required for the lease, including banning commercial development (at least initially), the college making repairs to the roadway and to allow the public to access the ski area at no cost, outside of any Winter Carnivals. By early January 1960, a verbal agreement for a thirty-year lease at one dollar a year was settled with the select board. Townsend estimated the cost to develop the slope and downhill trail to be $83,000, with no lift planned.

Despite the plans for a modest ski area with no lift, local residents were buzzing that a major resort was going to be built on Berlin Mountain, rumors that Townsend quickly put to rest. He did not rule out that one day a larger ski area could be built on the site but instead promoted Berlin Mountain as an excellent potential training site.

The final agreement to develop the Williams College Ski Area came on May 23, 1960, when the lease was signed by the town selectmen. The lease was quite detailed, and it took a half hour for it to be read out load during a board meeting. In addition to the earlier concessions, Williams agreed to grant a twenty-five-foot-wide right-of-way across its land for townspeople to access the slope. A future lift was not forbidden by the lease—but for the first several seasons, anybody who wished to race or jump would need to hike the slope to earn his or her turns.

Construction began in June 1960. The Northeast Wood Products Company of Pownal, Vermont, was hired to clear the trail and slope. Paul Ostrowsky, the manager in charge from the company, had previous experience clearing

ski trails at Wildcat in New Hampshire as well as Okemo and Sugarbush in Vermont. The downhill trail, with six turns, featured 700 feet of vertical drop and was cut at 50 feet in width. It fed into the slalom slope, which was much wider at 250 feet, with a vertical drop of 500 feet. It was cleared using modern standards of smoothing and grading and seeded to minimize erosion. Sel Hannah, who founded the Sno-Engineering firm, was hired as a consultant to the project to make sure that the ski area was built to the highest standard. When finished, the trail and slope were a combined 4,000-plus feet in length. Will Schmidt, who raced for Williams in the mid-1970s, described the upper section of the trail:

> *Some of the toughest sections were the "S" turn at the end of the downhill GS trail just before this trail joined the slalom slope. These had broad turns, steep variable pitches (including a super steep roll). This was probably the most challenging section of the slope given one came in at speed. Managing the section was tough, and then you had the entire slalom slope afterward to navigate.*

In addition to the ski trail and slope, two natural ski jumps were carved into the hillside just to the west of the slalom area. A smaller practice jump of twenty meters complemented the larger forty-five-meter jump that would be used in competitions, built to FIS (International Ski Federation) standards. Robert Deloye, an engineer from nearby Pittsfield, oversaw the creation of these jumps. Will Schmidt remembered that the

> *jumps were well liked on the circuit. They were all natural—no trestles needed except for a low-rise wooden platform at the lip/take-off. So they were perfect to the eye with a natural look, graceful slope, and wide run-out area. The landing area was a more modern, tempered steepness as opposed to jumps built earlier that tended to have a steeper landing area.*

By August 1960, the slope and trail were nearly finished. The setup was described as "modern and spotless," as well as the "steepest and best looking ski area in New England." Strong praise indeed, and it was true—a steeper slope was hard to find anywhere else. Townsend even needed to plan to include several control gates to reduce skier's speeds at the conclusion of the slalom slope. It was theorized that skiers could reach speeds of one hundred miles per hour otherwise. Unlike at many ski areas, this racing venue would feature a slope visible to nearly all spectators due to its straight down the fall

Construction progressed rapidly in the summer of 1960, and by August, the slalom slope was ready to be smoothed and graded. Its extreme steepness meant that bulldozers needed to be anchored, or else they would roll down the slope. *Williams College Archives/Special Collections.*

line nature. In order to ensure plenty of parking, a five-hundred-car lot was cleared just north of the ski area, with a path that led to the ski jumps just one hundred yards away.

As work continued into the fall months, a name for the slope was announced by Williams College: the Townsend Slope, in order to honor the coach. Throughout the rest of the ski area's operation, the complex was alternatively referred to as the Williams Ski Area as well as the Ralph J. Townsend Ski Area.

The inaugural season got off to a fast start, with deep snows covering the slopes by mid-December, allowing the ski team to begin practice. From December 17 to 19, 1960, the team practiced on the slalom slope as well as tested out the jumps. Ski team captain Tom Phillips and member Bruce Gagnier were the first to jump on the practice twenty-meter jump, with the forty-five meter tested shortly thereafter.

In the fall of 1960, construction crews finished grading the two natural ski jumps on Berlin Mountain. This was the forty-five-meter jump, with the shorter twenty-meter jump just out of view on the left. *Williams College Archives/Special Collections.*

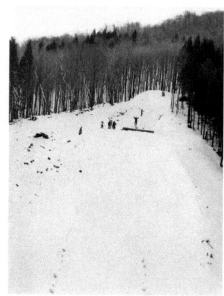

Left: The slalom slope at the Williams College Ski Area was named after Coach Ralph Townsend and was the steepest at any college or university ski area in New England. This image duplicates a well-known advertisement for Head Skis. *Williams College Archives/ Special Collections.*

Right: In this undated photo, ski team members test out the new forty-five-meter jump, likely in December 1960. Note that the jump is natural, carved into the hillside. *Williams College Archives/Special Collections.*

By all accounts, the first few seasons at the ski area went well, with the skiing events for Winter Carnival now secure in their new permanent location, including setting a record jump of 151 feet in 1961. However, the narrowness of Berlin Road, along with its frequent poor condition due to snow and ice, did result in cars often becoming stuck. By early 1963, a new traffic plan for Winter Carnivals was implemented, mandating cars use chains or snow tires, and for traffic to be one way on the road—inbounds allowed prior to the commencement of the day's events and outbounds only after the events concluded.

Major universities and colleges continued to be invited to partake in the Winter Carnival. In 1963, ninety students from ten schools competed in the twenty-second Winter Carnival—including Dartmouth, Harvard, University of Maine, Middlebury, University of New Hampshire, Norwich, St. Lawrence, University of Vermont, Williams and Yale. Competing for

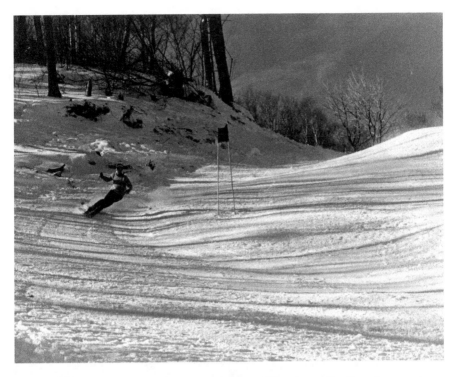

The downhill racing trail on Berlin Mountain was thrilling, descending from the summit and ending at the slalom slope at the base. Here, a racer negotiates a slalom gate through one of the trail's many banked turns in 1961. *Williams College Archives/Special Collections.*

Dartmouth was Dick Durrance Jr., the son of the famous Dick Durrance, who in 1935 was the first winner of the downhill on the Thunderbolt. A multi-feet snowstorm in late January required the slope and trail to be packed by students, including a bulldozer to smooth out the ten-foot drifts on the summit. Skiing would last until mid-April in 1963 due to this extensive snow cover.

Also in 1963, the Williams College Ski Area was considered for further development. Ski area engineer Sel Hannah produced a report stating that four mountains in the Northern Berkshires would be prime for development: Brodie Mountain, Saddle Ball on Mount Greylock, Berlin Mountain (Williams College Ski Area) and Spruce Mountain in Monroe. He theorized that the development of these four areas as lift-served ski areas would result in the area becoming more like the Laurentians north of Montreal, where numerous mid-sized ski areas were all in proximity. He

proposed that eleven thousand skiers could use all four ski areas on a busy weekend day, with all areas sharing tickets or package rates. The idea for large-scale development lingered into 1964 but was scrapped when it was discovered how much land would need to be purchased in New York State to have a successful expanded operation.

A major event was held on February 28–29, 1964, when the ski area hosted the EISA (Eastern Intercollegiate Ski Association) Championship. The snow surface was in perfect shape. John Clough won the downhill race, covering the course in 74.1 seconds.

Unfortunately, throughout the 1960s and 1970s, the ski area was a target for vandalism and illegal activities. Its somewhat remote location led to numerous parties and motorcycle gang activity. One such party in 1969 left the area strewn with over five hundred beer cans and someone taking the snow packer for a joyride to the summit, where it was abandoned. Cables by the ski jump were cut; railings were torn out and burned in a fire pit.

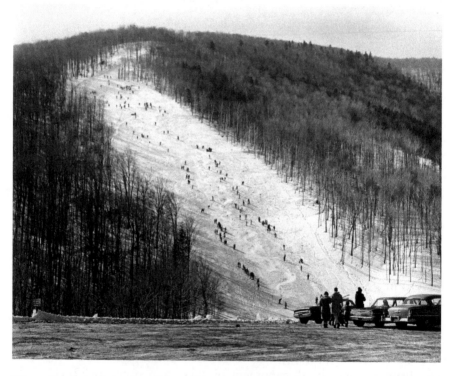

Winter Carnivals were major affairs and required student volunteers to help prepare the course. Here, students pack the slope as spectators begin to arrive at the 1964 Winter Carnival. *William H. Tague/Williams College Archives/Special Collections.*

Williams College used this Tucker Sno-Cat to help maintain a quality snow surface. Bertrand "Frenchie" Lavoie, the maintenance crew foreman at Williams College, often operated the vehicle. The Sno-Cat could only be driven down the slope and had to use a winding cat track to make it to the summit. *William H. Tague/Williams College Archives / Special Collections.*

In addition, items of value were stolen—such as gas cans, tools out of the maintenance garage—and windows smashed. Cars sometimes attempted to drive up the slope, causing ruts that resulted in erosion issues. Damage wasn't just limited to the warm season. In 1971, snowmobilers tore up the slopes and ruined the carefully packed snow on the jumps.

Some poor snow years did cause issues for the Winter Carnival, particularly in 1965. The snow cover throughout the region was as firm and hard as a rock due to a recent rain/freeze cycle. In the days before modern grooming, these cycles were disastrous for ski areas, and weeks could pass before trails were skiable once again.

The slalom race in 1965 had to be moved to Jiminy Peak, but the jumps were still held on Berlin Mountain. In order to create a useable surface, students hauled crusty snow out of the woods and onto the jumps. Due

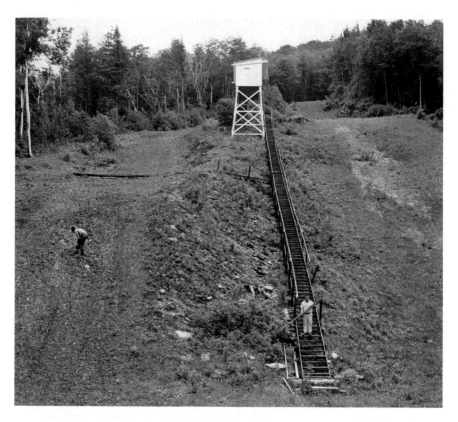

Coach Ralph Townsend (*right*) and maintenance crew foreman Bertrand "Frenchie" Lavoie survey the damage caused by vandals at the ski jumps in July 1969. Vandals used portions of the stairs as firewood, while motorcyclists gouged ruts in the slope. *William H. Tague/ Williams College Archives/Special Collections.*

to the extremely slick surface, students had to hold tightly onto a rope and "resembled mountain climbers."

Into 1966, the ski area was not lift served. But due to the steep nature of the slope, it was difficult for ski team members to make more than a few practice runs in a session. To solve this problem, Williams College installed a portable "Mighty-Mite" lift, which is a cable with plastic handles attached. Alumni David Close and John Jay donated the necessary funds for this lift. It first was in use for the 1966–67 season. This lift was only for the ski team— not available to the public—and went to the top of the slalom slope, the longest and steepest Mighty-Mite in New England.

During the rest of the late 1960s and early 1970s, Winter Carnivals continued with alternating numbers of other schools participating. In 1970,

only eight schools competed, but in 1975, thirteen were present. And in 1975, women competed for the first time. Local high schools also used the ski area from 1975 to 1977 for competition.

After twenty-two years of coaching the ski team, Townsend retired in 1972 but remained very active, managing the Williams Outing Club. Charles Hewitt took over coaching duties in 1972, followed by Robert "Bud" Fisher in 1974. The following year, 1975, Townsend received the highest honor for a skier, as he was inducted into the Ski Hall of Fame in Ishpeming, Michigan, where he will always be remembered and honored for his contributions to the sport.

Unfortunately, by the mid- to late 1970s, the end was near for the Ralph Townsend Ski Area. Without snowmaking and more modern lifts, the area was quickly becoming obsolete. A lack of snow resulted in the cancellation of carnival events in 1976. The final carnival was held on Berlin Mountain in 1979, and soon, the area fell silent. Bud Fisher remembered the difficulty of operating this steep and challenging ski area in its final years:

The downhill trail was very steep and had interesting S turns. But there were several problems. Events for the ski team were spread out between Savoy State Forest and Berlin Mountain, and equipment needed to be shared among them. Transporting and maintaining the equipment, such as the Tucker Sno-Cat, was time consuming. The slalom slope was so steep, the packers could not go directly up the slope, instead using a cat track that wound up to the top, before descending. Each pass took an hour to complete, and many passes were needed to sufficiently pack the slope. Between rolling the slalom slope, packing the ski jump and grooming the cross-country trails at Savoy, it just became too much to handle. Expanding the Ralph Townsend Ski Area into a modern ski area with a chairlift, snowmaking and additional trails was well out of the budget. Instead, we were invited to move the Ponylift (Mighty-Mite) to nearby Brodie Mountain, where it was relocated on Mickie's Chute, and ski jumping was discontinued. The cross-country ski program was also relocated to a new Nordic center across the street from Brodie.

Moving the program to Brodie had other benefits, as it allowed the ski team to focus more on training instead of maintenance of its own ski area. Team members continued to practice at Brodie for a few more decades. Ralph Townsend passed away in 1988 and is buried in the college cemetery.

While the ski area was abandoned, the open slalom slope has remained mostly clear to this day, as has the downhill trail closer to the summit. The

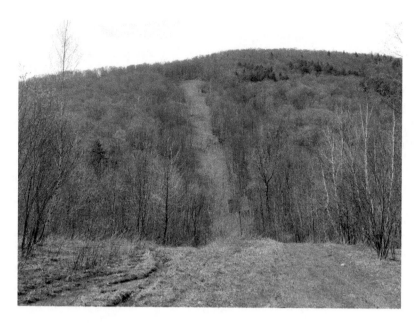

The steep Ralph Townsend Slalom Slope remains fairly clear and open to this day and serves as a testament to the well-liked ski coach. Telemark skiers continue to enjoy the slope when sufficient snowpack is available. *Author's collection.*

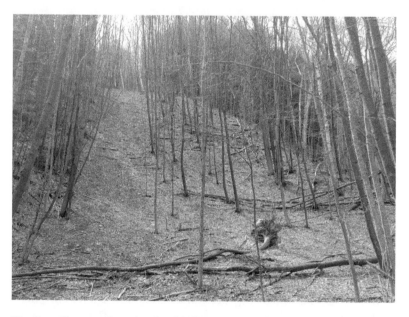

The forty-five-meter jump landing is still visible at the Ralph J. Townsend Ski Area, just to the west of the slalom slope. Its once wide-open landing is now filled with trees. *Author's collection.*

former ski jumps have not fared as well and are now overgrown. A casual hiker passing them would likely not even notice their existence, but a trained eye can spot them in the woods just west of the slalom slope.

Williams College continues to host Winter Carnivals to this day, though on an every-other-year basis. The last consecutive carnival was held in 2008, but it is now held in even years. Events are held at Berkshire East and Jiminy Peak.

VISITING THE AREA

There is a fair amount to see at the former Ralph Townsend Ski Area, with a visit lasting anywhere from thirty minutes if you explore just the base of the slope and jumps to a full day of activity if you hike to the summit.

The ski area is located at the end of Berlin Road in Williamstown. Heading one third of a mile west of the junction of Route 2 and Route 7, turn left onto Berlin Road. Follow the road for two and a half miles until you reach the end, where a parking area can be found. The last half of the road is dirt and can be muddy in spring. Note that this area is frequented by hunters, so be sure to take precautions and wear bright colors during hunting season.

The former ski slope is clearly visible just south of the parking area and is quite steep. Walk toward the bottom of the slope and then look up—and imagine all of the races that used to take place here. To explore the jumps, follow a woods road to the right for about eight hundred feet. You'll pass by both former ski jumps on the left. These are heavily grown in, but you can just make out the landing for both jumps, with the forty-five-meter jump farthest to the west. Hiking up the former ski jumps would be rather difficult due to the steepness and their overgrown condition.

Returning back to the base of the slope, you can either return to your car or hike up to the top of the slope. Although a short climb of just a fifth of a mile, it is unrelentingly steep, climbing five hundred feet in this short distance. You can continue climbing to the top of the race trail, which is another three thousand feet of hiking, climbing eight hundred more vertical feet. Return the same way you hiked to the summit.

RESORTS AND MAJOR SKI AREAS

The Berkshires were long known to be a summer resort—with many wealthy and famous people owning summer "cottages" with dozens of rooms on a sprawling estate. But it was mostly not until the 1940s that all-inclusive or destination resorts featured their own ski areas. The exception is the Jug End Barn, which began operations prior to World War II as a private club. Eight ski resorts and major ski areas formerly operated across the Berkshires, many with long histories. In addition, the G-Bar-S Ranch, described in the first section, "Snow Train Destinations," can also be considered a resort.

The benefits to having a ski area at a resort were numerous. Guests could easily leave their rooms in the morning, enjoy a hearty breakfast and be out on the slopes all day without having to drive anywhere. By remaining at a resort, skiers were also more apt to spend their money there instead of elsewhere, from ski lessons to meals. Accommodations varied from bunkrooms to standard motel rooms to suites and accommodated all budgets. Many activities were geared toward young people and singles and had quite the social atmosphere.

Eastover, Jug End Barn and Oak n' Spruce were the best known of the resorts and featured smaller ski areas but some major lifts like Jug End's T-bar and Eastover's chairlift. Smaller inns like the Avaloch and Marlboro Manor had their own small ski areas. Leisure Lee's was a private development for homeowners and only operated for a few seasons. Greylock Glen was a massive planned resort with a medium-sized ski area that was almost finished before developers ran out of money.

The largest and most well-known ski area to close was Brodie Mountain, which closed for skiing in 2002 and for tubing in 2007. This area was enjoyed by countless skiers and also pioneered many firsts in the ski industry, including the most vertical served by snowmaking and night skiing and the

development of a hard-pack snow pulverizer that could turn icy slopes into a skiable surface. Brodie was an area that will never be forgotten by those who patronized it for decades.

Avaloch Inn

Lenox

1960–CIRCA 1970

Prior to 1960, the Avaloch Inn in Lee was known only for its summer lodging and was shuttered during the winter. It was located directly across the street from the Tanglewood music venue, and many patrons would stay at the inn for concerts. But with the growth and success of other resorts like Eastover and Oak n' Spruce, its year-round potential was soon realized.

In 1959, Michael Bakwin—at twenty-six years old, the youngest owner of any resort in the Berkshires—purchased the Avaloch Inn. He immediately set out to renovate the guest rooms and modernize the dining facilities. He wanted to ensure a year-round source of income, and made immediate plans to add a ski area directly north of the main inn on Bald Mountain.

Beginning on September 1, 1960, work on the ski area commenced. To begin, three ski trails were cleared. Trail No. 1 was located directly behind the West House and was six hundred feet in length, geared toward beginners and lower intermediates. Trail No. 2 was built to the same length but was narrower and catered to more intermediate level skiers. Finally, Trail No. 3, at one thousand feet in length, was for the experts. A seven-hundred-foot-long rope tow was installed between Trails No. 2 and No. 3. A new manager, David Green, was hired to operate the ski area.

Bakwin built the ski area to accommodate approximately one hundred skiers per day, guests as well as the general public. A former greenhouse at the foot of the ski area was converted into a snack bar, and a small skating

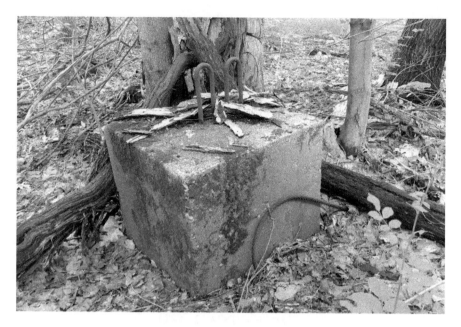

While a few trails are recognizable in spots, the main remnant left of the Avaloch Inn's Ski Area is this cement counterweight at the former unload station of the T-bar. It has been abandoned for almost fifty years. *Author's collection.*

rink was created next to the ski area. Tobogganing and sleigh rides would also be a feature at the area.

The rope tow was brought to life on December 30, 1960, with Green "delighted at the performance of the tow." Ticket prices were set at $1.50 for adults, and many guests enjoyed the slopes for the subsequent New Years holiday.

Although the Avaloch Ski Area was open to the public, guests were the primary patrons over the following seasons. Interest in the area remained strong, and in 1965, major upgrades were implemented. A new T-bar, 850 feet in length, was constructed alongside the rope tow to boost lift capacity as well as provide easier access to the summit. The vertical drop was increased slightly to 150 feet, and ticket prices soon rose to $3.00 for the T-bar and $1.75 for the rope tow. Two new trails were cleared from the top of the T-bar. The Avaloch advertised that after skiing, guests could "Sit by huge fireplaces…Relax with new friends…Sip warm drinks…Enjoy fine food… at reasonable prices."

But despite these fine attributes, the inn fell on hard times in the late 1960s, and on February 4, 1970, the entire property was sold for $125,000

to Richard Wieler. It is believed that the ski area folded at that time and the lift was removed, although its final destination or if it was scrapped remains a mystery.

The Avaloch was then sold, in 1976, to Alice Brock—made famous in the Arlo Guthrie song "Alice's Restaurant." Brock moved her restaurant to the Avaloch, where it remained quite popular for some time.

Today, the Avaloch remains in operation year round but under a new name: the Apple Tree Inn. For more information on the Apple Tree Inn and its history, please visit www.appletree-inn.com.

VISITING THE AREA

The former Avaloch Ski Area is located just north of the guest parking lot for the Main House. However, note that the grounds are for guests only and that the ski area is mostly overgrown, though a few trail sections are still somewhat clear. The T-bar and rope tow have been removed.

Brodie Mountain, Kelly's Irish Alps, Snowy Owl

New Ashford

1964–2002 (Brodie for Skiing), 2002–7 (Snowy Owl Tubing)

A much-beloved and pioneering ski area, Brodie Mountain was the largest to permanently close in the Berkshires. Countless skiers and snowboarders enjoyed its terrain for almost forty years, and the area evokes strong and positive memories for them to this day. It was a ski area integral to so many skiers' enjoyment of the sport—whether they learned at the area, skied it with their friends from school, took their families there on vacation or were employed in its operation. It was a ski area that few will forget.

Two ski areas preceded Brodie Mountain on the same mountain in the 1930s: Brodie Mountain Ski Trails and Brodie Mountain Sports Center, whose history can be read in the section "Pre–World War II Private Enterprises." Skiing at Brodie stopped at the Ski Trails in 1948, and only a small portion of the Sports Center trails were later incorporated into the Irish Stew slope at Brodie Mountain.

The mid-1960s was a prime time for the growth in Berkshire ski areas as the growth in the number of skiers was accelerating due to the baby boomers. New ski areas such as Butternut were opening up, while more senior ski areas like Bousquet, Jiminy Peak and Catamount were adding chairlifts and expanding snowmaking. In addition, there were movements to build a ski area on Mount Greylock and Saddle Ball.

With all of the new skiing possibilities and expansions, locations for additional ski areas were investigated. In a report from 1964, the firm Technical Planning Associates identified Brodie Mountain as a prime potential area. With good access directly off Route 7, a substantial vertical drop, consistently pitched slopes and a high elevation, Brodie had the best chance becoming a successful resort.

Seizing on the opportunity, James "Jim" Kelly and his father, John Kelly, of the Kelly Lumber Company of Pittsfield, purchased seven hundred acres of land on Brodie for $20,000 in February 1964. Previously, the Kellys had sold four hundred acres of property at the base of Killington's resort for $10,000, which helped sow their interest in ski area development. They hired Sel Hannah, the well-regarded ski area designer, to map out ambitious plans for a resort. The trails were designed in a way to minimize wind exposure, and with the slopes facing east, they were generally well protected from the prevailing winds. Plans for the future resort were announced to the public in June 1964, and the venture was officially incorporated as the Brodie Mountain Ski Club Inc. in August 1964. In addition to operating the lumber business, the Kellys also owned apartment buildings, liquor stores and restaurants throughout the surrounding area.

Development at the mountain progressed rapidly. The Kelly Lumber Company was well suited to clear the ski trails—after all, it had years of experience harvesting lumber in the region. A team of eighteen employees started clearing the slopes in April and progressed rapidly through the summer. A total of six trails and glades were prepared for the upcoming season, and they were soon cleared of rocks and graded. To serve these trails, two lifts were installed: a four-thousand-foot-long Stadeli double chair (called Gramp's, Jim Kelly's nickname) that would terminate near the summit and serve three trails, and a seven-hundred-foot long T-bar that would access the beginner slope. Three other rope tows were spread along the lower slopes to be used by beginners.

By the middle of September 1964, the ski area was nearing completion. The towers for the Stadeli chairlift had been erected and would have cabling installed by the end of the month. Lights for night skiing were being installed, which would give Brodie the most vertical drop served by night skiing in New England. The ski trails were now named: the over one-and-a-half-mile-long novice Paddy's Promenade, the intermediate Shamrock and the expert Kelly's Leap. The beginner slope was named Irish Stew, and the two glades were called Gilhooley's and Shamrock.

To serve skiers, a three-story $200,000 lodge was designed by architect William M. Kirby and built during the fall and summer. It featured a stone chimney with fireplaces on two floors. A gourmet restaurant called the Blarney Room would occupy to the top floor, and it was the first restaurant of its kind in Massachusetts to get a liquor permit. The Massachusetts Liquor Authority had never issued a liquor permit to a ski area—and it ruled that patrons would need to be member of a private club to imbibe. Thus, the Brodie Mountain Club was initiated for the first season to satisfy this rule, which gave members access to the restaurant and bar for just five dollars a year. The rule was changed in future years, and adult beverages were then available in the Leprechaun Lounge and Kelly's Irish Pub in future seasons.

In early December 1964, the final touches to Brodie were rushed to completion. On December 10, a special preview of the mountain was held to dignitaries, including ski legend Toni Matt and Governor Nelson Rockefeller, along with representatives from other nearby ski areas. To celebrate, a torchlight parade that evening dazzled the dignitaries. The excitement was building for the official opening on the twelfth.

And what an opening it was—an estimated ten thousand people visited Brodie on that first weekend open house. The skiing was free and greatly impressed all who visited. Representatives from each department, including ski school director Don Valenti, ski patrol director Jack Haspellen and ski shop manager Bill Murthey, held an open house to orient skiers to the features of the resort. There was just one problem—the trails were nearly snowless. It would take until late December for there to be enough snow to open.

Once it did open, the new chairlift was a bit of a challenge to ride for most of the skiers. Chairlifts were still quite rare at that time in the Berkshires, with most skiers having only used rope tows or T-bars, so few were adept at loading it. Bob Blair, just seventeen years old and the upper lift attendant on the first day, kept noticing the lift was starting and stopping frequently. Another employee, a foreman who worked for the sawmill, took a snowmobile up to the top of the lift. He asked Blair if he would be comfortable loading the lift at the base. Blair accepted, took the snowmobile to the base, replaced that attendant and solved the loading issues.

Snowfall remained sparse through the new year but finally arrived in early January. Employees occasionally took trucks down to Pittsfield to load them up full of snow from parking lots, dumped the snow on the slopes, and proceeded to spread the snow out so that some terrain would be available. By February, the ski area was offering access on the old one-and-a-half-mile-long Brodie Mountain Trail from the summit—but as its terminus was well

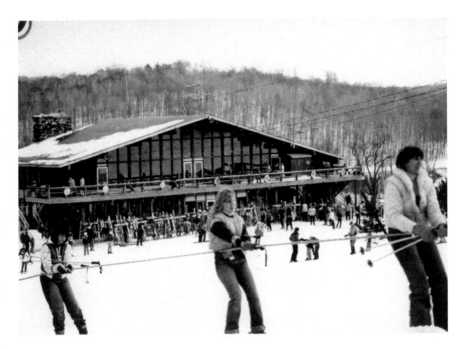

Designed by William Kirby, Brodie's base lodge was the focal point of the ski area. The Blarney Room was the restaurant and bar on the second floor, and it featured a deck overlooking the slopes. A cafeteria and Kelly's Irish Pub were located on the first floor. Here, skiers ride one of the novice tows in front of the lodge. *New England Ski Museum*/Skiing Magazine *Collection*.

south of the ski area, shuttle buses would be needed to return skiers to the base lodge. This arrangement did not last long due to the shuttling logistics.

Steve Murthey, whose father, Bill Murthey, ran the ski shop, shared his experience of skiing at Brodie during that first season:

My dad, Bill Murthey, ran the ski shop at Brodie during the first year of operation, maybe two. I remember standing in the mud in my galoshes, watching bulldozers knock down trees just above where the base lodge would be. The only building then was the small A-frame that became the ski patrol building for the first few years. It was 1964. I was six.

When not in school, I was the first person on the slopes, standing there waiting for the T-bar to open. I used to build a jump right by the T-bar lift line and fling myself off it to the delight of folks waiting in line—always trying to get more applause—at least until the ski patrol guys would wipe it out. During the break between day and night skiing (yes, they actually used

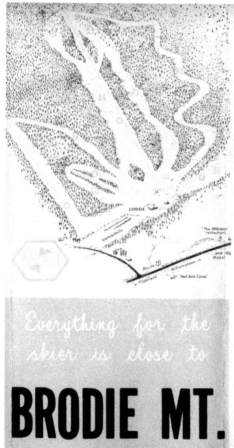

1. Shamrock Trail (Intermediate)
2. Kelly's Leap. (Expert)
3. Paddy's Promenade. (Novice)
4. Gilhooley's Glade. (Expert)
5. Shamrock Glade. ((Intermediate)
6. Harp's Hump. (Novice –Intermediate)
7. Mickey Finn (Proposed Intermediate)
8. Irish Stew. (Beginner)

LIFTS

A. Double Chair Lift C. Beginners' Rope Tow
 (4000 ft)
B. T-Bar (700ft) D. Proposed T–Bar
 (2500 ft)

Brodie Mountain Ski Area Operates Daily and 4 Nights a Week Wednesday–Saturday, 7–11

• • •

Don Valenti Ski School

Our friendly ski school instructors are carefully trained to explain ski technique, demonstrate each maneuver step by step, and analyze your skiing problems. Why struggle on your own when a few lessons can help you so much in reaching the goal of accomplished skiing? For faster progress, greater enjoyment, and maximum safety, we recommend you enroll in our ski school classes

Ski School Director Don Valenti is a certified member of the Canadian Ski Instructors' Alliance.

• • •

Everything for the skier is close to

BRODIE MT.

Yes, We have a Nursery

Located on the bottom level of the base lodge, the nursery is open daily. Parents, don't stay home for lack of a sitter. Relax on Brodie's trails, knowing your children are well cared for by our nursery staff.

Brodie's first trail map shows the resort in its infancy. The 4,000-foot double chairlift served three trails and two glades, while two other novice areas were accessed with a rope tow and T-bar. A proposed 2,500-foot-long T-bar, shown here as a "D," was never installed. Also note the details for Don Valenti Ski School. *Author's collection.*

to shut down for a bit), me and the Kelly kids would take the cafeteria trays out on the hill to kill time.

 Most of my lunch money allotment went into the jukebox. I remember Jim Kelly asking me not to keep playing "California Dreamin'" and "Day Tripper" over and over again because he was getting complaints. After we closed the ski shop at the end of night, I'd head up to the third floor with my parents (yes, at that young age) to listen to the bands and marvel at everybody having such a great time.

Since it was an Irish-themed ski area, celebrating St. Patrick's Day would become one of Brodie's best known attributes. The Brodie Mountain Cup was inaugurated on March 17 and would become an annual event that would last decades. If your last name was Kelly, you could ski for free. On the holiday, Brodie celebrated further by hosting Wexford, Ireland's mayor Kevin Morris to a special corned beef and cabbage dinner in the Blarney Room. The snow was dyed green to celebrate the day. These traditions continued for decades, with the bar serving up green beer and Kelly's Special Irish Coffee.

Brodie's first season concluded on April 4, 1965. Plans were immediately set in motion for further improvements for the 1965–66 season. Wanting to ensure adequate snow depths, Brodie contracted with Larchmont Engineering to install snowmaking on seven miles of terrain, from top to bottom, at a cost of $120,000. The Kellys had seen the benefit of a large snowmaking system in action at Mount Tom, which was able to weather a poor snow year just fine. More trails were cleared in the summer of 1965, including Ryan's Express, Clover and JFK, named in honor of the fallen president. A future lift line to the summit in anticipation of even more growth was cleared. Summer and fall activities, including a beer garden and foliage rides, were added to the resort's offering.

To satisfy a need for lodging, a new ski area motel was built above the snowmaking equipment. The six rooms would only be open when the snowmaking system was not in operation due to the noise and vibrations, but otherwise, the motel gave the ski area its first slope-side lodging. In February 1966, the famous broadcaster Lowell Thomas stayed in the motel while skiing at Brodie.

Brodie opened for its second season on December 10, 1965, and became the first Berkshire area to do so. In fact, Brodie would become well known for its early openings—opening as early as October 20 in 1969 and 1972, often competing with nearby rival Jiminy Peak. These were thanks to one of the world's largest snowmaking systems, which was a must due to New England's variable weather.

Not to rest on its laurels, Brodie continued to expand in the late 1960s. For the 1966–67 season, Mickie's Chute and Glade opened. From the top of Gramp's Chair, a new 2,00-foot-long Poma-brand T-bar to the actual summit was built for the 1967–68 season, boosting the ski area's vertical to over 1,200 feet. The JFK Trail was extended to the summit and was now two miles long and one of the most popular trails. Night skiing was added on more trails, with Shamrock now lighted from top to bottom.

The Kellys' dream of adding a base-to-summit chairlift was met in 1968, when the 6,000-foot-long Dot's Double Chairlift was erected. Named in honor of Jim's wife, this Borvig-brand chairlift accessed the mountain's full 1,250 feet of vertical, with even more trails added to the summit. While blasting the summit for the chairlift's counterweight, Jim Kelly noticed an exposed ledge that shone brightly in the morning sun—just like gold would. He called in an expert who said he could determine in a few minutes if it was gold or pyrite. He performed a test that incorrectly showed it was gold—sparking off a two-week gold rush with hordes of excited amateur prospectors showing up to see if they could find any themselves. Kelly noted that it started to become an untenable situation, and they were ready to call the police to handle the huge crowds that were showing up. A few weeks later, additional tests showed that it was mostly pyrite—and the prospectors soon left.

To round out the 1960s, Brodie was chosen to be the filming location for a new movie starring Johnny Cash. Named *The Trail of Tears* and produced by National Educational Television, the film tells the story of the forced relocation of sixteen thousand Cherokees from Georgia and North Carolina to Oklahoma. The producer was from the Pittsfield area and sought out the slopes of Brodie to film some of the scenes. The actors, film crew and Cash all stayed at Brodie Mountain wherever there was space—from the garage to the Dublin Motel. Recalling the visit, Jim Kelly said that he wrote a song in honor of Cash, while his wife, Dot, wrote the music. When they presented Cash with the song, the singer remarked that he would have loved to sing it for them—but that he didn't read sheet music—so the three of them hummed the song instead.

Sadly, family patriarch John Kelly passed away in 1970 and left the ski area to his son Jim, who would own it until 2002. Jim would later bring two of his five sons into management, including Matt and Douglas, making this a true family-operated resort.

The original novice T-bar was replaced for the 1970–71 season with a new Borvig chairlift. The lift, named Matt's Chair after Matt Kelly, had a vertical drop of two hundred feet and resulted in an overall larger novice area.

In the early 1970s, Jim Kelly designed a patented hard-pack snow pulverizer, which helped grind up ice and turn it into useable skiing surface, and sold the invention to other ski areas. According to Kelly, the invention was a game changer for New England skiing, as icy surfaces were a frequent occurrence and the device produced a suitable snowpack. John

Delorean (who later formed the Delorean Motor Company) built a rival device—based partially on Kelly's design—in the late 1970s. Delorean had recently purchased Thiokol, a firm that built Sno-Cat machines and groomers. Kelly met with Delorean about ceasing his infringement, but Delorean refused—Kelly decided to pass on pursuing further litigation, as his patent was expiring shortly anyways.

Seizing upon the burgeoning cross-country ski area development in the early 1970s, Brodie soon had its own area. Located just down the street across from Route 7, the center featured trails designed by Williams ski coach Bud Fisher, with its first season offering eight kilometers of trails. In the following years, the center expanded to include twenty-five kilometers of terrain.

All the snowmaking improvements, along with copious natural snowfalls, led to some of the longest ski seasons in Berkshire history in the early 1970s. For the 1969–70 season, Brodie was open for an astounding 159 days, with 138 days for 1970–71, closing on April 14 that year.

In the early 1970s, Brodie was at the forefront of the emerging freestyle skiing scene. Inspired by Peter Pinkham's masters program at Attitash, coach Jack Kirby (whose brother William had designed the base lodge) and Al Cassidy started their own program at Brodie. They taught youth various ski and freestyle techniques, including aerial skiing and spread eagles, and the team put on a display in front of the lodge. Before long, a high number of ski areas across the country had their own freestyle programs. Kirby's son John, who started his freestyle career at Brodie, was on the U.S. Freestyle Skiing Team from 1977 to 1980 and was the U.S. National Champion in 1977.

Moving into the mid-1970s, Brodie continued to innovate with the times. In 1974, it opened up the only full-time kite skiing school in the East. Hang gliding demonstrations were performed by Doug Weeks, who managed the rental shop. Trails were continually improved, either widened or smoothed, along with large investments in snowmaking.

Many well-known families and celebrities patronized Brodie in the 1970s. In February 1975, the Kennedy family, including Ted and JFK Jr. (who was honored to ski on the trail named after his father) enjoyed the slopes during a weekend. J.D. O'Connell was there when the Kennedys were skiing:

In 1975, Senator Ted Kennedy took his family on a ski tour of Massachusetts. This was soon after his son, Teddy, had his leg amputated. He had lost his leg but was back on skis that winter. Seeing how he beat cancer and was back skiing was an inspiration to people around the country.

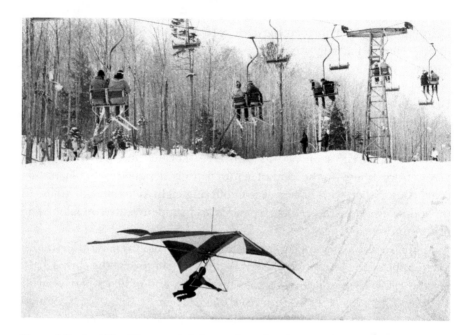

Hang gliding and kite skiing were briefly popular at Brodie in the 1970s. Here, Doug Weeks lands on the Shamrock Trail next to Gramp's Chair. *New England Ski Museum/*Skiing Magazine *Collection.*

My family was lucky enough to be invited to ski with the Kennedy entourage, which included the Senator, his kids, Teddy, Patrick and their sister and a fifteen-year-old John Kennedy, Jr! Plus a ton of security and Secret Service personnel.

The Senator led the entourage and the first run they skied—the JFK trail. Jim Kelly, Brodie's owner, and his kids skied with the Senator—I sort of trailed behind. There were so many people on the ski tour by the time I got off the lift, they would be halfway down the trail.

I have to tell you, Senator Kennedy was a fast skier. On one run, I skied ahead, hoping to catch a glimpse of him and the family—that guy just blew by me like I was stopped. Young Teddy skiing on one leg was also incredibly fast.

After a morning of skiing, the group had lunch in the Blarney Room. My dad brought me up so I could at least get a look at the Senator. I remember seeing him eating lunch with his kids laughing just like any ordinary family enjoying a day of skiing. Brodie Mountain was such a unique and fun place to ski and have fun. I truly miss that place.

Brodie's reputation for making large quantities of snow was so well known, the snowmaking team was contracted out by NBC to make snow for a made-for-TV movie in 1977. *Snowbound* features the story of a couple who become stranded on the Mass Pike in a raging snowstorm—all produced by Brodie's snowmaking equipment, temporarily moved to the filming location.

That same year, Brodie installed the last of its major lifts, the 4,500-foot-long Andy's Chair, situated between Gramp's and Dot's. This boosted the overall uphill capacity to a respectable four thousand skiers per hour. For 1980, plans were made for yet another lift on the north side of the mountain but never came to fruition.

The time frame from the mid- to late 1970s and early 1980s was quite difficult on many Berkshire ski areas. Gasoline shortages proved problematic, as skiers were not sure they would have enough to make it home. Inflation was high and competition with larger ski areas to the north was increasing. To combat high energy costs, Brodie installed a windmill at the summit. A

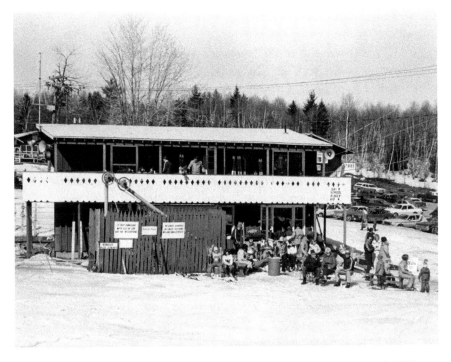

At the base of Gramp's Chair, one could find the Ski School (*upstairs*) and First Aid/Ski Patrol (*downstairs*). A beginner's rope tow was directly next to the building. *New England Ski Museum/*Skiing Magazine *Collection.*

precursor to today's wind turbines—like those found at ski areas like Jiminy Peak—the windmill was not entirely successful, as it was not as robust as today's turbines. But it was thirty years ahead of its time. It only lasted a few years before becoming damaged due to high winds. The winters between 1979 and 1981 were nearly snowless, but Brodie's snowmaking equipment did provide for some skiing.

Throughout the 1980s, although there were no major expansions of terrain or lifts at the ski area, Brodie continued to be one of the most popular ski areas throughout the Berkshires. Its reputation as the place to ski on St. Patrick's Day remained strong. It continued to host pro races, beer leagues and the Bay State games. Williams College moved its ski racing program to Brodie in the early 1980s due to growing issues with its Ralph Townsend Ski Area. Using Mickie's Chute, the Williams College race team honed its skills on a slope with plenty of snowmaking and night skiing.

As the 1990s approached, Brodie remained a popular resort for families. Dan Xeller, who learned to ski at Brodie and later became a snowboarding instructor, fondly remembers what it was like to ski at Brodie as a kid in the 1990s:

> My first memories of Brodie Mountain began when I was nine years old, and my parents joined our local ski group (Delmar, New York) that met there. This was back in 1990, and my whole family (mom, dad, sister) joined the likes of co-workers and friends and family at the mountain for skiing lessons. Our group nights were Saturdays for ten weeks, but we would also go on Friday nights if we were good. My first impression of Brodie was the lodge and how cavernous it was. Huge, dark wooden pillars and beams complemented by giant tables of the same material spread around an enormous stone fireplace. This is what ski lodges should be modeled after. This lodge emanated a welcoming feeling, and whether coming in from the cold or just relaxing with a book on the huge couch in front of the fire, comfort was its sole purpose. Our ski lessons were always fun—after the embarrassment of having to go down the bunny hill in front of everyone for group placement had passed. I actually learned to ski quite well in the four years of lessons. Embarrassment was only limited to the lessons and was completely absent once St. Patrick's Day (or the Irish Olympics) rolled around.
>
> This ten days of madness and mayhem were what we waited for every year as kids and, eventually, as adults. Cafeteria tray races, green snow, green beer, three-legged races, leprechauns, bagpipes and happiness made our March

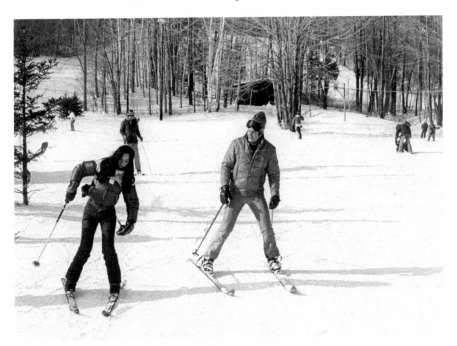

Brodie Mountain Ski School was top-notch and taught countless skiers the sport over many decades. Here, a beginner receives a lesson on the Leprechaun's University slope, served by its own rope tow. *New England Ski Museum*/Skiing Magazine *Collection.*

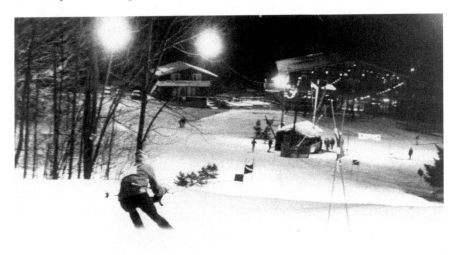

Night racing leagues at Brodie gave skiers a chance to have fun and fine-tune their skills, often on a weeknight after work. *New England Ski Museum*/Skiing Magazine *Collection.*

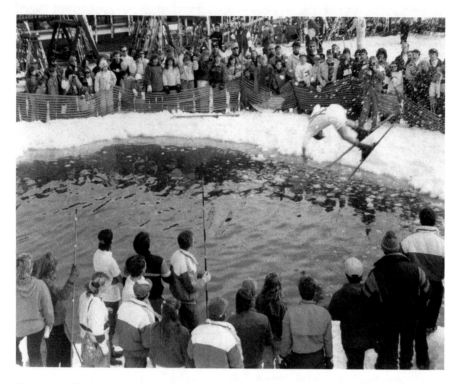

The annual Slush Jump was held at Brodie for St. Patrick's Day, with skiers performing aerial maneuvers and landing in a pool of frigid water. Hundreds of spectators annually watched the event. *John Hitchcock.*

at the mountain. The one event that we could not miss was the Slush Jump in which you went as fast as you could, looking as ridiculous as possible, down Harp's Hump and off a huge jump into a pond of freezing water and slush. What did you get for your spoils? A T-shirt that said "I survived St. Patrick's at Brodie Mountain." I am the proud owner of one after a pitiful hop off the jump in 1997 that I'm still hounded 'bout to this day.

Snowboarding grew throughout the 1990s at Brodie, adding to the resort's business. Dan Xeller described being a snowboard instructor in the late 1990s:

I had an absolute blast as a snowboard instructor. My buddy Andy Gutman signed on as a ski instructor, and we got free season passes as a result and worked insane hours at the mountain to feed our passion.

*Teaching others came natural to us, and we soon worked our way up the pay
ladder. The season of 1997–98, Andy and I got certified through PSIA*
[Professional Ski Instructors of America] *and gained some respect
through our peers. By this time, we had made a ton of friends and called
Brodie home due to the fact that we spent every free minute there. At the end
of the day, everyone at Brodie was family. From the ski/snowboard school,
the rental shop, the kitchen/bar staff and the lift operators. No one was
above or below someone else, and we all looked out for each other.*

Entering the digital age in 1997, Brodie became one of only two lost ski
areas in the Berkshires (the other was Eastover) to have its own website. The
website was www.skibrodie.com (which later became www.brodiemountain.
com), and it can still be visited at www.archive.org. For the 1997–98 season,
Brodie added four new trails and glades: Wexford, Galway, Finnegan's and
Mary's Garden. The trails—now forty—were all renumbered.

Major changes came to Brodie in its final season. In 1999, Jiminy Peak
purchased Brodie, with the intentions of building a $60 million resort.
This resort would include over three hundred condos, a water park, retail
establishments and restaurants. The ski area would be an integral part of
the resort, with the potential for a high-speed quad if enough passes could
be sold.

As part of the changes, a new snow tubing park was built on Harp's
Hump, served by its own lift, a magic carpet. A combination ski ticket with
Jiminy Peak was now available, an option the author took advantage of in
2001 when he skied both areas in one day.

Unfortunately, the deal to build the resort fell through; ticket sales
were falling, and revenue was decreasing. Jiminy Peak then sold Brodie to
Silverleaf Resorts and leased back the snow tubing operation, which utilized
Matt's Chair. Silverleaf still planned on building a time-share resort, but
that was not to be. As a clause in the purchase agreement, it was not allowed
to operate a public ski area (though a private own would be permissible).
The tubing park closed at the end of 2006–7, and Brodie Mountain, the
much-beloved ski area, was permanently closed.

After selling Brodie, Jim Kelly turned his attention to another
of his passions—golf—and built the Donnybrook Country Club
(www.donnybrookgolf.com) on a farm just to the south of the Brodie
Mountain Ski Area, overlooking the surrounding mountains. Many
employees at Donnybrook formerly worked at Brodie, and the country club
continues to celebrate the Irish heritage that was such a part of the ski area.

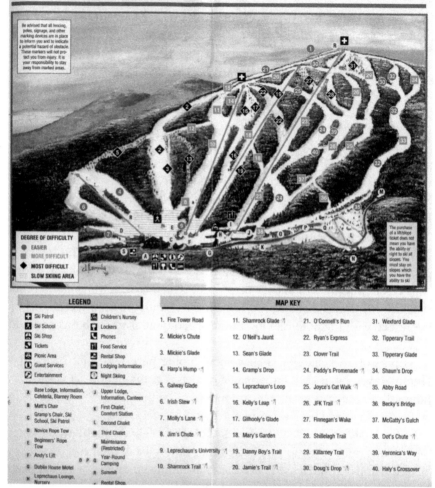

This Brodie's trail map from the late 1990s shows the ski area as it was just before being purchased by Jiminy Peak. Note the three main chairlifts serving the mountain. *From left to right*: Gramp's, Andy's and Dot's, which served terrain for all abilities. The novice Matt's Chair and a rope tow accessed the beginner area at the lower left. *Author's collection*.

In the late 2000s, a large wind turbine project was built on the Brodie Mountain ridgeline, and due to the change of the view shed, the potential to build a time-share resort is quite unlikely at the time of this writing.

Brodie Mountain continues to live on in the memories of all involved. From the skiers who relished skiing on its slopes, to the ski patrol who kept

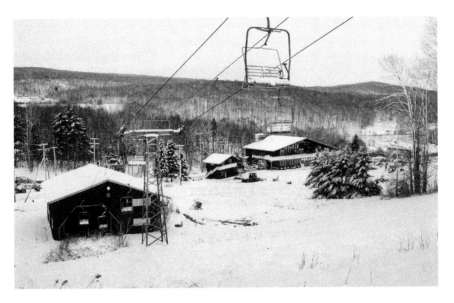

In 2005, skiing had been absent from Brodie for three years, but the lifts were all intact, including Andy's Chair, shown here. The base lodge was still standing but mostly unused. If you look carefully at the middle right, you will be able to just make out snow tubers waiting in line to ride Matt's Chair. *Dan Xeller Photography, http://www.dan-xeller.com.*

them safe, to the employees who worked so hard to provide a positive guest experience and the Kelly family who built and owned it, Brodie was a one-of-a-kind ski area that will never be forgotten. The best part of Brodie was the "people who came there—from the beginners to the experts and the families that made it so special," as told to the author by Jim Kelly.

VISITING THE AREA

Brodie Mountain is gated private property and cannot be visited by the public. The access road leading to the ski area is open up to the gate, located three quarters of a mile north of the junction of Route 7 and Brodie Mountain Road, if one wishes to look at the ski area from a distance. The area can also be seen just north of the access road on Route 7.

The best distant view of Brodie can be seen from the summit of Mount Greylock's Bascom Lodge, where all of the trails and windmills along the ridge can be seen on a clear day.

Eastover

Lenox

1949, 1954–99

A classic Berkshires resort, Eastover operated a ski area directly on its property for decades. First tailored to young singles and couples, the resort later attracted families. A wide variety of activities, including skiing and tobogganing, were the highlights for guests' winter vacations.

Eastover's history traces back to Harris Fahenstock, a New York banker who purchased the property in 1910 and subsequently built his own mansion in 1910. It was sold and became the Duncan School for Boys in the early 1940s. The property was then purchased by George Bisacca, who intended to open a resort.

Bisacca, who immigrated to the United States from Italy as a child, had worked a series of odd jobs, including as a streetcar operator and for the Ringling Bros. Circus. He later developed a chain of gas stations in Connecticut in the 1930s and 1940s.

Seizing upon the postwar boom in recreational tourism, he learned of the Fahenstock property, purchased it in 1946, then set about a yearlong renovation project to bring it up to modern standards, adding guest rooms throughout the mansion along with other accommodations. One building on the property was converted into the Tally Ho recreational building. Bisacca sought out to create a resort that was geared toward young people of moderate means. The resort was meant to be casual and inclusive, with space for up to two hundred guests who wanted to get away from it all. Like

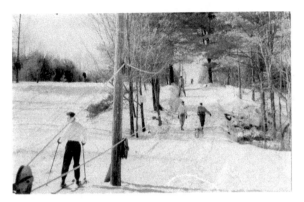

The Tally-Ho slope was originally served by a six-hundred-foot-long rope tow that took a path in the woods alongside the slope. The tow was later replaced with a unique flatcar track, and the Tally-Ho was tripled in width compared to the narrow trail shown here in the 1950s. *Woodward Bousquet.*

Jug End and Oak n' Spruce, this was a new kind of resort for the Berkshires, which previously catered to a more established crowd who would stay for weeks at a time in the summer.

On May 27, 1947, Eastover opened for business for the first time. Business was brisk for the first few years. Seeing the growth of skiing at other similar resorts, in 1949, Bisacca proceeded to open up a six-hundred-foot-long rope tow directly behind the Tally Ho building. For a ticket price of one dollar, skiers could enjoy an eight-hundred-foot-long intermediate slope, along with frequent ski parties. Dick Olmsted, previously employed at the Beartown Ski Area, was hired as an instructor.

Initially, the ski area only operated that first year and would not reopen for another five. It is likely that much of the resort had not been winterized, but starting for the 1954–55 season, the resort began a permanent year-round operation and the ski tow was reactivated. Another tow was installed for beginners on an easy slope to the south of the intermediate trail, directly downhill from the mansion. The addition of an indoor heated pool, a relative novelty at the time, was installed in the mid-1950s. Here, swimmers could enjoy the view from large glass windows and watch skiers slide down the trails.

Business boomed throughout the rest of the 1950s. For the 1956–57 season, Bisacca installed one of the earliest snowmaking systems in the Berkshires. Similar to the system at Bousquet, three snowmaking machines could produce snow to cover much of the beginner slope. The snowmaking was well received, and in February 1957, the area's Winter Carnival was so popular that 8,000 potential guests were turned away. On-site, it hosted about 360 guests, with another 140 sent to nearby homes or other lodging establishments. The Winter Carnival attracted independent guests along with numerous ski clubs.

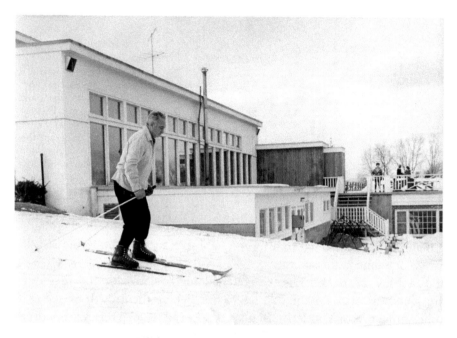

George Bisacca, who owned Eastover, was not a lifelong skier. He took up the sport in 1962, at the age of fifty-nine. This photo shows Bisacca taking a lesson, skiing past the pool. *Art Marasco via Bob McNinch.*

Building on the success of the first year of snowmaking, the system was doubled in capacity for the 1957–58 season, which then could cover the entire slope. In addition, the intermediate slope was tripled in width (and called the Tally-Ho), making for wide-open descents. Bisacca would later use this slope as a driving range due to its expansive width.

The 1960s would start with even more improvements. To offer more amenities for non-skiers, a seven-hundred-foot-long toboggan chute was built on the north side of the intermediate slope. The chute featured banked walls, which prevented sledders from flying out of the track. To serve both tobogganers and skiers, a unique lift was then built to replace the rope tow. This lift, a flatcar that traveled on a track, took both skiers and tobogganers the one hundred or so vertical feet from the base to the summit. Skiers could even leave their skis on for the short ride. This lift was one of a kind in New England, though a similar lift was built at a resort in the Catskills of New York. Skiers and sledders alike could warm up between runs at the Tally Ho, where a snack bar and circular fireplace were available. Three new ski instructors—John Carney, Ed Deane and Leon Heart—taught

EASTOVER, LENOX, MASSACHUSETTS

Eastover featured several slopes, including the Tally-Ho, pictured here in the 1950s. This slope had just over one hundred vertical feet and could also be used for short slalom courses. It would be later used as a driving range in the summer months. *Woodward Bousquet.*

many of the guests who had never skied before. Occasionally, a famous guest would stay at the resort, including Ted Kennedy on a promotional trip for Berkshire attractions in 1963.

The ski area was further expanded for the 1964–65 season. Joining the larger ski areas in the Berkshires, a new Hall double chairlift, 1,400 feet in length, was built from just south of the Tally-Ho slope to just north of the mansion. Ralph McDermott, the father of Court McDermott (who was Bousquet's ski school director for forty years), helped to install the lift. The unloading area was originally flat—so Bisacca had 14,000 cubic yards of fill brought in from a nearby hill. A new trail, the Shenandoah, was also cleared from the base of the novice slope to the base of the chairlift. All told, the vertical drop was increased to just over 160 feet. All of these improvements gave the resort everything it needed for a complete ski destination.

Eastover made sure that guests felt welcome and well cared for. If a new skier fell or was having difficulty, staff brought over hot chocolate. If someone left skis on the trail, the staff would return them. And marketing continued attracting a youthful and active crowd, as evidenced by a 1960s brochure:

Eastover's unique flatcar track carried both skiers and toboganners to the top of the Tally-Ho slope, and skiers did not even have to remove their skis. The toboggan chute featured high walls to prevent users from exiting the track. *Author's collection.*

Royal is your welcome. You've found it. Finally. After all this time. Your own mountain retreat. Where the surrounding hills and valleys echo the laughter and happy times of year 'round fun at Eastover.

Your own special hideaway. To forget your cares. To see new faces. A change of scenery. Meet new people. To just let loose with laugher. For a frolicking, rollicking good time.

They're all here. Your kind of people. Young. Fun. Sporting. Friendly. They're happy people. Like you. Out to have the time of their lives at the prime of their lives.

Although their clientele was youthful and active, it was not the type of crowd that returned again and again, at least on the skiing side, with many skiers venturing off to larger resorts once they learned to ski proficiently at Eastover. In a *Berkshire Eagle* article from 1965, Bisacca was quoted as saying, "There is very little repeat business from the resort skier. We get a whole new wave each season. Once the ski bug bites them, they go off to ski at the big areas. We are the cradle of the industry."

In the late 1960s, another unique addition was added to the resort—a Civil War museum. Bisacca was a Civil War buff and had one of the

Chairs empty their passengers as two skiers take a break and head for the Mansion for lunch.
Top notch ski instructors offer free lessons on the slopes!
Chair lift and rope tow provide the uphill rides for those downhill runs.

The addition of a double chairlift for the 1964–65 ski season greatly improved uphill transportation at the resort. The unload area of the chairlift was expanded with the addition of fourteen thousand cubic yards of fill from a nearby hill. It dropped skiers off right next to the mansion, where a full sit-down lunch was available. *Woodward Bousquet.*

largest private collections of memorabilia in the country. Many of the features on the property were named after aspects of the Civil War, including the trails Tally Ho and Shenandoah, accommodations named Georgian and Carolinian and Union and Confederate flags throughout the property. A functional cannon graced the entrance and was often used in local parades.

Although the ski area was brought up to more modern standards, it was soon eclipsed by other areas both in the Berkshires and in northern New England in the late 1960s and 1970s. Skiing remained an important part of the resort into the 1970s—even operating as far as April 10, 1971, following a rare late-season snowfall. The beginner tow had already been put away for the year, so skiers were transported up by grabbing onto ropes attached to a Sno-Cat.

Eastover has a connection to the Olympics and World Cup circuit. Krista and Kim Schmidinger learned to ski at Eastover as children in the early 1970s. Later, Krista would race in the 1992 Winter Olympics in Albertville (placing eleventh in the women's combined), with Kim on the team but

THESE TWO SOUTHERN BELLES ARE ENJOYING THEIR
FIRST SNOWY WINTER IN YANKEELAND AT
EASTOVER, LENOX, MASS.

Eastover attracted guests from all over the country, including from the South, some
of whom had never seen snow before. As the owner George Bisacca was quite
the Civil War buff, some advertisements alluded to this connection, such as these
"Southern Belles in Yankeeland." *Author's collection.*

unable to compete due to an injury. Krista raced again in the 1994 Winter Olympics in Lillehammer, where she placed twenty-seventh in the women's downhill. She also raced for six years in the World Cup.

John McNinch, Bisacca's grandson, grew up at Eastover during this time. He learned to ski there in 1969 at the age of three, and by the time he reached the age of thirteen, McNinch had gained enough experience to teach adults. He remembers assisting with the snowmaking system, which was hooked up to a fire hydrant during this time.

The 1980s would see further changes at the resort. Bisacca passed away in 1983, with the ownership falling to daughter and son-in-law Susan and Bob McNinch and daughter Ticki Winsor, who continued to operate the resort and ski area. In addition to guest use, the ski area continued to host special events and was the site of the Massachusetts Special Winter Olympics from 1982 to 1999.

The chairlift continued to operate through 1999. Then, the lift ceased to operate, though the toboggan slide continued into the early 2000s. Winsor became the sole owner during this time frame.

Before the resort was sold, the chairlift was removed in 2002 and installed at the nearby Bousquet Ski Area. Here, the chairlift would now serve skiers again in the middle portion of Bousquet's. The installation of the chair was in honor of Ralph and Court McDermott for their dedication to Bousquet's and the ski industry in general. The toboggan lift continued to operate into the early 2000s.

Eastover would go through several ownership changes throughout the 2000s and 2010s, and it is now a holistic retreat center, with events and accommodations for all types of visitors. While skiing is no longer available, the spirit of the resort continues to this day.

Visiting the Area

If you are staying or attending a class at Eastover, be sure to check out the few remnants left of the former ski area.

About halfway between the north entrance of the Mansion and the Tally-Ho building was the former unload station for the double chairlift. You can see how the unload area was raised above the natural slope of the hill. As you look directly down the former lift line, note the greenhouse-type structure, a new eco-powered water treatment facility. The double chairlift line is still visible through the woods directly downhill of this facility.

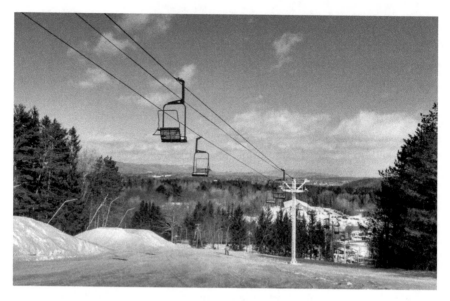

Eastover's former double chairlift still operates on occasion as Bousquet's in Pittfield. It was installed in 2004 and mainly runs on a few busy weekends and holidays. *Author's collection.*

Walk down to the remains of this building, and you will quickly find yourself at the top of the Tally-Ho slope and toboggan hill. The cable car/sled lift for the toboggan run was located at the far northern edge of the slope. No lift remnants can be seen.

Heading back toward the treatment facility, you will pass the former Shenandoah slope on your left about one hundred yards later. Then, turn to your right, toward the mansion. This is where the novice slope was located, with the rope tow along the southern the edge of the trees.

If you wish to see and ride the chairlift that operated at Eastover, you can check it out at the Bousquet Ski Area (www.bousquets.com). It is now the Green Double and operates occasionally on weekends and holidays.

For more information on Eastover, along with directions, please visit www.eastover.com.

Greylock Glen

Adams

Built 1973–74

Greylock Glen is a cautionary tale for massive ski area development gone awry. While it was envisioned as an all-inclusive resort with a wide variety of seasonal offerings, financial problems led to it never being completed. No other similar-sized ski area has ever come so close to opening yet failed to do so in New England. Its remnants are a testament to the failure of this project, frozen in time.

This ski area is certainly a one-of-a-kind example in the Berkshires. The author considers this to be a lost ski area, as it was actually constructed and nearly finished, as opposed to a proposed ski area that was never built. In addition, season tickets were sold but refunded, and a cross-country ski area operated on the lower slopes and golf course for one season.

The east slopes of Mount Greylock were long targeted for ski resort development. The Thunderbolt Trail was and is the most challenging ski trail in southern New England and briefly had its own rope tow. Two rope tow ski areas, Sheep Pastures and the Thunderbolt Ski Area, once graced its lower slopes. Other proposed developments of a tramway up Mount Greylock and later a ski area on Saddle Ball almost came to fruition. But the Greylock Glen project would take resort development on this side of Mount Greylock to a whole new level.

The impetus for this project began in 1969, when Joseph Dragone, the former head of the Mount Greylock Tramway Authority, was hired by a

group of investors to study the potential for another ski area, this one on the lower slopes of Mount Greylock and just north of the proposed Saddle Ball ski area development. At first, the study was shrouded in mystery, as the investors were not identified.

Once Dragone had shown the feasibility of a resort to potential investors, properties that were to become part of the resort was acquired by Dragone, including the two-hundred-acre Picard Farm, where Roger Picard's Thunderbolt Ski Area once operated in 1958. By 1972, more nearby properties had been secured, and the group of investors was revealed to be ELCO Resort Developers of Springfield, Massachusetts. This corporation, headed by Alan Canter, was a business conglomerate that contained several entities, including a horsemeat exporter and a military base supplier and developer. It also had a resort development branch that was in the process of constructing the interior of the Evergreen Valley, Maine ski area's base lodge—another ski area that faced financial troubles and closed in 1982. Dragone was involved in this project as well.

The plans for the Greylock Glen development were officially announced in October 1972. The plans were grand: 520 condominiums, a 350-room eight-story hotel, and an eighteen-hole golf course designed by Robert Trent Jones. A ski area consisting of two chairlifts (one four thousand feet long) and two T-bars would utilize part of the Thunderbolt Ski Trail. Canter anticipated that guests would arrive via a special train depot or fly in to the North Adams Airport from all over the Northeast. The project would cost an estimated $13.6 million and take two years to complete. Even more ambitious was the planned employment—550 were expected to work at the resort when completed, providing a much-needed boost to the community.

In late 1972, plans progressed, and hearings were held in Adams for the highly anticipated project. There was local opposition—the Greylock Protective Association, the organization that helped defeat the Greylock Tramway in the mid-1960s, was reactivated to stop to the project, or at least stop the Town of Adams from providing additional acreage.

The first signs of trouble appeared in December 1972, when a controversial land survey was proved to be inconsistent with property boundaries. The survey included the Thunderbolt Trail as part of the ski terrain. Additionally, Everett Lord-Wood, who had designed the master plan for the resort, was late in being paid for his work.

More planning and approvals occurred in 1973, with the official groundbreaking on September 15. Alan Canter presided over the

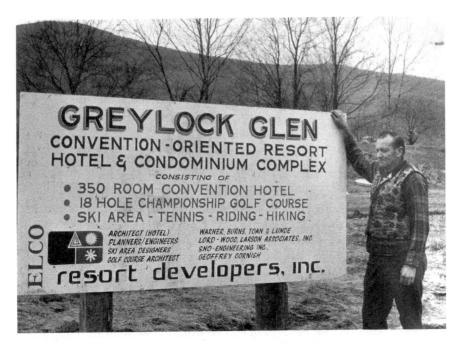

The Greylock Glen development was to be the largest in the Berkshires, with a 350-room hotel, 18-hole championship golf course, the ski area and other facilities. Elco Resort Developers Inc. of Springfield, Massachusetts, was the developer. Only the golf course and a ski touring center ever operated—and on a very brief basis. Berkshire Eagle *(Used with permission)*.

groundbreaking and announced more aspects of the project. Elco hired Sno-Engineering, the leading ski area design firm, to develop the plan for the ski area. This was now changed to include three double chairlifts and several surface lifts, with the longest lift 3,600 feet, all served by a modern underground snowmaking system. Skiing "will range from easy beginner slopes on wide open meadows to sporty wooded trails," according to Canter. The use of the lower Thunderbolt Trail was again touted as an important feature, with the top of one of the ski lifts ending just five hundred feet away from the trail.

The eighteen-hole, 6,400-yard golf course would be built by Cornish-Robinson Associates of Amherst and feature spectacular views of Mount Greylock. At the hotel, guests would enjoy indoor tennis courts, cocktail lounges, a health club and an indoor pool. Outside, there would be polo, horseback riding, biking, cross-country skiing, fishing and hiking. Canter stated that everything would be in operation by 1975. The cost had now

ballooned to $40 million. In anticipation of the hotel, conventions were already booked for 1975.

By February 1974, half of the ski area's trails had been cleared, and 35 percent of the golf course had been prepared. It was announced that the price tag to improve the Thunderbolt Trail was $65,000, which the state was to provide, with Elco paying for the cost to tie into the trail network.

Land speculation continued into 1974. In March, Elco purchased the Oparowski Farm. This farm, located across the valley in Adams, was rumored to be on the list for a rival ski area. With Elco purchasing the farm, the potential for a competitor was squashed. In August 1974, Canter purchased a freight house along the nearby railroad in order to convert it to a modern train depot to serve skiers arriving in that fashion.

While work progressed on the ski area, plans were readied for the hotel. In March 1974, Princess Hotels of Bermuda was named as the principal operator for the proposed lodge. The price for the hotel alone had ballooned to $9 million. The architects, Warner Burns Toan Lunde, estimated that it would take another year to year and a half to complete, opening sometime in 1975. The hotel would now feature a top-story restaurant, a terrace, a bar, ski lockers, and a supper club and would "resemble the nearby rugged mountains."

Incorporating the historic Thunderbolt Trail into the Greylock Glen network hit several hurdles in 1974. The Sno-Engineering design firm stated that the Thunderbolt should be simply rerouted into the trail system, but this was opposed by several groups, as it would only benefit the resort and not the average citizen. The Greylock Advisory Council stated that the overgrown ski trail should be converted into a hiking trail. Although the $65,000 was approved in the state budget in 1974 to restore the trail, the stalling of the ski area development in late 1974 and 1975 put an end to any consideration of widening the trail.

More problems started to develop in July 1974, when Robert Trent Jones, the design firm for the golf course, filed a suit in violation of the design copyright. It declared a breach of contract, as another firm, Cornish-Robinson, was using the former's plans to build the course. The opening of the golf course was pushed back to July 1975. In addition, seemingly ballooning out of control, the hotel costs had skyrocketed to $23 million in August 1974. In September, it was announced that further delays would result in the hotel not opening until June 1976.

Despite the inklings of financial and other issues, most local businesses and ski areas were excited about the project. Brian Fairbank, who owned the

Greylock rates

Lift Tickets	WEEKDAY	HOLIDAY AND WEEKEND
All Lifts:		
Adult	$7	$10
Junior	$5	$8
J-Bar		
Adult	$4	$5
Junior	$3	$4
Mornings (9 to 1) all lifts	$5	$8
Afternoons (1 to 5)	$5	$8
Sundown (3 to 10:30)		
Adult	$6	$6
Junior	$4.50	$4.50
Night (6 to 10:30)		
Adult	$4	$4
Junior	$3	$3
Saturday and Sunday combined ticket		$18
Monday through Friday ticket		$25
(except holiday weeks)		
*Sundown and Night Skiing—Tuesday through Saturday		
**Holidays Dec. 25–Jan. 1 and Feb. 17–Feb. 21		

Season Passes	
Adult	$150
Junior (12 and under)	$120
Family Plan	
Two Member	$260
Added Adult	$115
Added Junior	$90
Maximum	$560
Weekday Pass (except holidays)	$60
Evening Pass (3 to 10:30)	$60
Night Pass (6 to 10:30)	$45

A—800'
B—1200'
C—3500'
D—2000'
E—Thunderbolt
F—Base Lodge

Greylock Glen was to feature three double chairlifts and a J-bar on a dozen trails and slopes. Trails were mostly of beginner and intermediate difficulty. Note the Thunderbolt Trail on the map—it was going to be widened and rerouted into Greylock Glen, but this never came to fruition. Lift tickets for adults were set at seven dollars for weekdays and ten for for weekends. *Author's collection.*

Jiminy Peak ski area, thought it would be "good for all." Essentially, bringing more tourists to the Berkshires was considered a good thing in a time of economic uncertainty.

Progress on the Adams-Berkshire Inn also continued throughout 1974. This inn, built in downtown Adams, was intended for both lodging options in Adams as well as a headquarters for the Nordic Center. By late August, the inn was nearly complete.

In September, it was announced that John Hitchcock was hired to lead the ski school at Greylock Glen. Hitchcock was a well-known figure in Berkshire skiing circles, as he often wrote columns for local newspapers and taught skiers at Petersburg Pass. Gordon Terwilliger was hired to manage the ski area. Bill Beattie, the director of alpine racing at Glen Ellen, Vermont (now Mount Ellen at Sugarbush), was brought in for the same position at Greylock Glen. Beattie recalls Hitchcock's and his work with the developing ski area in 1974:

In the late summer of 1974, I was contacted by John Hitchcock who was inquiring to see if I would be interested in being the director of

Despite the resort never opening, race bibs for the Junior NASTAR race league were produced. Bill Beattie was hired to lead the racing program but never had the chance. *Author's collection.*

alpine racing at Greylock Glen. John was a ski writer and involved in what seemed like every aspect of the ski industry. He was an early mentor to me at the beginning of my ski coaching career. He was involved with ski area management, ski schools, Nordic skiing and alpine racing. In short, John knew just about everyone who worked in the ski business and certainly everyone locally who did. I had met John Hitchcock when I was first hired as a ski coach at Dutch Hill in nearby Readsboro, Vermont. He also ran a summer ski racing camp in Cooke City, Montana, during the late '60s and early '70s, and he had hired me to be on the camp coaching staff.

John was responsible for staffing the Greylock Glen—naturally, he reached out to those he knew from the area. I agreed to take the position and joined the staff in late August, where it was all hands on deck to get the lifts and snowmaking system ready. We worked through the fall seeding trails with winter rye, completing the snowmaking system, installing lights for night skiing and erecting lift towers.

Work continued to progress at the ski area in September and October. Twelve trails were cleared, graded and smoothed out. Underground snowmaking pipes and valves with eighty-eight outlets were constructed along the edges of nine out of the twelve ski trails. Poles with lights for night skiing were erected. The foundation for the ski lodge was poured in late October. And by early November, three chairlifts were nearly ready for completion, with an opening date set for November 14, 1974.

These three chairlifts, manufactured by Borvig, were all double chairs. Robert Blemis of Dolomite Construction from New Jersey was contracted out to build the chairlifts. In addition, foundations for the beginner's J-bar lift were poured. The longest and highest chairlift, serving the middle portion of the ski area, had a vertical drop of 761 feet and had a length of 3,341 feet. The second, located to the north, was 1,795 feet long with a vertical drop of 480 feet. The shortest chair, serving novices, was 1,110 feet long with a vertical drop of 170 feet. Finally, the J-bar, built on the

Dolomite Construction of Vernon, New Jersey, installed the Borvig double chairlifts. Here, a tower is erected on what is likely the "B" Double Chairlift. Installation of the chairlifts ceased once payments stopped to Dolomite in November 1974. Berkshire Eagle *(Used with permission)*.

golf course's fifteenth and sixteenth holes, had a vertical drop of 84 feet and a length of 775 feet. Towers for all of the chairlifts were erected, though none for the J-bar. The engine drives were not yet installed by early November, nor was cabling or the chairs themselves.

Major trouble was brewing for Elco and Greylock Glen. In early November, sensing potential problems ahead, Terwilliger suddenly resigned and went to work at Paucatuck, a rope tow ski area near Springfield, Massachusetts (now a lost ski area). Then, in mid-November, all progress at the ski area and hotel came to a screeching halt. The financing was running dry. The Dimeo, Petricca and Dolomite construction firms, all working on various aspects of the resort, had not been paid in sixty days. Work at the hotel ceased immediately, leaving only the foundation complete. By late November, season tickets were refunded, and another mortgage was signed. Greylock Glen would fail

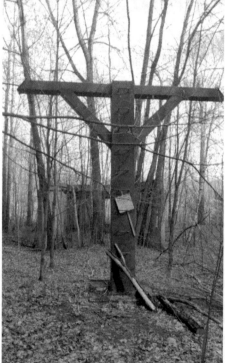

Above: The longest chairlift at Greylock Glen was to be the 1,800-foot-long "D" Borvig Double Chairlift. Partially constructed in 1974, the lift was to be directly uphill of the proposed hotel and lodge. This view, likely circa November 1974, shows the engine house for the lift and the first tower. No further significant construction occurred after the photo was taken. Note the foundations for the 350-room hotel that are visible behind the engine house. Berkshire Eagle *(Used with permission)*.

Left: In 2017, the area around the "D" Double Chairlift base was still intact but quite deteriorated from over forty years of abandonment. Trees have grown up where the engine would have been installed, and the lift tower was rusting away. *Author's collection.*

GREYLOCK GLEN SKI SCHOOL
Adams, Massachusetts

TICKET GOOD FOR ONE

GROUP LESSON

Instructor

Not Redeemable No. 2799

In preparation for the 1974–75 ski season, tickets were presold, including this one for a group lesson. Tickets were refunded in November 1974 once it became clear that Greylock Glen was not going to open. *Woodward Bousquet.*

to open for the 1974–75 season, with a nearly completed ski area sitting silent on the lower slopes of Greylock.

Although the alpine ski area did not open, the Nordic center did operate for the winter of 1975. Hitchcock and Beattie ran the center out of the Berkshire-Adams Hotel, as recounted by Beattie:

> *In late 1974, many of the staff left for positions at other ski areas. John Hitchcock and I ran a Nordic Center out of the Adams Berkshire Inn, which was also a property owned by the Greylock Glen. We brought tours on cross-country skis to the Glen, lower Thunderbolt and Bellows Pipe Trails. By the next year, it was clear that further funding was not to be found for Greylock Glen, and I moved on.*

To finish the project, Elco sought more financing—including two more mortgages in January 1975 to the eight already granted. Another $27 million loan from the Berkshire County Regional Planning Commission was declined, due to the overextension of the project. But despite all of this, the golf course did open for a few months in the fall of 1975, albeit on just nine of the eighteen completed holes.

More controversy swirled in the fall of 1975, when it was announced that $31.5 million in financing was in the final stages of approval from the Banque Nationale de Paris. However, the bank denied the veracity of this report or ever meeting with Elco, and no loan existed.

In December 1975, the Community Savings Bank of Holyoke, which held the mortgage for the Adams-Berkshire Inn, seized control of the property, which had suffered due to low occupancy from the resort's non-completion. The inn would continue to operate through 1977 before closing.

Additional financing was sought but declined. In 1976, another effort to finish the ski area by Elco failed as well—$1 million was needed to complete it. In May 1977, the golf course was seized by the Community Savings

Bulldozers work to smooth the terrain for the golf course, likely in 1974. Note the ski trails in the background. The slopes to be served by the longer "C" Borvig Double Chairlift are visible on the left side of the photo. Berkshire Eagle *(Used with permission)*.

Bank of Holyoke, as it was already in disrepair. It never operated again. And in December, the bank foreclosed on and sold the inn, which closed immediately, putting fifty employees out of work.

With the resort having so much potential to change the economy of the Berkshires, the financial collapse of the Greylock Glen resort was a major blow. Over the course of the next several decades, the ski area gradually became overgrown, although nearly all of the ski area accouterments like the partially complete chairlifts, snowmaking pipes and lights were left standing but decaying. The golf course reverted to fields and woods, and the Berkshire-Adams Inn is now the Berkshire Arts and Technology Charter School.

Despite the failure of the resort, other developers tried to make a case that it should be resumed. From the 1980s and into the 1990s, various plans sprouted up each year for casinos, hotels or reviving the ski area—though all failed.

However, the tide changed for Greylock Glen in the 2000s. New hiking and biking trails have been built throughout the Glen, including through the former ski area. These trails have been developed with assistance from the Town of Adams, the Department of Conservation and Recreation (DCR), Thunderbolt Ski Runners and the Berkshire NEMBA and allow for a wide variety of outdoor recreation. Some of the trails pass by the remnants of the old ski area, allowing visitors to view the relics.

The trail work is just a start to a new, $50 million plan to finally develop the Greylock Glen resort. This time, it is a partnership between the Town of Adams, the DCR and private developers. Centering on eco-tourism, the new project will feature the 170-room Thunderbolt Retreat hotel, a

conference center, a new campground, a performing arts amphitheater, an environmental education center, an outdoor environmental art gallery, expanded trails, a cross-country ski center with partial snowmaking and over one thousand acres of conserved land. Already, Phase 1, a newly 1.7-mile-long upgraded Meadow Loop trail was finished in the late spring of 2017. This trail passes the base of the abandoned chairlifts and is suitable for running, cross-country skiing, walking and other passive outdoor recreational sports. The present environment is quite a bit different than it was in the mid-1970s, and Greylock Glen may be able to attain the goal of becoming a year-round resort, appealing to outdoor recreational enthusiasts who will be able to enjoy the wide offerings of outdoor sports in the Glen.

VISITING THE AREA

With progress ongoing at the time of the writing of this book, much could change at Greylock Glen over the next several years. If you wish to explore the relics of the former ski area, you may want to do so sooner rather than later, as some remnants may be removed pending further development. Indeed, the progress at the Glen is occurring swiftly, including the construction of the Meadow Loop trail in between the author's several visits to the ski area in the spring of 2017. Other hiking trails may be developed or removed by the time you read this, so be sure to obtain the latest trail map before setting out.

There are multiple points of entry into the former ski area, but the quickest way to reach the former ski lifts is via a parking lot on Gould Road. From the junction of West and Gould Roads in Adams, drive up Gould Road for one-third of a mile, then turn left at the junction of Thiel Road. There will be a parking lot a few hundred feet on the right. Park here, and follow a connector trail west for three hundred feet until you reach the Meadow Trail. Turn north, and walk the easy to follow trail for half a mile, until it reaches Thiel Road, and turn left. Continue along the road for two-tenths of a mile, where you will reach the foundation for the maintenance building, never finished. Head back the way you came, and shortly turn right to continue on the Meadow Trail. As you follow this trail, you will encounter many remnants of the base of the three chairlifts, including lift towers and foundations for the drive buildings. The trail then continues around a pond, then south back to your car.

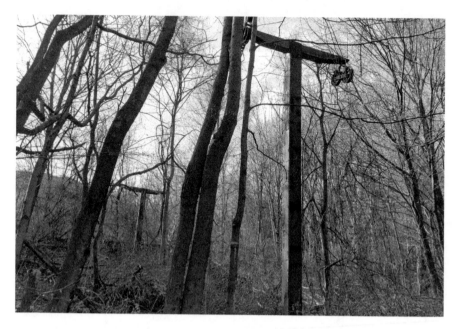

The upper two towers of the 1,100-foot-long "B" Borvig Double Chairlift are slowly disappearing into the forest. This lift was going to serve beginners and was to be the first chairlift they would ride after learning on the J-bar. *Author's collection.*

Alternatively, you can continue beyond the parking lot in your car to the small parking lot at a gate at the end of Gould Road. Heading north from the parking lot along the Bellows Pipe Trail, you will shortly reach the remnants of the J-bar (look carefully for a foundation on the left) and then the novice chairlift. One can continue heading north along the trail to explore the rest of the chairlifts or walk down another trail that parallels the chairlift, leading to the Meadow Loop trail.

Updates on the trail system at Greylock Glen can be found at www.mass.gov/service-details/greylock-glen-multi-use-trail-system-plan.

Jug End Barn

South Egremont

CIRCA 1936–47 (NO LIFT SERVICE), 1947–81
(LIFT SERVICE, SPORADICALLY FROM 1977 TO 1981)

A four-season resort with a rich history, Jug End Resort offered a wide variety of activities for its guests. Its sprawling campus included numerous accommodations, tennis courts, a swimming pool, a restaurant and its own ski area, located half a mile away at the base of Mount Sterling. Although the ski area was relatively modest by today's standards, it was enjoyed by guests for nearly forty years. The resort fell into financial difficulties in the late 1970s and early 1980s, which led to its closure, but it remains a vibrant area as a Massachusetts state park.

The resort's history traces back to 1921, when Major Hugh Smiley purchased the two-thousand-acre colonial Bradford Estate in South Egremont. Smiley and his wife had left New York City in order to start up a gentleman's farm in the Berkshires they named Fenton Brook Farm. Here, they raised turkeys, dairy cows and produce, and it became one of the most productive farms in the area.

Although the farm products did provide a source of income to the Smileys, an additional revenue stream was sought. They gave up the farm life and converted the property into a resort. In the summer of 1935, Smiley added stone fireplaces to the cow barn, a bowling alley and a banquet and recreation hall. Renaming the property the Guilder Hollow Club after the valley in which it sat, he marketed the resort as a respite for outdoor sports

enthusiasts from New York City. Only a few select guests were invited to the property, who in turn could invite their friends—as long as a letter of recommendation was provided. The club opened in the winter of 1936 and was an instant success.

It was in 1936 that the ski trails were first developed on Mount Sterling, a short distance away from the barn, which faced east and held snow into early spring. These trails included the Sterling Mountain Trail, the Jug End Trail (from the summit of Sterling Mountain) and the Guilder Hollow Trail, but they weren't served by ski lifts.

Despite the Great Depression, the club expanded, and Smiley soon converted other farm buildings into accommodations. Over one hundred people were on the approved membership list. However, Smiley had spent a significant amount of money on these expansions and went bankrupt, selling everything in 1938 except for his antique gun collection, which was relocated to Henniker, New Hampshire, where he went on to found a gun museum.

The property was sold to several parties, but the main club property was kept intact, purchased by Robert Lexow. He immediately changed the name of the property to the Jug End Barn—based on a historic name for the property, *jugend*. It is a Dutch word that translates to "youth" and was split into two sections for reasons unknown. One can use his or her imagination to visualize the end of a jug on nearby Jug End Mountain, visible from Mount Sterling. Lexow then made additional improvements to the burgeoning resort, including a concrete swimming pool, hiking trails and new lodging options in the barn.

In the late 1940s, due to personal reasons, Lexow sold the property to a newly formed corporation made up of local businessmen. This corporation continued investment into the property, adding guest rooms within the barn silos, but most importantly to the ski area—a new ski room/ warming hut. The ski area was a fair distance away from the heart of the resort, and this improvement was greatly welcomed by skiers. An additional improvement was the addition of a rope tow for the 1947–48 season, finally bringing lift-served skiing to the lower slopes. A new ski shop opened at the resort near the barn. With the area now under corporate ownership, the guest list was expanded to include the general public, but all visitors still needed to show a letter of recommendation in order to book a reservation. Jug End proved so popular that management had to turn away two thousand reservations for Washington's Birthday vacation week.

By 1949, a second rope tow was built on the expanding ski area, and in 1950, Jug End completed the purchase of the G-Bar-S Ranch, a competing

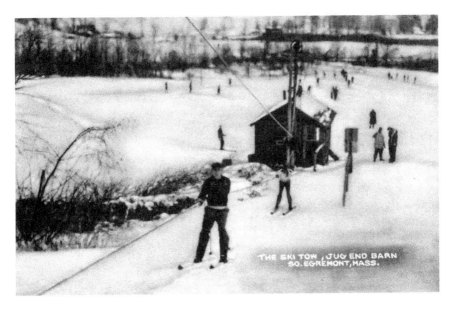

Although Jug End was initially not served by a ski lift, this rope tow was installed for the 1947–48 season. It made access to the slopes and trails far easier and helped to draw skiers from all over the Northeast to enjoy the resort. *Woodward Bousquet.*

resort and ski area located on Warner Mountain in Great Barrington. The management of both ski areas and resorts merged, and guests of either property could enjoy the facilities of both. The ski offerings at Jug End were enhanced, and the 1950-51 season featured two permanent long rope tows (1,200 and 1,000 feet), along with a portable tow. Several trails had been cleared around the main slope, and formal ski instruction was added. After a few years, Jug End sold off G-Bar-S Ranch in order to focus on its core property in South Egremont.

By the mid-1950s, the market for Jug End had changed. While it had been a more rustic resort for quite some time, its facilities were gradually becoming rather dated. To solve this problem, the corporation hired husband-and-wife team Angus MacDonald and Mimi Logan MacDonald in 1957 to operate the resort as a team effort. Angus was a young businessman from California who had operated a sport-fishing outfit and moved to Massachusetts, where he was active in real estate and insurance. It was hoped that he would breathe new life into the resort. Indeed, the combined efforts of the MacDonalds would result in them winning multiple awards for hotel marketing and décor over the next two decades at Jug End.

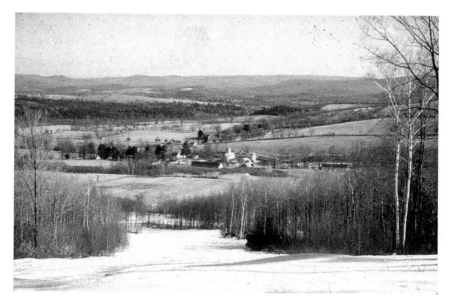

Jug End's slopes retained snow cover for longer periods of time than the surrounding terrain, as depicted here in 1954. This view shows the intermediate slope. In the valley, the Jug End Barn complex can be seen, with its variety of lodging and entertainment options. *Lou Tsotsi via Jim Tsotsi.*

The MacDonalds worked to remodel the rooms, modernizing them to mid-century standards that guests were now expecting. But most importantly, for the ski area, much-needed improvements were in store.

In late 1957, snowmaking equipment was installed on the main slope, which helped ensure a ski season from December to early April. It was one of the earliest snowmaking installations in southern New England. In addition, a brand-new base lodge was built at the foot of the ski area in 1958, with an expansive deck, snack bar, lounge and ski shop. All of the skiers' needs were anticipated, and this also avoided skiers having to haul rental skis from the former ski shop near the barn. In the summer months, the lodge also served as headquarters for a new nine-hole golf course (later expanded to eighteen holes) just below the ski area.

More upgrades to the resort followed over the next couple of years, including a swimming pool and a new cocktail lounge. Angus MacDonald noted in a personal history of the resort that the lounge was the "most important single feature in the complete change of the complexion of the resort-hotel." It was now an "adult operation" with a clientele that included singles, couples and a growing convention business. The Jugendkeller, a

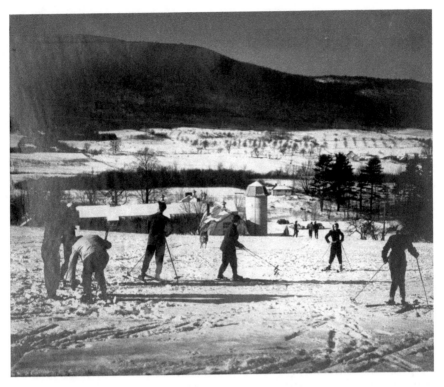

In addition to the ski area on Mount Sterling, a practice slope was located just above the Jug End Barn itself. No lift was installed on this slope, but it was convenient to guests staying in the guest rooms below. Note the silo, the most recognizable part of the resort. *DCR Archives.*

greatly expanded banquet hall that could also be used for conventions and night club shows, was added to the resort in the early 1960s.

As was common in the 1960s with local ski areas, Jug End's ski area was modernized further with a new surface lift. In 1961, a 1,500-foot-long T-bar lift expanded the vertical drop to nearly 300 feet. A series of new trails and slopes were cleared and merged with the existing network of rope tows and older slopes, quadrupling the overall ski terrain. David Scott, a PSIA instructor, was hired to improve the ski school, with nine other instructors serving under his leadership. As most of the slopes were geared toward beginners and intermediates, this focus on instruction served the resort well, and many skiers learned to ski here on vacation and weekends alike. One did not need to be a guest to enjoy the slopes, which were open to the public. Trail names included the three Christmas Tree trails (beginner, intermediate, expert), Trail X, Suicide, Main Slope, Ski

The ski rental shop at Jug End was a busy place, with guests getting outfitted for skis, boots and poles, many for the first time. Here, adjustments are made on a skier's leather boots before they headed out for the slopes. *Nancy-Fay Hecker.*

School and the Bunny Slope. Night skiing on limited terrain was added to further increase the options for guests. And in 1965, a plastic ski track was added underneath the paths of the T-bar and major rope tow to ensure an easier ascent.

Also beginning in 1961, Jug End planned to expand the ski area to join the ranks of the larger ski areas in the region. Project V was to include a double chairlift to the summit of Mount Sterling, along with a Pomalift. Trails from the summit were to be called the Launching Pad, Mad Run, Sterling, Rocket, Comet, Orbit, Tyro and Long Jug. Most trails were to have a space theme in honor of the Space Race. Although these plans never came to fruition, they were modified.

In 1963, to expand some of the ski area's offering, a new expert trail was partially cleared from the summit, the Thunderbird. Gosta R. Truedsson, writing for the *Ski Time* magazine, described the trail as a "gem" and said it was "truly a trail of expert caliber, with features designed to challenge the very best—to be sure, only a few will have the courage and technique to 'let

Skiers ride the 1,500-foot-long T-bar at Jug End. Installed in 1961, the T-bar expanded the vertical drop to 300 feet and made access to the trails far easier than the previous rope tows. *Gary Leveille/Berkshire Archive.*

'er rip.'" The trail featured "a fifty-three percent grade, moguls, rolls dips, drop-offs, and sweeping curves."

Initial plans for this trail were to have it served by Sno-Cat and helicopter—this would not to be. The middle portion of the trail was accessed with a new rope tow, bringing the total number of lifts at Jug End to four. Tom Packlick remembered skiing the Thunderbird:

I do remember the "Thunderbird" trail and actually skied on it....I recall the portion that was accessible from a rope tow was quite steep, and the trail was moderately narrow. You could manage turns on it, but it was a challenge.

I believe the ski-able portion of the trail was only serviced by the rope tow for one season. The trail was only briefly open for lack of snow. I assume the ski patrol determined it was too dangerous. The snowmaking equipment did not reach this area, and as I recall, it did not hold snow well. Also, any grooming machine would have difficulty packing the slope because it was quite steep and narrow.

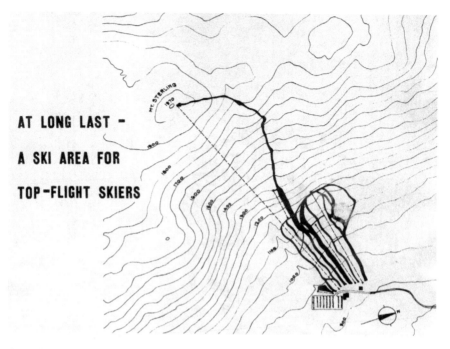

An ambitious expansion plan for Jug End was announced in 1963, with the clearing of the new Thunderbird ski trail from the summit, as seen here. Note the new rope tow that served the middle portion of the Thunderbird. Other lifts, including the T-bar (*far right*), a middle rope tow and beginner tow (*bottom left*) are also depicted. A double chairlift was anticipated to bring skiers to the summit, but it never came to pass. *Author's collection.*

I can verify that the trail was "cleared" all of the way to the summit of Mount Sterling. In the 1960s, we Packlick children hiked up Mount Sterling, following some of the abandoned logging roads. There was a small clearing near the summit, known as "Indian Lookout." Following the logging road north from there, we came to the cleared trail. As I recall, the trail was made up of trees that had been cut down, but not cleared away.

Even an artificial surface for summer training was envisioned as part of this expansion, with the ski area compared to the German Pista Barytine at St. Andreasberg, where skiers could train year round. A double chair was still expected to be installed to the summit over the following years, along with new trails for all abilities.

Outside of the new Thunderbird Trail, these grand plans never came to fruition, perhaps due to their expected high cost. The rope tow for the Thunderbird was soon abandoned, and the trail slowly returned to nature.

By the mid-1970s, Jug End had peaked. Although the planned expansion on Sterling Mountain had been canceled, the ski area served the clientele well. Over twenty ski instructors, led by Hugh Dickinson, were on hand to teach lessons to guests. The resort had added even more facilities—including a skeet shooting range, volleyball courts, domed tennis courts, a modern business center—just about everything that someone would want for vacation. A cross-country ski trail network was even added in 1973. During this time, Angus MacDonald described the resort as "halfway between a dude ranch and posh resort," a happy medium.

Tracey Rock, whose parents worked at the resort, recalled her experience at Jug End during this time:

I grew up just above the resort. My parents moved us from Rhode Island to South Egremont in 1973. My dad got a job at Jug End as head of maintenance, and my mom was head of the snack bars. I learned to ski on the ski slope. My mom ran the snack bar in the ski lodge—I can still picture it as if I was just there. There was a great toboggan chute off the back of the lodge that came down from the roof—we used to use it with or

In the mid-1960s, Jug End was a popular ski area for intermediates and beginners. Visible up the mountain at the far right is the T-bar, with a longer rope tow just to its left. The main intermediate/beginner slope is in the middle, with other beginner tows on the left. Note that a rope tow serving the middle portion of the Thunderbird Trail can be seen on the higher elevations above the lower slopes. *Woodward Bousquet.*

without the toboggans! I remember the bunny tow, the big rope tow, and I was thrilled when I was old enough to go on the T-bar. My two brothers and I spent just about every day here. My older brother became part of the ski school. The ski patrol used to yell at me for skiing too fast and at my brothers for making jumps. What wonderful memories I have of Jug End. I got my first waitressing job in the dining room in the main barn.

The year 1976 would be the peak popularity of the resort, with over thirty-six thousand alumni guests on the active mailing list. Over the decades, famous guests who stayed at Jug End included Eleanor Roosevelt (who opened the first charter of the American Association of the UN at Jug End), Margaret Truman Daniels, Governor John Volpe and Joan Kennedy.

But despite this, the changing markets of the 1970s took their toll on Jug End. Nearby ski areas like Catamount and Butternut offered more substantial ski facilities and higher vertical drops than Jug End's. The resort industry was changing, and more people were traveling farther north for their ski vacations. The corporation's stockholders took the resort in a different direction and soon sold the stock to Joseph and Kendra Bruno. The debt at Jug End was piling up, and despite a loyal clientele, sales were slipping and maintenance costs were growing.

Several poor snow seasons followed in 1979 and 1980, and the ski area had closed by 1981. The Jug End Barn closed permanently in 1983, a sad end to one of the Berkshire's most popular all-season resorts. The property was eventually added to the Massachusetts state park system, and all of the abandoned buildings were removed, with only the foundations remaining today. At the ski area, the base lodge was removed, along with the T-bar and rope tows, though scattered remnants remain today.

The memories and experiences at Jug End are fondly remembered by patrons and family members who enjoyed the resort for so many decades. Nancy-Fay Hecker, the MacDonalds' daughter, recounted the fun and importance of the resort:

So many families came to ski at Jug End. Lots of people in the southern Berkshires and beyond still remember how they learned to ski there and what fun we all had! Jug End drew guests from all over, but it is the community ties that I remember the best. Not only did the resort employ many local residents but it provided an almost magical atmosphere for their families where it was ok to play and share great times with our neighbors and friends, old and new. There was no place quite like it!

Angus and Mimi MacDonald managed the Jug End Barn from 1957 to 1976 and made it into one of the Berkshire's most popular resorts. They frequently promoted the ski area at trade shows, as shown here. *Nancy-Fay Hecker.*

Although Jug End has been lost for almost four decades now, its role in introducing countless skiers to the sport continues to reverberate today. For Paul Edwards, a visit here in the 1960s led to a lifelong appreciation of skiing:

The year was 1966. I was fifteen. I had barely heard of snow skiing. My girlfriend and I went on a one-day CYO bus trip to a resort called Jug End. It was probably my first time out of Connecticut without my parents.

As we got off the bus, we could see the ski hill. It was early, but people were already coming down that hill. It looked huge! Being somewhat cautious, we first tried ice skating. Next, we tried a snowmobile. I was able to ride it around a big field with my gal clinging onto me for dear life. I'm sure she was terrified; I thought it was cool! It was my first time driving any motorized vehicle. I'm sure we did a few other things before we sauntered over to the ski hut, but they've long since been forgotten. As we approached, we watched people going in all sorts of directions on those boards; some falling, others crawling, some really gliding!

There was a tall, leathery, wiry fellow in the ski building who looked as if he'd broken horses or wrestled bears in the mountains and had just come out this once to help run the skiing area. He got us a pair of skis each, and off we went. It turned out to be one of the best experiences of my life.

Subsequently, we went back the following year and brought others with us. The rope tow ate up easily three pair of gloves that first season. One very memorable day on this slope I had fallen so many times that my new jeans left long blue slicks on the snow. We never laughed so much or so had so much fun as we did learning to ski at this place.

I will always have a soft spot in my heart for that tiny little ski area in the Berkshires. Since then I've taught skiing and skied out west and in Europe but I don't think that I have ever enjoyed my skiing quite as much as those first few years at Jug End!

Visiting the Area

The Jug End Reservation is one of the best hiking options to explore a former resort and ski area. It is free, open to the public and has plenty of parking.

The parking lot is located on Jug End Road, half a mile south of the intersection of Mount Washington Road and Jug End Road in South

Egremont. Although the lost ski area is located on Brookvale Road, there is no parking available close to the old ski slopes. The ski area is a relatively short, one-third-of-a-mile hike from the parking lot. This hike is best done in the cooler seasons without leaves on the trees in order to make out the old ski trails and would make for an excellent snowshoe excursion. Backcountry skis could also be used to ski down a portion of the mowed slopes.

Once parked, walk toward the southern end of the lot. Take a look at the foundations for the barn and silo, all that remains of the main building at Jug End.

To begin your hike toward the ski area, look for the trail that leads to the right (west), which shortly crosses the stream over a bridge. Take this trail for about eight hundred feet, until you reach an intersection in a field. During this portion of the hike, you are walking through what used to be a portion of the old resort—buildings, tennis courts and so on. Then, bear to the right, toward Mount Sterling, and follow the trail for one thousand feet, until you reach Brookvale Road. Just before you reach the road, you will be standing at the site of the old base lodge, though there are no remnants.

Directly in front of you is the Jug End Ski Area. Some of the trails are still occasionally mowed, but if you visit in the summer, the grass may be quite tall. You can hike directly up the slopes if you wish, but another option is to follow the path a skier might have taken decades ago—via the old T-bar lift line.

This lift line is found on the right as you face the former ski area, a straight path up the hill. It is easy to follow, though occasional trees have fallen across its path. The lift line is not particularly steep, though it does rise more rapidly at the end. The line is about 1,500 feet in length. As you climb up it, you'll see a few remnants, such as some power cabling and a few pulleys from the ski lift. The main rope tow lift line is just to the left of the T-bar as you face the mountain.

You will soon reach the summit unload for the T-bar, which is noted by a flat, graded area. More lift remnants can be found here, including some rope, the counterweight and power cabling.

As you face uphill, turn to the left and follow this cat track for a short distance, then take a right on another cat track. This will take you to the base of the upper rope tow that served a portion of the Thunderbird Trail. If you look closely, you will see some pulleys high up in the trees from the rope tow. The slope is quite overgrown above this, as is the Thunderbird Trail, and it would be difficult to ascend it.

Instead, as you turn to face downhill, continue down right along the abandoned ski slope. Soon, you will reach the top of the mowed slopes.

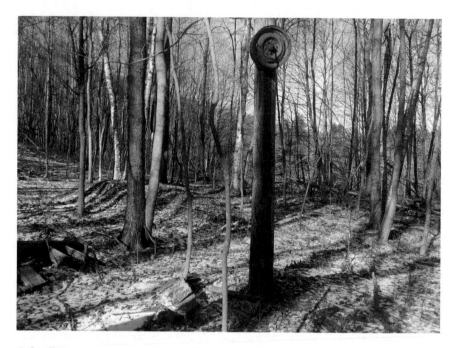

At Jug End, only one lonely rope tow lift tower remains standing at the beginner slope. A few remnants of the engine drive building can be seen on the left, just a few boards and some electrical components. *Author's collection.*

Continue down the slopes to the base of the ski area. A short detour to the right (facing downhill) at the base of the ski area will take you to the beginner rope tow slope. One lift tower remains standing in the woods.

After enjoying your hike, return to your car the way you came.

For more information on the Jug End Reservation, please visit www.mass.gov/orgs/department-of-conservation-recreation.

Leisure Lee

Lee

1968-76

Founded in 1967, Leisure Lee was conceived by Eugene DelVecchio and the Barnum Investment Group of Bridgeport, Connecticut. Its aim was to be an all-inclusive vacation community, with homes and chalets that took advantage of a wide variety of outdoor activities. As part of the community, residents were able to enjoy fishing, tennis, hiking, snowmobiling, skating, softball—and skiing. The ski slope was one of the very few to be open only to residents and their friends and was constructed about 1968.

The slope itself was basic, about 1,000 feet in length with a vertical drop of 150 feet, and was accessed by a rope tow. Often, DelVecchio or his son Gene Jr. operated the rope tow. In addition to the tow, a multipurpose lodge was available for skiers to enjoy between runs.

But Leisure Lee's ski area would only operate sporadically from 1968 through 1976, as the facility was fairly basic compared to other nearby resorts like Butternut or Brodie, which were soon preferred by residents. And the tow was difficult to ridge—Gerry Gauding remembered that the tow was so long, "it was almost impossible to graph the rope all the way to the top."

By 1976, the ski area was abandoned and soon reforested. Leisure Lee remains a private community to this day.

VISITING THE AREA

The former Leisure Lee Ski Area is a part of a private and gated development and cannot be visited. Recent satellite imagery indicates that the ski slope has largely reverted back to forest.

Marlboro Manor

New Marlborough

1963–64

The Marlboro Manor was known in the early 1960s as the "Showplace of the Berkshires." It offered guests a complete 625-acre resort, with swimming, golf, tennis and horseback riding. In 1963, it began to offer skiing on its slopes. A rope tow was built that fall to service intermediate and beginner skiers, with rates of just two dollars per day. Besides guests, members of the public were also allowed to enjoy the slopes. Other outdoor activities such as tobogganing and skating were popular features.

But as fast as the ski area was developed, it was soon closed, likely in 1964. The resort was sold in 1964 and again in 1965, with the final sale to the private Marlboro School.

VISITING THE AREA

The Marlboro Manor Ski Area was located on Route 57, approximately ten miles east of Great Barrington. No trace of the ski area remains.

Oak n' Spruce

South Lee

1947–CIRCA 1982

One of the longer-operating ski areas in the Berkshires, Oak n' Spruce consisted of a short novice slope served by a rope tow. Although the skiing was simple, the resort itself was the main attraction. Here, guests could enjoy a wide variety of activities, from skiing to skating and tobogganing, among an atmosphere designed for maximum guest interaction. Although the ski area no longer operates, the resort itself continues to remain open for guests.

Oak n' Spruce traces its history back to the 1930s and 1940s, when it was the Ascension Farm School for Boys. Operated by the Episcopal diocese, the school provided students who came from broken homes a safe place to be raised. It ceased operation in 1942 and was vacant for several years.

Meanwhile, Frank Prinz of West Hartford, Connecticut, was looking for a career change. He was a mechanical engineer by trade and worked at United Aircraft in East Hartford on some of the early prop jet airplanes. Learning about a large property for sale in the Berkshires, he decided to embark on a new adventure and develop a resort. Much of the following history relies on Prinz's recollections of his ownership of this property as told to the author.

Prinz purchased the former school for $25,000 in January 1947 and took full ownership on March 1. At that time, it consisted of several run-down buildings, including a dorm, a barn, chicken coops and a

farmhouse. He immediately went to work rehabbing the structures. The lodging was quite rustic in the dorms—the Queen's Room held thirty women in bunks, while the King's Room held twenty-eight men in bunks. Only four rooms offered privacy. Prinz also upgraded the kitchen and dining area, which consisted of rustic tables and benches, to serve eighty, along with a recreation hall in the basement. The resort opened on May 17, 1947, to a packed house.

Summertime facilities were hastily constructed, including tennis courts and a dammed-up pond for swimming. Archery and cycling were also featured. At first, the clientele consisted of singles, as Prinz recalled:

> *When Oak n' Spruce opened as a resort, its clientele were young singles who would put up with bunk room accommodations and "no choice menus" served family style.* Playboy *magazine called Oak n' Spruce a "frenetic" resort. One of the most important staff members was the "social director," whose job was to plan morning, afternoon and evening activities. In the Berkshires, our competition was G-Bar-S Dude ranch, Jug End Barn (which was well established) and Eastover that opened a week after us. We all offered recreational facilities, BYOB bar and all meals included in the rate.*

Building upon the growing summer business, Prinz soon turned this attention to the approaching winter. He installed a two-hundred-foot-long rope tow at the rear of the property on a modest hill, with a vertical drop of about eighty feet. There was no room for any significant expansion, but that was part of the plan—the ski area was designed specifically for novices. Prinz did note that the resort was within a half an hour's drive from more ski tows than anywhere in the world—perhaps a bit of an exaggeration—but other ski areas were nearby if experts wished to ski somewhere else.

The tow opened in late December 1947 with good snow conditions. For the first season, the slope was open mainly on weekends and holidays, but by the second year of operation, night skiing was added, which allowed for expanded hours three days a week. In a 1953 *Ski Time* article, Prinz touted the benefits of night skiing for his guests:

> *Anyone who doubts that night skiing is terrific, for skier and spectator alike, should visit Oak n' Spruce and see the young men and women enjoy this sport. Here, in sight of the floodlighted skating rink, the superior thrill of night skiing can be seen and appreciated. Our guests take to it immediately*

and return to it on every trip. After a pleasant dinner, they can walk out a few dozen feet, put on their skis and enjoy our own ski tow. Those that are just learning can pick up valuable experience and those who already know how to ski can obtain valuable practice. After a bit of floodlighted skiing, there's dancing and pleasant fireside companionship to make it a perfect evening.

As the resort continued to ramp up operations, a Swiss ski instructor, Emil Ehrenzeller, was hired. He worked for the resort for several years, from 1948 through the early 1950s. Ski packages offered by Oak n' Spruce included instruction with Ehrenzeller along with unlimited use of the ski lift, lodging and food. This gave new skiers the chance to try out the sport "without wasting a lot of money," according to Prinz.

A major change to the resort offerings occurred in late 1950. Frank Prinz's brother Al took over the operations at the nearby Beartown Ski Area. The ski trails at Beartown were located just one-quarter of a mile away as the crow flies (though the access through the railroad station was a bit farther, at one mile from the resort). With the two brothers in charge of the two ski areas, guests would be able to enjoy the novice slope if they were inexperienced or head over to Beartown for more challenging terrain. Ehrenzeller continued to teach novice lessons at Oak n' Spruce each morning, then taught more advanced skiers at Beartown in the afternoon, usually on the Polar Trail and Slope.

This arrangement would last until the 1954–55 season. At that point, Al Prinz gave up on the operation at Beartown—citing its lack of parking as a serious concern. Focus then returned to the Oak n' Spruce area. Throughout

Novices particularly enjoyed the easy slope at Oak n' Spruce. Here, skiers gather at the top of the slope overlooking the resort. The vertical drop was less than one hundred feet and was just a few hundred feet long. *Frank Prinz.*

The novice rope tow was especially designed for easy use. In addition, the tow was sited right next to a base lodge (seen at the foot of the tow), which served hot soup, sandwiches and coffee. The two main buildings for lodging can also be seen on the left—skiers had to walk only a minute to the slopes. *Frank Prinz.*

the rest of the 1950s, the resort continued to attract skiers from New York and New England. If snow was absent, other activities were made available to keep guests happy and busy.

As the 1960s began, Oak n' Spruce was about to embark on its most successful decade. On the ski area side, a rudimentary snowmaking system was installed for the 1959–60 season. This system, designed by Joe Tropiano of Larchmont Engineering, resembled a lawn sprinkler. According to Prinz, it often froze up and eventually was no longer used. A toboggan chute was built for non-skiers, and the snowmaking system, when functional, could also be used to cover the chute. This is the first known example of snowmaking for a tubing/sledding area in the Berkshires, a precursor to today's resorts that often have snow tubing facilities.

To better serve the growing clientele, a new ski lodge was built at the foot of the slopes for 1960. Located next to the stream that flowed through the property, the attractive timber-framed lodge contained huge picture windows overlooking the slope. A log-burning fireplace helped warm skiers up between runs. Hot soups, sandwiches and other refreshments were enjoyed by skiers at lunchtime. Music was piped out across the slopes, which were now served by a new and lengthened electric rope tow, with the engine purchased from the defunct G-Bar-S Ranch. Additional indoor attractions were added, including more movies, orchestra performances, expanded dancing, new offices and a gym.

Although the ski slope was primarily used by guests, Oak n' Spruce did open them up to the public. An affordable two dollars per day was charged.

In 1963, the resort underwent a $500,000 expansion, the largest in its history. After seven months of construction, thirty-two new rooms with a Japanese motif were added. The menu was expanded to include fancier

dishes, replacing the comfort food of old. The dining room was expanded to four times its original size, with a cocktail lounge added.

With the failure of the original snowmaking system, Prinz turned to other methods. One such method involved using mattress stuffing as an artificial surface, as Prinz explained:

> *One of Oak n' Spruce's innovations was to cover the slope with mattress stuffing materials and then cover this material with "ground up plastic poker chips." The tow line was covered with a narrow blanket of nylon mesh. It worked; however, the slope had to be raked every time a skier came down.*

With the obvious drawbacks to this system, Prinz turned again to Larchmont. In the years since the first system, a more efficient snowmaking machine had been developed called the Superjet. Nicknamed "the world's smallest snowmaking machine" and installed for the 1965–66 season, this new system could make up to three feet of snow on a frigid night. Two pipelines, one air and one water from the Powderhill Brook, combined in a large nozzle to produce quality snow. The machine could also be moved to the five-hundred-foot toboggan slide if needed.

Turning to the theme of being the smallest around, Prinz started to market the ski area as the "Largest Little Ski Area in the U.S.A." An emphasis was placed on "social skiing"—skiing at Oak n' Spruce was meant to be fun with friends and family, with parties and relaxation afterward, as opposed to the frenetic skiing often found at a major resort.

Oak n' Spruce was even the backdrop for a ski documentary in March 1968. Station WNRC of New York City came to film for a weekend, following forty-two secretarial students from the Berkeley School in New York. The documentary was meant to show how much fun a weekend of skiing could be in the Berkshires.

In the late 1960s, Prinz purchased 130 acres of land to the south of the resort with the hopes of developing it into a major ski center. As he was tapped out financing the resort expansion earlier in the decade, this plan never came to fruition.

Although the 1960s had seen Oak n' Spruce's ski area at the height of popularity, this began to change in the 1970s. A better interstate highway system was now in place, and skiers could travel much farther in shorter periods of time. Larger and more northern resorts offered more ski terrain and newer hotels. By the mid-1970s, Prinz began to explore the possibility of selling the resort. The resort was listed for sale, but that

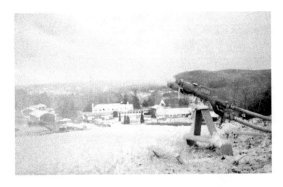

After an initial failed snowmaking installation in 1960, Larchmont Engineering installed this dual nozzle Superjet snowmaking machine in 1965. On a cold night, it could put down up to three feet of snow and helped ensure skiing during snow droughts. A mobile system, it could also be moved to cover a toboggan chute. *Frank Prinz.*

would not take place for another ten years, in 1985. In the meantime, the ski area began to be used less and less, as guests gradually gravitated to other resorts. It would cease operation around 1982, after thirty-five years of operation.

In 1985, Prinz sold the resort to a time-share company, which then sold it to Silverleaf in 1988. The company expanded the resort, adding more lodging, with a portion of the ski slope excavated for its construction. The ski slope is gone—but the memories of skiing at Oak n' Spruce continue to live on.

As for Prinz, he later moved to California and remained active well into retirement. At age seventy, he returned to his first passion of aviation and built his own experimental aircraft. He sold it at age eighty and then proceeded to build another, which he sold at age eighty-five. At the time of this writing, at age one hundred, Prinz is the last link to the ski area founders in the classic age of Berkshire ski resort development. The legacy of Prinz, along with his wife, Bea, and their children—Roy, Patti, Nancy, Carol, Betsy, Tom, Rick and Ed—continues in the memories of all who skied here and continue to enjoy the resort to this day.

VISITING THE AREA

Today, Oak n' Spruce is a private time-share resort owned by Holiday Inn Resorts and is not open to the public. But if you are staying here, a tiny portion of the ski slope can be seen directly to the northwest of Building 18.

More information on this property can be found at members.holidayinnclub.com/explore-our-resorts/oak-n-spruce.

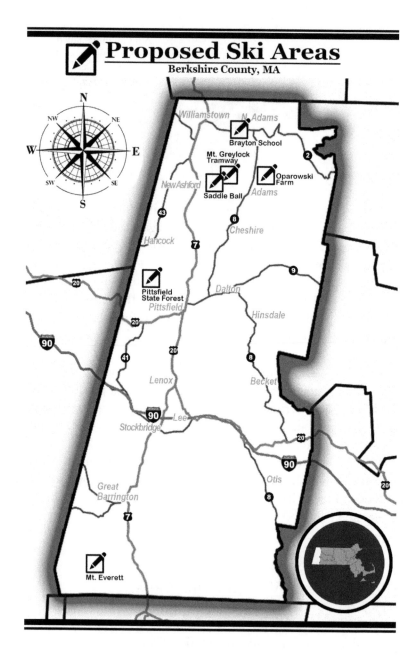

Proposed Ski Areas
Berkshire County, MA

Six ski areas were considered for development in the Berkshires. These ranged from a proposed rope tow at the Brayton School to a massive resort complex on Mount Greylock and Saddle Ball. *Brandon Capasso.*

PART VIII

PROPOSED SKI AREAS

everal lift-served ski areas were proposed in the Berkshires but never made it off the drawing boards. In order to be considered a proposed ski area, lifts were not constructed, but the plans did have to make it beyond a casual discussion, such as by appearing in a newspaper. For a few of these areas, such as the Brayton School and the Pittsfield State Forest, ski slopes, trails and jumps did operate. Others, such as the Mount Greylock Tramway were heavily debated and planned for many years, only to be canceled due to strong opposition and court decisions.

There may have been other areas that were discussed privately by potential developers never reached the public sphere. Some proposed expansions, such as at Beartown or Oak n' Spruce, were possible additions to existing areas and are discussed in their histories.

Brayton School

North Adams

1966

The brief ski area at the Brayton School is a hybrid proposed area. While it did open for skiers in 1966, plans for a ski lift never came to fruition, and the slope was only open for a few months.

In the fall of 1965, the North Adams Parks and Recreation Commission were investigating the potential of opening a small municipal ski area. The goal was to provide a simple family ski slope that would be affordable (or free for residents). The commission investigated several sites, including one at Windsor Lake, but that location would need a significant amount of work and it was too late in the year to proceed. Another spot on the city's sanitarian George Heisler's personal property was also looked at.

Instead, the open slope at the Brayton School was chosen to be developed, as it was already clear and had parking. Commissioner George Fairs noted that it only needed a minimal amount of work to open it as a small ski area. Volunteers from the Dutch Hill, Vermont Ski Patrol came forward to offer their expertise. Fairs estimated that it would cost no more than $500 to open the ski area with a portable rope tow.

On January 4, 1966, the commission officially opened the ski slope at the school. Lights were available for night skiing. However, no lift was available. Fairs noted that "providing electric power for the tow would be prohibitive." Although the short slope was open for evenings during that winter, a lift was never installed.

The commission abandoned the project in the fall of 1966, when it shifted its attention to a new ski area that would indeed have a rope tow—at Windsor Lake. Today, the short open slope at the Brayton School is still visible.

Mount Everett

Mount Washington

Proposed 1936

In late 1936, a unique ski area was planned for Mount Everett. Here, a five-mile-long trail would be built to challenge the Thunderbolt. Birger Torrissen, who led the U.S. Eastern Ski Association, and W. Whitman Bowers and Andrew Westhead proposed the ski area. The trail would lead down to Guilder Hollow (near the future Jug End Ski Area), winding its way through the pines. A unique ski tow was devised—using horse-drawn sleighs to bring skiers to the summit. The plan never materialized, and this unique ski tow never came to fruition.

Mount Greylock Tramway
and Saddle Ball

Adams

PROPOSED 1951–EARLY 1970S

From the 1950s and into the early 1970s, multiple proposals for a tramway up Mount Greylock were considered and nearly implemented. Along with that proposal, a ski area on Saddle Ball, a peak just south of Mount Greylock, was considered for development. While two distinct projects, they were potentially going to be interconnected and were often discussed together, as they will be here. Although the two projects never got off the ground, they did, at least indirectly, lead to the development of the Greylock Glen ski area.

Mount Greylock, as the highest mountain in the Berkshires and southern New England, has long been a target for various developments. The Thunderbolt Ski Trail and other trials in the 1930s led to its consideration for a more advanced ski area. And in the early 1950s, plans began to coalesce around a tramway to the summit.

Tramways in the United States were and are relatively rare. They were much more common in Europe in the 1950s, with seventy tramways in operation. The only one near Mount Greylock was at Cannon Mountain in Franconia Notch, which had a somewhat similar profile to Mount Greylock. The Cannon Mountain Tramway carried 150,000 skiers to the summit each year in the 1950s, and if this ridership could be replicated on Mount Greylock, then that would greatly add to tourism income.

A special committee was formed in the fall of 1951 to consider the development of a tramway up the east face of Mount Greylock, starting from the Gould Farm area. In 1952, Marvin Wineberg was selected to chair the committee, and the Adams Board of Trade threw its full support behind the project. Promotional films and visits to the tramway at Cannon Mountain were undertaken to show the potential for the lift.

By 1953, details emerged about the potential lift. It was to be built by American Steel and Wire and would have a vertical drop of 2,050 feet. Two cars would carry forty passengers each at a speed of 1,200 feet per minute, resulting in a lift ride of four minutes and twelve seconds. The cars would be outfitted with special racks for skis, and the lift would run during the warmer months, providing much more rapid access to the summit than the auto road. Ski trails would fan out from the summit, including the use of the Thunderbolt Trail. The large vertical drop would have made the ski area one of the tallest in New England.

In 1953, the Mount Greylock Tramway Authority was formed via an act at the Massachusetts legislature, designated to plan the potential for the tramway and ski area. In 1953, $10,000 was allocated for planning and the same amount in 1955. Sel Hannah, who would later found Sno-Engineering, a leading ski area design firm, made preliminary design plans for the ski trails in 1955. The potential for up to five hundred new jobs as part of the project was bandied about.

Support slowly grew for the project in the mid-1950s, but by 1957, it had stalled. The Massachusetts legislature failed to get behind a bond proposal to raise funds for the tramway. In 1959, only $785 of the $20,000 appropriation remained, the majority spent on planning expense.

Meanwhile, there was growing concern about the feasibility of ski trails on the east flank of Greylock. In 1959, James Garstang, the president of the Mount Greylock Ski Club, stated that the tramway site would be terrible for ski terrain. Poor snow conditions due to crosswinds, combined with topography, made access to the ski trails problematic for the summit.

These concerns started to make their way into the public discourse. If the tramway and attendant ski trails were built, many local residents feared that Mount Greylock would be irrevocably altered. Local opposition groups were formed, including the Greylock Protective Association, in order to prevent what they considered to be the harming of the mountain.

The Tramway Commission, nearly depleted of funds, took a hiatus for a few years from 1960 to 1961, but by 1962, it had reactivated. New executive director Joseph Dragone from Springfield led the organization, and in

September 1962, he unveiled an even larger $8.5 million development. A tramway or gondola would take skiers from the Gould Farm to the summit of Mount Greylock, where additional trails and lifts would fan out along the east slope. Restaurants, gift shops, cocktail lounges and swimming pools would be featured at both the top and base stations.

At the same time, other groups and local business leaders were pushing for a different area to be developed. Located on the same ridgeline but just to the south of Mount Greylock, Saddle Ball, above a plateau, would be able to feature gentler trails and slopes for all abilities. There were concerns that the Tramway trails would be much too steep for the average skier, as well as limited in scope, which would reduce the patronage to fewer than six hundred skiers per day. The Saddle Ball development would be able to host a few thousand.

From 1964 to 1966, there were numerous hearings, studies, legislative action and plenty of controversy over the Saddle Ball and Mount Greylock Tramway development. In the end, it all boiled down to a Massachusetts Supreme Court decision on March 10, 1966, saying that the four-thousand-acre lease for the project was an illegal use of public land for private profit.

The Saddle Ball project, however, was not dead. In May 1967, Joseph Deliso applied to the Department of Natural Resources for a lease of land on Saddle Ball, in conjunction with property that he already owned. The plans were to include a lodge off of West Mountain Road, two 3,000-foot chairlifts rising 600 feet, and then another, likely a mile-and-half-long, bubble chairlift to the top of Saddle Ball. All told, the ski area would have a vertical drop of 2,200 feet, by far the largest in Massachusetts. A swimming pool, lodging and horseback riding would all be available.

By June 1967, the project had been discussed with the Adams Planning Board, and Joseph Dragone was back once again as a consultant for this project. In September, Deliso purchased the nearby Petersburg Pass Ski Area, located along Route 2 on the New York–Massachusetts line. The ski area was purchased in order for Deliso to gain experience in operating a ski area.

Although Deliso attempted many times throughout the late 1960s to get the project off the ground, there was a lack of financing and trouble securing a lease for the public land. Many Adams town officials remained skeptical of the project, calling it a "utopian dream." In 1969, Deliso tried one more time for a lease but was denied, and the project fell apart. Later, some of the property belonging to Deliso was purchased by the developers of Greylock Glen and incorporated into that project.

Oparowski Farm

Adams

Proposed 1974–75

As part of the land speculation surrounding the Greylock Glen Development, the Oparowski Farm in Adams was purchased in 1974. Located across the valley to the east of Mount Greylock, the farm was purchased by Philip Grande (who was the former assistant ski school director at Brodie) and Harry Patten, then immediately purchased by the Elco Corporation, which was developing Greylock Glen. It was bought as a hedge against a potential ski area that was going to be built at the farm.

In 1975, after financial troubles at Greylock Glen were reaching a fever pitch, Philip Grande, who still held the third mortgage at the farm, worked to foreclose against Elco for nonpayment of debts. Grande proposed a $2 million ski area that would be smaller in scope than Mount Greylock but would still be a moderately sized resort. A vertical drop of one thousand feet, two lifts, lights and snowmaking were expected to be included in the development.

Although the plans were discussed openly, the project never got off the ground, likely spooked by the failed development of Greylock Glen.

Pittsfield State Forest

Pittsfield

Proposed 1948–52, Ski Trails Open From 1935–Present, No Lift Service

Skiing has been a part of the Pittsfield State Forest since the mid-1930s. Two ski trails, the Ghost and Shadow, a wide-open slope called the Lulu Cascade and a ski jump all made their mark. A tragic skiing accident in 1936 led to major changes for skier safety nationwide. And in the late 1940s and early 1950s, a contentious plan to add ski tows, widen trails and make other improvements was approved by the legislature but never implemented.

Ski trails were developed by the Civilian Conservation Corps in 1935. Initially, one trail, the Ghost, was cleared on the east slope of Pine Mountain. This trail featured a vertical drop of 682 feet 3,000 feet in length, was intermediate in difficulty and rather narrow, just 18 to 35 feet in width. Its twin, the Shadow, was cleared in 1938 and had a similar drop and width. The trails were considered to be "twisting and interesting with a steady descent" in the 1940 *Skier's Guide to New England*. A wider slope, the Lulu Cascade, had a vertical drop of 200 feet and was a third of a mile long—it was designed to be a slalom slope. A ski lodge was built by the 125th Company of the CCC in 1937 to best serve skiers.

With the Ghost trail opening for the 1935–36 season, hundreds of skiers soon flocked to enjoy it. It boasted one of the higher vertical drops for a ski trail and was quite interesting. Buses were employed to bring skiers who arrived on the snow trains from the Pittsfield station, a twenty-minute trip.

Tragedy hit the fledgling development on March 8, 1936. Twenty-eight-year-old Franklin Edson III, from Greenwich, Connecticut, was a member of the Amateur Ski Club of New York and a real estate broker. He was staying the weekend at the Guilder Hollow Club, later known as Jug End (another lost ski area), as a guest of Major Hugh Smiley. Conditions on the trail were fast and icy. As part of a four-person team racing that day, Edson, who had nearly completed the run, lost control and crashed into a tree. He fractured his ribs, suffered other internal injuries and broke his foot. Rushed to the hospital by a doctor on duty, Dr. Clement, Edson was treated, but the injuries were too serious for him to recover. He died on March 9.

Members of the Amateur Ski Club and Edson's friends were devastated. At this time, there was no national group that could be organized to ensure safe racing and skiing conditions. A few years later, in 1938, Charles Minot "Minnie" Dole, a friend of Edson, had formed his own ski patrol at the National Downhill Race in Stowe. Roger Langley, head of the National Ski Association, approached Dole and asked him if he could take this idea nationwide. Working with Langley and Roland Palmedo, Dole founded the National Ski Patrol, which continues to serve skiers today, ensuring safe conditions for all. Although Edson's death was a tragedy, the accident in the Pittsfield State Forest was the impetus for the formation of the patrol, which has saved countless lives over the years.

During World War II, the ski trails saw less activity due to wartime restrictions but were occasionally used for high school meets. A twenty-five-meter jump was built during this time. But despite the site having the facilities of a typical ski area of its time (trails, slopes, a jump and a lodge), no lift service was available.

Attempts to change this began in 1948, when in December, State Representative Daniel Casey (D) met with Governor-elect Paul Dever (D) to discuss the possibility of adding a ski tow to the state forest. The plans went nowhere at first, but that all changed in 1950.

As a precursor to some of the battles ahead on Mount Greylock for a state-operated ski area, in 1950, State Senator Michael Condron (D) made a push for the installation of ski lifts and other improvements. The rough plans were to put in a tow to service the Ghost and Shadow, with another tow on the Lulu Slope. The Ghost and Shadow Trails were to be widened to accommodate more skiers, and other trails were to be cleared.

During budget negotiations at the statehouse on August 11, Condron was able to insert a $100,000 line item for the ski area improvements, better roads through the state forest and a fire truck. But although the improvements might have meant more jobs and increased tourism, the budget request was not well

received by Pittsfield-area residents. Editorials were printed that it was nothing but pork and that there were more pressing needs. Others doubted whether the improvements were necessary at all, as there were plenty of other ski areas burgeoning throughout the Berkshires. Out of the $100,000, $500 would go to an expanded jump, $2,500 to widen the trails and $5,000 for the ski tows. The rest would go toward the road improvements and equipment.

On August 16, the budget was approved by the legislature and signed by Governor Dever. Condron's opponent for reelection was Silvio O. Conte (R), who railed against the plan as a huge waste of taxpayer money. At a forum in late October, he repeatedly attacked Condron for the $100,000 request and accused him of doing it as a quid pro quo to support a Boston-area budget request. Conte went on to beat Condron in the election.

Although Condron was no longer in office, the appropriation still was. Plans to put in a ski tow were put on hold in 1951 due to the Korean War. The National Production Authority (NPA) did not allow the use of metal pipes for drainage or the purchase of rope tow equipment. In 1952, the restrictions were lifted, and supervisor Edgar Gillett tried one more time to have an eight-hundred-foot-long tow installed—but had no luck. Instead, the appropriation went toward repairing the ski lodge, improving trails and purchasing other equipment. The plans to put in a lift never resurfaced.

Throughout the 1950s and into the 1970s, the facilities were still very much in use, often the site for high school ski meets and for hardy skiers willing to earn their turns. But by the late 1970s, the days of ski meets ski areas with no lift service was coming to an end, and events were held at other resorts. The ski jump and Lulu Slope were abandoned. However, the Ghost and Shadow Trails continued to be maintained by the DCR, and today they are in pristine shape—true classic examples of historic ski trails that can still be enjoyed by hikers and those who wish to earn their turns.

Visiting the Area

One can enjoy the ski trails at Pittsfield State Forest any time of year. From the ski lodge, directions to the Ghost and Shadow Trails are clearly noted. These are not difficult to hike in the summer and can be snowshoed or backcountry skied in the winter. Farther north, at the parking lot just south of the Lulu Cascade, one can explore the remnants of the ski jump (just west of the parking lot) and visit the overgrown Lulu Cascade Slope, just south of the jump.

Please visit www.mass.gov/locations/pittsfield-state-forest for more information, directions and a trail map.

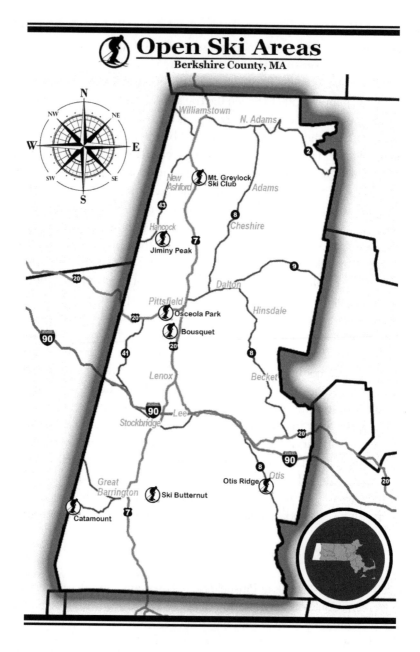

Open Ski Areas
Berkshire County, MA

Only seven ski areas remain in operation in the Berkshires out of a total of forty-four. Despite the reduced number, these excellent ski areas offer a wide variety of skiing for all budgets. The author strongly encourages the reader to check out the six public areas or join the Mount Greylock Ski Club to support a classic area. *Brandon Capasso.*

PART IX

OPEN SKI AREAS

lthough thirty-seven ski areas have been shuttered across the Berkshires, seven continue to operate as of this writing. These areas continue to keep the spirit of Berkshire skiing alive, by either preserving traditions and by innovating for the future. Rope tow areas such as Osceola Park and the Mount Greylock Ski Club harken back to a simpler time when surface lifts and natural snow were king. Family ski areas like Otis Ridge and Bousquet offer affordable skiing with terrain for all ability levels.

Mid-sized ski areas such as Catamount and Butternut are perfect for skiers of all abilities—allowing skiers of different skill levels the chance to ride the same lift but pick their own trails down. And Jiminy Peak offers a complete resort experience without having to travel farther north to northern New England. Many ski areas also offer night skiing.

The author encourages the reader to visit and enjoy these ski areas. If you are staying in the Berkshires for a long weekend, you can check out three different areas, with relatively short driving times regardless of where you stay. If you live in the region, consider joining the Mount Greylock Ski Club where you can be part of an eighty-year tradition.

BOUSQUET MOUNTAIN
Pittsfield

Address: 101 Dan Fox Drive, Pittsfield, MA
Opened: 1932 without lifts, 1935 with a rope tow
Vertical: 750 feet
Trails: 23
Lifts: 4 total: 3 Doubles, 1 Carpet
Night skiing: Yes

Web: www.bousquets.com
Phone: (413) 442-8316

Bousquet Mountain is the oldest operating ski area in the Berkshires. The first descents of the mountain occurred during the 1932–33 season, when members of the Mount Greylock Ski Club skied its pastures. Clarence Bousquet developed it as a snow train destination beginning in 1935, and today, it is a family-friendly resort with a variety of ski terrain. Trails from the summit feature a scenic view of Pittsfield and surrounding mountains. One if its chairlifts, the Green Double, once operated at the now lost Eastover Ski Area. Among its nearly two dozen trails, the narrow and expert Louise's Folly challenges skiers from the summit with its natural snow conditions. Beginners will enjoy the Drifter Trail on the east side of the mountain, with intermediates cruising down the sweeping Easy Rider to the Yokun Slope to Harris from the summit.

BUTTERNUT
Great Barrington

Address: 380 State Road, Great Barrington, MA
Opened: 1963
Vertical: 1,000 feet
Trails: 24
Lifts: 10 total: 3 Quads, 1 Triple, 1 Double, 1 Poma, 4 Carpets
Night skiing: Yes
Web: www.skibutternut.com
Phone: (413) 528-2000

Ski Butternut opened in 1963 on the site of the former G-Bar-S Ranch ski area. Over the last fifty years, Butternut has earned the reputation for family-friendly skiing and riding on two dozen trails and parks. Experts gravitate to the quick drops of Lucifer's Leap or the moguls at Downspout, while Applejack provides intermediates with excellent cruising terrain. Beginners have their own learning center and, once they progress to the novice level, can enjoy the long Pied Piper from the summit. An active racing program trains racers on its own racecourse slope, served by a Poma.

CATAMOUNT
South Egremont

Address: 17 Nicholson Road, South Egremont, MA
Opened: 1940
Vertical: 1,000 feet
Trails: 36
Lifts: 7 total: 1 Quad, 1 Triple, 2 Doubles, 3 Carpets
Night skiing: Yes
Web: www.catamountski.com
Phone: (413) 528-1262

One of the Berkshires' longest-operating ski areas, Catamount has been enjoyed by skiers for almost eighty years. Once boasting up to eleven rope tows sixty-five years ago, it now features four chairlifts and three carpet lifts. Its unique layout allows skiers to ski in two states—trails on the western side of the ski area are in New York, and those on the eastern side area in Massachusetts. A wide variety of ski terrain is available for all abilities—from easier terrain off the Meadows Triple, to long intermediate cruising on Sidewinder and the double diamond Catapult, the steepest trail in Massachusetts.

JIMINY PEAK
Hancock

Address: 37 Corey Road, Hancock, MA
Opened: 1948
Vertical: 1,150 feet
Trails: 45
Lifts: 9 total: 1 high-speed six-passenger detachable lift, 2 Quads, 3 Triples, 1 Double, 2 Surface
Night skiing: Yes
Web: www.jiminypeak.com
Phone: (413) 738-5500

Jiminy Peak is the largest ski area in the Berkshires and has a wide variety of terrain and lifts. Novices can enjoy the long Left Bank trail from the summit, while intermediates gravitate toward North Glade, Riptide or Upper Fox for cruising. Expert skiing abounds, with the double diamond Jericho challenging the best skiers. Jiminy also has ties to a lost ski area—its early rope tows were from the former Farnams in the Berkshires ski area.

Mount Greylock Ski Club
Williamstown

Address: 285 Roaring Brook Road, Williamstown, MA
Opened: 1937
Vertical: 310 feet
Trails: 17
Lifts: 2 rope tows
Night skiing: No
Web: www.mtgreylockskiclub.com
Phone: (413) 445-7887

The Mount Greylock Ski Club is a true, living ski area museum and is one of the best operating examples of its kind. Its facilities harken back to the early days of the former rope tow ski areas in the Berkshires. The area is supported 100 percent by its membership, who both perform physical work maintaining and operating the ski area as well as providing for its finances. While the ski area is only open to members and their out-of-town guests, prospective members may ski at the area once if they are considering joining. Yearly membership rates are extremely affordable for singles and families at prices that are less than a day at a major ski area. Trails range from the beginner West Pasture to the winding intermediate Twister to the expert Chute and several gladed runs. The ski area also is the last one to allow Bousquet Tow Grippers to make riding the rope tow easier.

Osceola Park
Pittsfield

Address: 41 Osceola Street, Pittsfield, MA
Opened: circa 1947
Vertical: 85 feet
Trails: 1
Lifts: 1 rope tow
Night Skiing: no

Web: www.cityofpittsfield.org/city_hall/community_development/parks_
 and_recreation/winter_spring/osceola_park_rope_tow.php
Phone: (413) 499-9370 (Pittsfield Recreation activities coordinator)

The last rope tow–only ski area open to the public in the Berkshires, Osceola Park is operated by the Pittsfield Recreation Department, mostly

The 1,300-foot-long rope tow at the Mount Greylock Ski Club is the longest rope tow still in operation in Southern New England. It travels at a rate of eighteen feet per second, about as fast as a high-speed quad. Bousquet Tow Grippers are still allowed to make riding the tow easier on the arms. Classic ski trails and slopes cascade from the summit for all abilities. *Author's collection.*

on weekends and holidays. It is a simple operation, with a rope tow serving one slope, and relies on natural snow. It is used now mostly by sledders, but skiers and snowboarders are still welcome to practice their skills at this community area.

Otis Ridge
Otis

Address: 159 Monterey Road, Otis, MA
Opened: 1946
Vertical: 400 feet
Trails: 11
Lifts: 4 Total: 1 Double, 1 T-bar, 1 Pony, 1 Handle Tow
Night Skiing: yes
Web: www.otisridge.com
Phone: (413) 269-4444

Otis Ridge is a family ski area with a variety of trails for all abilities. Classic ski trail aficionados will enjoy the narrow, twisting Dutchman and Ridge Run Trails, while novices will enjoy the long Acorn Trail, which skirts the periphery of the resort. Two lifts access the summit—a double chairlift that used to operate at Flagg Hill (a lost ski area in Acton, Massachusetts), along with a T-bar. The Otis Ridge Ski Camp, located on the opposite side of the ski area, has been teaching racing techniques to children for nearly seventy years. The low rates and friendly vibe of Otis Ridge makes it a must-visit for anyone who wishes to experience the heritage of skiing in the Berkshires.

Afterword

Preserving the Lost Ski Areas
of the Berkshires

lthough the loss of thirty-seven ski areas has been hard on so many skiers and operators, it is hoped by the author that this book will help to illustrate their unique and varied histories. These ski areas had such a positive impact on so many, and their legacies will live on forever. Sharing and documenting your own experiences helps contribute to this goal.

One way to share your own memories and photos of lost Berkshire ski areas is to visit the book's Facebook page, available at www.facebook.com/lostskiareasoftheberkshires. You may even be able to connect with old friends you used to ski with at these mountains and learn about special events connected to lost ski areas. You can also learn more about lost ski areas in the Berkshires and beyond by contributing to the New England and NorthEast Lost Ski Areas Project (www.nelsap.org) and Facebook page (www.facebook.com/lostskiareas).

It is important to support efforts to document and record these ski areas. The New England Ski Museum (www.skimuseum.org) is one such organization that archives and researches skiing in the Berkshires and beyond. By becoming a member, you can support efforts to preserve the future of skiing's past.

If you are visiting Adams, be sure to visit the Thunderbolt Ski Museum (thunderboltskirunners.org/museum/about-the-museum) located a 3 Hoosac Street. Here, you can explore various exhibits that document the history of skiing on the Thunderbolt and Mount Greylock, with free admission.

You can even directly help preserve a piece of skiing history by joining the Thunderbolt Ski Runners (thunderboltskirunners.org), a group that hosts an annual ski race on the famed trail and actively maintains it.

Local historical societies often document the ski history in their particular town or city. Be sure to support these societies and contribute your memories, photos, ephemera and so forth so that others may enjoy them as well.

Finally, take the time to explore some of these lost areas. Throughout the book, directions are given on which areas are best to check out. When exploring, take a moment to reflect on the efforts to make the ski area a vibrant place. By doing so, you honor all of the contributions and efforts of those who worked so hard to make it possible.

Bibliography

Berkshire Eagle (Pittsfield, MA). January 1931–December 2017.

Brooklyn (NY) Daily Eagle. January 1935–March 1942.

Buxton, John. *Eastern Ski Slopes.* Greenwich, CT: John S. Harold Inc., 1964.

Clark, Jeremy. "Eastover Resort." New England Ski History. http://newenglandskihistory.com/Massachusetts/eastover.php.

Conniff, Cal, and E. John B. Allen. *Skiing in Massachusetts.* Charleston, SC: Arcadia Publishing, 2006.

Elkins, Frank. *The Complete Ski Guide.* New York: Doubleday, Doran and Company Inc., 1940.

Explore Adams. "Progress at the Glen." http://exploreadams.com/9-adams-archive/29-progress-at-greylock-glen.

Federal Writers Project. *Skiing in the East: The Best Ski Trails and How to Get There.* New York: M. Barrows & Company, 1939.

Find a Grave. "George Joseph Bisacca." https://www.findagrave.com/memorial/167782380.

Fitchburg (MA) Sentinel. January 1940–April 1959.

Greenfield (MA) Recorder. January 1936–April 2006.

Guerinoi, Jack. "Greylock Glen Trail Work to Begin in Spring." IBerkshires. April 7, 2017. http://www.iberkshires.com/story/54285/Greylock-Glen-Trail-Work-To-Begin-In-Spring-.html.

Haslam, Patricia L., Charlie Lord and Sepp Ruschp. *Ski Pioneers of Stowe Vermont.* Bloomington, IN: IUniverse LLC, 2013.

Knickerbocker News (Albany, NY). May 1954.

Landman, Joan, and David Landman. *Where to Ski*. Boston: Houghton Mifflin, 1949.

Moore, Herbert. *Ski Time—The 1953 Ski Guide for Nearby New England*. Lenox, MA: Berkshire Sketch, 1953.

New York (NY) Sun. January 1935–February 1942.

North Adams (MA) Transcript. January 1935–January 2014.

Pain, William. *The American Ski Directory*. New York: Permabooks, 1961.

Peattie, Robert. *The Berkshires—The Purple Hills*. New York: Vanguard Press. 1948.

Purple Mountain Majesty. Prod. Blair Mahar. 1999. Film.

Recreational Development Committee, New England Council. *The Skier's Guide to New England*. Boston: New England Council, 1938–47.

Scott, Meredith. "Mezzy Barber." Vermont Ski and Snowboard Museum. www.vtssm.com/hall-of-fame/2003/311.

Skiracing.com. "Ski Industry Legend Ed Chase Dies." https://www.skiracing.com/stories/ski-industry-legend-ed-chase.

Ski Time. "Pleasure Takes Over in the Berkshires." (January 1965): 15–40.

Sports-Reference.com. "John Ericksen." https://www.sports-reference.com/olympics/athletes/er/john-ericksen-1.html.

———. "Ralph Townsend, Jr." https://www.sports-reference.com/olympics/athletes/to/ralph-townsend-jr-1.html.

Truedsson, Gosta R., PhD. "At Long Last—A Ski Area for Top-Flight Skiers." *Ski Time* (1964): 11-25.

UNH Today. "UNH Skier Awarded Purple Heart." February 14, 2013. https://www.unh.edu/unhtoday/2013/02/unh-skier-awarded-purple-heart.

Williams College. "Williams Skiing." http://ephsports.williams.edu/sports/skiing/history/history.

Williamstown Rural Lands Foundation. "Sheep Hill." wrlf.org/sheep-hill.

INTERVIEWS AND CORRESPONDENCE

John Allen	Ellen Chandler	Nancy Florio
Bill Beattie	Ed Chase	Alec Gilman
Bob Blair	Cal Conniff	Chris Groves
John Borwick	Tom Dwyer	Nancy-Fay Hecker
Woodward Bousquet	Paul Edwards	Hermy Henriquez
Jud Cairns	Bud Fisher	John Hitchcock

Jim Kelly
Jack Kirby
John Kirby
Gary Leveille
Heather Linscott
Chris Lundquist
Blair Mahar
Bill Martin
Steve McDermott
Bob McNinch

John McNinch
Gerry Michaud
Steve Murthey
C. Twiggs Myers
J.D. O'Connell
Marcia Packlick
Tom Packlick
Roger Picard
Frank Prinz
Roy Prinz

Leslie Reed-Evans
Maria Robarge
Tracey Rock
Will Schmidt
John Schneiter
Jim Shulman
Kurt Sullivan
Cathy Talarico
Warren Whitney
Dan Xeller

Index

About the Author

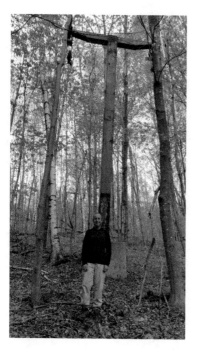

*J*eremy Davis is a passionate skier, writer and meteorologist. Originally from Chelmsford, Massachusetts, he graduated from Lyndon State College with a degree in meteorology and has been employed at Weather Routing Incorporated since 2000. He is an operations manager/meteorologist and forecasts for maritime clients worldwide.

In 1998, he founded the New England and NorthEast Lost Ski Areas Project (www.nelsap.org), which documents the history of former ski areas throughout the region and won a Cyber Award for best ski history website from the International Skiing History Association (ISHA). In 2000, he was elected to the board of directors of the New England Ski Museum and continues to serve that institution today today. He is the author of four books—*Lost Ski Areas of the White Mountains, Southern Vermont, Southern Adirondacks* and *Northern Adirondacks*—with both Adirondacks books winning Skade Awards for outstanding regional ski history from ISHA. He also serves on the editorial review board of ISHA's magazine, *Skiing History*.

The author resides with his husband, Scott, in Saratoga Springs, New York, and is a frequent skier in the Berkshires.

CPSIA information can be obtained
at www.ICGtesting.com
Printed in the USA
BVHW041152131219
566585BV00002B/3/P